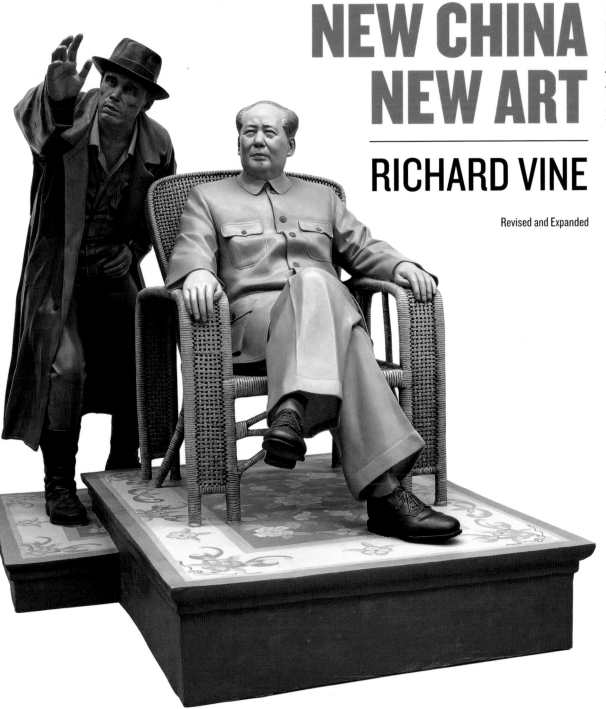

NEW CHINA NEW ART 中国当代艺术

RICHARD VINE

Revised and Expanded

PRESTEL

In the past decade contemporary Chinese art has exploded onto the international scene, attracting intense critical attention and soaring market responses. The fast-paced social and economic transformation of the People's Republic of China is reflected by a startling liberalization in subject matter, frenetic formal experimentation, canny appropriation of Western themes and mediums, a struggle to preserve and express Chinese identity in a global context, and rapid commercialization that at once embraces and challenges the international gallery and auction systems. Now fully updated and revised, Richard Vine's groundbreaking critical survey *New China, New Art* takes a medium-by-medium approach to this vitally important artistic field, featuring illustrations of works by some 150 established and emerging artists.

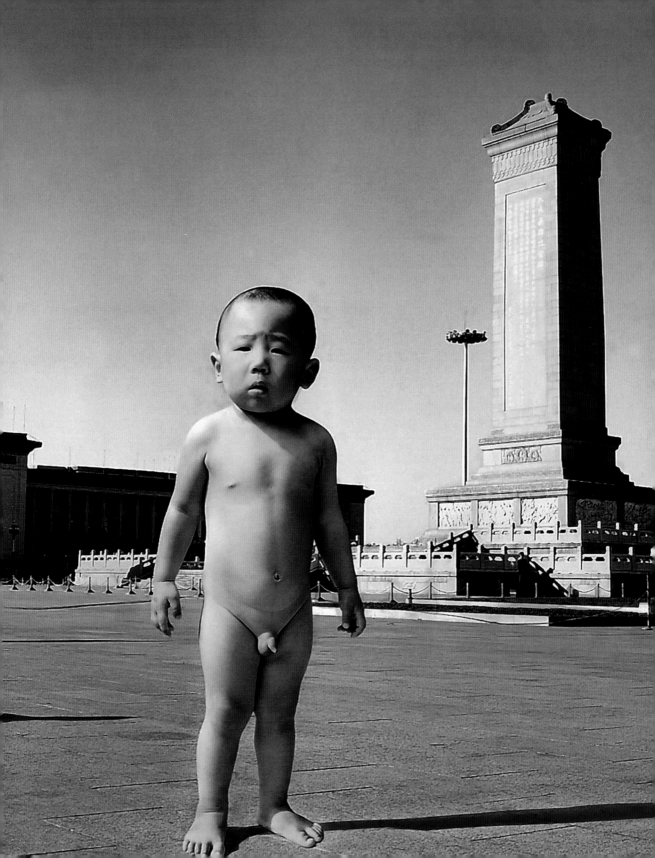

WHY CHINA, WHY NOW?

The Shock of 艺术

When the landmark exhibition *Inside Out: New Chinese Art* appeared in the United States in 1998, many viewers—even those with considerable international art-world experience—found themselves suddenly confounded. The show, organized by Gao Minglu, then a doctoral candidate at Harvard University, presented not modern variations on traditional Chinese ink painting and ceramics, or Socialist Realist images of the sort prescribed in China since midcentury under Mao Zedong, but startlingly up-to-date works from mainland China, Hong Kong, and Taiwan by some seventy-two contemporary artists and groups versed in every current Western art form: oil painting, sculpture, installation, photography, performance, video, and new media. Styles and themes varied widely, from Zhang Peili's analytical painting of gloves to Gu Wenda's screens of human hair, from Hong Hao's altered maps to several Zhang Huan nude-performance photographs (*page 84*). References to Western art were numerous (seeming take-offs on Abstract Expressionism, Pop art, installation art, and so on), but certain elements, such as the deadpan stare of Zhang Xiaogang's flat, big-headed family portraits (*page 28*), remained deeply puzzling to non-Chinese viewers.

The following year at the Venice Biennale, artistic director Harald Szeemann, a longtime curatorial maverick, surprised many by including works by a large contingent of Chinese artists, notably major installations by exiles Chen Zhen and Cai Guo-Qiang on view at the Arsenale, while Huang Yong Ping served as national representative of his adopted France. Again, this time on an international scale, the public reaction was one of embarrassed amazement. Edgy, formally diverse new art was being produced, in abundance and with great imaginative verve, by Chinese artists both in the People's Republic of China and across the globe. Why was the Western art public so unaware of this well-developed phenomenon? And given what we recalled of postwar events in the PRC—the decades of Maoist regimentation, the ideological hysteria of the Cultural Revolution, the bloody Tiananmen Square crackdown—how could it have happened? What had we missed, and what other marvels would the New China yield?

In large part, such wonder was due to our own myopia. Since the early 1980s, a number of Chinese artists had managed to study or exhibit abroad, and from time to time international shows, especially in Europe, presented post-Mao work that suggested the rise of an avant-garde in the People's Republic. Most

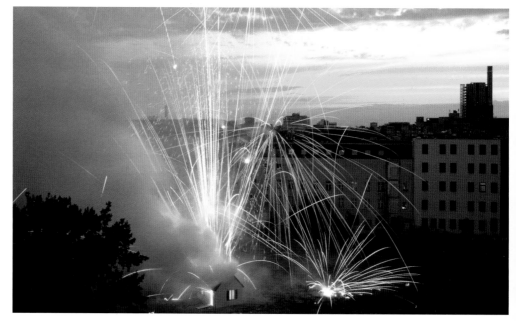

notably, in 1993 Andreas Schmid and Hans van Dijk (a Belgian, soon to become a pioneering organizer and archivist within China) curated *China Avant-garde: Counter-currents in Art and Culture*, a sixty-artist survey at the Haus der Kulturen der Welt in Berlin. Nearly a score of mainland Chinese painters appeared in a group show at the 1993 Venice Biennale, and a few others turned up in subsequent installments. The seminal 1993 exhibition *China's New Art, Post-1989*, organized by scholar-dealer Chang Tsong-zung (Johnson Chang) with critic Li Xianting, was documented by an English-language book that reached far beyond the show's original Hong Kong venues. And in 1997, shortly after the first progressive galleries opened on the mainland, Texas expatriate Robert Bernell began to offer hundreds of English-language articles and books on new Chinese art through his Beijing and Hong Kong–based website, bookstore, and publishing company, today called Timezone 8.

However, during the 1980s, Western critical and commercial attention was focused on German and Italian Neo-Expressionism and the emergence, particularly in the United States, of a new art-star system, a branch of the ever-expanding celebrity culture. In the 1990s, as the art market struggled to recover from the recession that took hold in the late 1980s, attention remained focused locally: on the culture wars in the U.S., on the sensation of the Young British Artists. Only at the turn of the twenty-first century did China suddenly seem rich enough—economically, socially, and artistically—to seize widespread art world attention.

Since then, the cognitive jolt of *Inside Out* has been repeated many times. Curators have responded with myriad new shows, and dealers are increasingly eager to proffer Chinese work to a mounting number of collectors whose desire—reflected in travel plans and soaring prices—has reached a near frenzy. By now, most Western viewers have encountered recent Chinese work or at least have come across reproductions of it in magazines or books. What they have encountered is partly familiar and partly alien, as if one were reading an English sentence and suddenly came upon 艺术, the Chinese term for "art." Ideally, the response would be combined pleasure and discomfort, coalescing into a wish to understand.

Among Westerners, perhaps only sinologists fully conversant in the history, culture, and language of China may claim to apprehend contemporary Chinese art as it is seen and felt within the PRC itself. Yet other alert Western viewers need not lose heart, for seeing through Chinese eyes may yield only part of the rewards offered by this work—and arguably only a secondary part at that. Since its inception, China's experimental art has responded avidly to influences from abroad, and has aimed, in large part, to gain critical and commercial acceptance in the global milieu.

For better or for worse, the Chinese avant-garde has merged into the international monoculture—a realm where artists from Prague to Mumbai, from Sydney to Reykjavik absorb a ubiquitous popular culture, address similar critical issues, use a common visual language (subject to minor regional inflections), and seek validation by the same museums, critical publications, universities, galleries, and auction houses. Any viewer familiar with today's visual lingua franca, derived primarily from Western avant-gardism of the turn of the last century, will find contemporary Chinese art accessible. Even its strains of inherent Chineseness are reasonably interpretable when one takes into account certain key effects of history and sensibility.

"Make the past serve the present and foreign things serve China," goes an old Maoist maxim, still resonant both in halls of power and in artists' studios now. We begin, then, with the most basic question: what are the chief factors that determine how art is made and received in the People's Republic today?

Size Matters

Geographically, China is the fourth largest country on earth (after Russia, Canada, and the United States)—stretching roughly 3,200 miles from north to south and east to west. Ordinarily, a land this size would be divided into five time zones; but, as a sign of national unity and central authority, the clocks in all 22 provinces, five nominally "autonomous" regions, four provincial-level municipalities (Beijing, Chongqing, Shanghai, Tianjin), and two special administrative regions (Hong Kong and Macau) are set to concur with those of the capital. China's populace comprises some

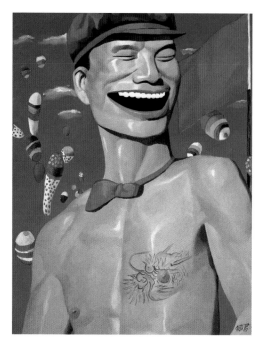

Yue Minjun, *Tatoo*, 1994.
Oil on canvas, 78 x 56 cm

per year in 2008; new college graduates could expect $2,700. Professors at the Central Academy of Fine Arts in Beijing, the nation's premier art school, are paid about $9,000 a year; workers in the enormous factory complexes take home some $3,500 per annum (as do mid-rank museum staff members), and millions of provincial farmers live on annual incomes of under $1,000.

For all its recent industrial gains, China remains preponderantly an agricultural country, with 57 percent of the populace (nearly 740 million people) now living in rural areas. Only about 15 percent of the land is arable, and subsistence is still the goal for many. Consequently, up to 150 million people in a marginal "floating population" seek day labor in cities where they have no official residency status.

These disparities feed a national preoccupation with China's place in the world—a matter of both pride and concern, and an implicit theme in a great deal of contemporary art. (Consider the fact that the U.S. has land borders with just two countries, whereas China neighbors 14 diverse nations.) When and how will the New China assume its proper role as a global power? Will it do so by emulating Euro-American models and eventually beating the West at its own "modernization" game? Or will the country cunningly subsume all foreign influences into its own deeply rooted tradition, as it has done so many times before in its 5,000-year history as the world's oldest (and arguably most refined) major civilization?

fifty-six ethnic groups (although the Han make up a 92 percent majority), speaking several distinct languages and seven major Chinese dialects in addition to the official Mandarin. The population now numbers 1.3 billion, nearly twice that of Europe and more than four times the United States total. Indeed, China holds one of every five persons alive today.

This giant, nominally Communist, but, in practice, capitalist dynamo, boasts industries (70 percent of them now in the private sector) generating a GDP of some $8.8 trillion. China has the world's second-largest economy, with a growth rate of nearly 10 percent per year for the last quarter century. While the country's burgeoning wealth creates rising expectations, an immense consumer market that foreign firms are racing to service, and a construction boom of gargantuan proportions, it also reveals some tremendous prosperity gaps—especially between city and country (a 3:1 income ratio) and between China and the West ($6,700 per capita GDP vs. $47,000 in the U.S.). Though the new Chinese entrepreneurs make millions, and corporate managers can attain salaries roughly comparable to those of peers abroad, other citizens lag far behind. According to the *China Daily* newspaper, migrant works made an average of $2,200

Past and Present

China's long evolution—from folk culture to dynastic rule to incipient modernization to Communist authoritarianism to market fervor (see the appendix, "History Lessons")—yields a strange psychic mix in which cultural nostalgia and ruthless futurism, nationalistic loyalty, and avid globalism perpetually contend. Massive recent changes have left post-Tiananmen artists spiritually unmoored—looking out for themselves and their families in a skeptical, utterly pragmatic society striving for normalcy (and hoping for affluence) in the aftermath of a cultural cataclysm. For ironically, Mao Zedong, having set out to establish a

Communist utopia, inadvertently paved the way—at a cost of forty to seventy million peacetime lives—for a postmodern society par excellence.

Certain vestiges of Old China have not been entirely lost, despite determined efforts to eradicate them in the middle of the last century. Folktales and ghost stories are still retold; animism and shamanism persist in guises such as non-empirical Chinese medicine, astrological charts, fortunetellers, marriage readers, and feng shui. The lunar calendar functions alongside the Gregorian. In temples, now treated as living museums, one still finds aged shrines to such beings as the Local Town God.

Neither early modernism, nor later Maoism, nor today's money fever has completely extinguished China's previous major belief systems. Confucianism, founded in the sixth century B.C. and rising to prominence three hundred years later, based social order and harmony on a system of hierarchical fealty, with youths admonished to give respect and obedience to older persons, women to men, subjects to officials, and officials (after the advent of the Mandate of Heaven) to their superiors in a ladder of authority leading ultimately to the emperor.

In approximately the fifth century B.C. (ancient sources conflict on the date), Lao-tzu is said to have established the doctrine of Tao, or the Way, a state of mind and method of behavior meant to put one into accord with the natural flow of all existence by emphasizing forbearance, patience, and nonaction (*wu wei*). Buddhism, entering China from India in the first century A.D., brought the goal of Nirvana, a spiritually elevated escape from cyclical reincarnation and suffering through the elimination of worldly desire. Buddhist art, from the paintings and sculptures of the thousand-temple Dunghuan caves, begun in the fourth century A.D., to the ornate structures of the late imperial period, has provided great visual stimulus to Chinese artists up to the current day. Islam first reached China in 651 A.D. and is today the core religion of several ethnic minorities. Christianity, after small incursions in the seventh and sixteenth centuries, gained a foothold with the involuntary opening of China in the mid–1800s.

Mao, of course, enforced atheism from 1949 onward. Under his successor, Deng Xiaoping, freedom of religion was finally legislated in 1978, although faith is still deemed incompatible with membership in the Communist Party. More recently the government, for the sake of national heritage, has worked to restore many temples and religious sites. These days, allowing for overlaps between Buddhism and other practices, about 30 percent of the population is Taoist, 8 percent Buddhist (although 70 percent occasionally participate in the rituals), 4 percent Christian, and 2 percent Muslim.

For avant-garde artists—as for many of the urban, educated, post-Mao young—these belief systems are residual and attenuated at best, sources of occasionally useful cultural forms, or perhaps of wishful sentiments, more than personal convictions. On the international art circuit, Old China constitutes a handy image repertoire. Whenever an unmistakable touch of Chineseness is needed, one can salt a show with pagoda tops and Buddha statues—about as meaningful to the vanguard Chinese artists who use them as the face of Mao was to Warhol or a crucifix is to the average artist in Brooklyn.

Of greater consequence, even for the most radical Chinese conceptualist today, is the long legacy of fine art. In the ancient social ranking, notes the 1996 Grove *Dictionary of Art*, intellectuals (including artists) occupied the eighth of nine descending grades, one notch below peasants and one above beggars. Over the millennia, their fortunes varied, but even when art was distinguished from craft, only painters were admitted (third in rank) to the more exalted company of poets and calligraphers, while sculptors, ceramists, and metalworkers—because of the common materiality of their endeavors—remained mere artisans.

Vernacular art was carried on by tradesmen whose motifs and techniques were so codified that they could often be memorized and transmitted in rhymed formulas. Court art, while infinitely more refined, was often stymied by the artists' fear of drawing adverse notice or raising suspicion of involvement in political intrigue. The art of the nonprofessional literati, scholars who regarded their ink-brush images as a species of literature, was addressed to a small audience of fellow initiates. Like calligraphers, the literati

Ai Weiwei, *A Study of Perspective*: Tiananmen Square, 1997. Photograph

believed (along with the population at large) that personal intellect, spirituality, and moral worth were conveyed by the manner in which the conventions of the medium were executed. Brushmanship, in essence, bespoke character.

So ingrained—and so esteemed—was this soul-to-hand correlation that for some 1,800 years mastery of calligraphy and the literary classics, along with more mundane administrative knowledge, was a central component of the civil service examinations that allowed candidates from every region and (in theory at least) every clan, family, and social rank to compete for administrative posts in the imperial bureaucracy. These rigorous exams (the success rate hovered around 2 percent) have their modern-day echo in the killingly competitive screening system for colleges, universities, and art academies in China.

Beijng's Central Academy, which had about 200 students during the 1980s, when today's avant-garde emerged, now boasts an enrollment of 4,000, though it admits only about 10 percent of applicants. The Sichuan Fine Arts Institute, with 6,000 students, accepts only 3 percent of those who apply. When one takes into account the 7,000 students at the China Art Academy in Hangzhou, and those at the schools in Hubei and Guangzhou, China's top academies are turning out a total of about 6,000 trained artists a

year. In all, hundreds of thousands of young people are currently enrolled in the nation's university-level studio, art history, and arts administration programs. The sheer numbers, not to mention the Chinese names, befuddle Westerners who are eager to keep abreast of China's art world.

In a 1942 address in Yan'an, Mao incorporated artists into the proletarian movement and later, when in power, made them part of the great propaganda machine for Chinese socialism and his own exalted persona. How and why artists have regained their individuality, and the details of their differences, is the story in these pages.

Forms of Freedom

Broadly speaking, the changes that shaped today's art—a deregulation of both style and content—occurred in distinct, wavelike phases. Avant-garde stirrings began even before Deng Xiaoping's economic reforms of the late 1970s. The No Name Group—a largely self-taught, clandestine, and literally unnamed band of about twenty artists who painted in various nonpolitical, post-Impressionist styles—originated at the Xihua Fine Arts Institute in 1959. Members held a private home exhibition in 1974 (the first known unof-

ficial show), began to display their work publicly in 1979, and remained active until the early 1980s.

At the end of the 1970s China experienced a moment of political openness known as the Beijing Spring. "Seeking truth from facts" was briefly encouraged, in order to point out the errors of Deng's rivals and predecessors, especially the Gang of Four (see appendix), and to encourage improvements in current governance. A physical symbol of this policy was the Democracy Wall, a stretch of brick masonry near a bus depot in Beijing where, beginning in December 1978, ordinary citizens could post political comments and complaints. Within days, a young activist named Wei Jingsheng put up a call for a Fifth Modernization—democracy—to supplement Deng's four economic overhauls. Wei, who also denounced Party corruption and advocated prison reform, was arrested in March 1979 and spent most of the next eighteen years in jail. He was deported to the United States in 1997.

The Democracy Wall itself lasted only one year, closing in December 1979 after having been moved to a park and placed under restricted access. But around the time of this brief Beijing Spring interlude, the new art of China began to appear, bolstered by the leeway granted to cultural productions by the 1978 Third Constitution of the People's Republic.

In late 1978 and early 1979 the April Photographic Society disseminated once privately hoarded images of huge protests against the Gang of Four that had taken place in Tiananmen Square in April 1976 (see Photography chapter). Meanwhile, prompted by the August 1978 publication of a short story titled "Scar," progressive artists in all disciplines started to produce works that honored the goals of the Cultural Revolution but also portrayed, in very concrete terms, the human costs of its excesses and failures. Scar painting, first exhibited in fall 1979, was vividly anecdotal in a manner, deriving from Socialist Realism but focused on physical and psychological traumas that could not previously be acknowledged. Many of the artists were former Red Guards.

On Sept. 26, 1979, murals by several artists, including Yuan Yunsheng (previously imprisoned for sixteen years as a rightist), were inaugurated at the international airport in Beijing. Free of political content, done

Li Wei, *Mirror*, 2000.
Photograph

in a purely aesthetic style replete with nudes, and evoking mythological landscapes and folklore, this large-scale public commission—the first since Mao's death in 1976—helped open up new artistic and critical possibilities, despite being partially curtained just seven months later.

The day after the airport murals' launch, the Stars, a group of twenty to thirty young artists, was permitted to hang works outdoors on the fence of the National Art Museum, then hosting a show marking the thirtieth anniversary of the PRC's founding. When local authorities objected, the Stars organizers posted responses on the museum fence and the Democracy Wall. On September 29 their works were impounded. The artists, egged on by political activists, replied with another message on the Democracy Wall and on October 1 marched in protest under banners proclaiming slogans such as "Demand Political Democracy, Demand Artistic Freedom!" Surprisingly, they were granted a ten-day exhibition at a hall

belonging to the Beijing Artists' Association. The show (November 23–December 2, 1979) drew forty thousand visitors and engendered a second approved exhibition the following year (August 20–September 4, 1980).

Although many of the Stars artists left China in the early 1980s, they had already established the go-your-own-way model that liberal artists in China have adopted ever since. After the Stars shows, formal experimentation, though still officially disdained in the art academies, began to build among recent graduates (divided between advocates of rationalistic and expressionistic modes), culminating in the second half of the 1980s in a concatenation of movements, groups, shows, and individual endeavors known as the '85 New Wave. That phenomenon was celebrated in *China/Avant-Garde*, an exhibition of 293 works by 186 artists, curated by critics Gao Minglu, Li Xianting, and others at the National Art Museum in 1989. Slated to run for two weeks (February 5–19), it was shut down twice for a total of eight days: first, within hours after its opening, due to the use of live gunfire in an artist's performance; second, because of bomb threats (see Sculpture & Installation and Performance chapters). Four months later, the Tiananmen Square showdown took place.

It is no accident that the first major surges of avant-garde art and the democracy movement coincided. Both were made possible by the same loosening of strictures, the same influx of information from abroad, the same impatience with authoritarianism and conformity, the same eagerness to embrace new ways of behaving and being. And both promulgated their message of liberation not only through statements, manifestos, and communiqués but also through galvanizing images. (Who can forget the Goddess of Democracy, or the daring young man standing defiantly in front of a tank in Tiananmen Square?)

Today's artists are, in psychological terms, heirs of the June 4 Movement—if one holds that the ultimate aim of that cultural revolt was the assertion of individual worth and the pursuit of individual meaning. The avant-guardists do not, however, share either the political intent or the reckless bravery of the Tiananmen organizers. The cruel lesson of June 4, 1989, is that repression sometimes works—at least for a considerable period. In the two decades since the massacre

critics of the regime have been routinely jailed while those who hold their tongues, dodging and weaving in response to shifting regulations, have survived and prospered. Critical imagery remains oblique: it is at most focused on troublesome social conditions and visible manifestations of governmental failings, but it rarely conveys direct political criticism or protest.

Immediately after Tiananmen, the avant-garde went private again, with artists making work for each other and exhibiting, when they could, more or less on the sly. Yet by 1993 they were already congregating in fraternal (though, pointedly, not collective) living and working spaces—called artist "villages"—on the margins of respectable society. With Chinese officialdom eyeing them askance and no domestic galleries to carry their work until late in the decade, they developed an oddly internationalist mindset: they were proudly Chinese and passionately involved in internal critical debates, yet also attuned to global art-world currents and selling (though rarely and at meager prices) only abroad or to foreigners living in China. Some artists were able, with considerable bureaucratic difficulty, to travel or study outside the PRC, especially once international curators began to mount surveys of recent Chinese art. (To this day, there remains in some circles an ingrained skepticism about those "overseas Chinese" artists who opted for long-term residence abroad or were born of émigré parents.)

The shift to the Chinese art environment of today, with its frenetic activity and get-rich-quick mentality (see "The Scene Now" chapter), began with the new millennium. The third Shanghai Biennale in 2000, the first to go truly international, is often cited as a turning point—especially since its renegade, artist-run satellite shows drew more intense critical reaction than the official event. Most noted of those half-dozen exhibitions was *Fuck Off* (or *Uncooperative Attitude* in its less abrasive Mandarin version), a display of boundary-pushing works by forty-seven artists, organized by artist-provocateur Ai Weiwei and independent curator Feng Boyi at Shanghai's alternative Eastlink Gallery.

Authorities closed *Fuck Off* a few days after its opening, and oversight of exhibitions became stricter for a year or two. But gradually, more and more commercial galleries opened in China, progressive work came into ever greater demand from dealers and

curators, and critics everywhere started to treat the work with fascination and respect. As a result, officials in the PRC began to change their view, especially after international collectors grew excited and global auction houses opened new departments dedicated to the highly profitable resale of contemporary Chinese art.

Exhibitions are now much less frequently and less severely censored, and the overall atmosphere in the Chinese art world is freewheeling within broad, "reasonable" limits (no direct political criticism, no really raunchy sex). Permission to travel flows easily these days to artists who can bring substantial income back to the mainland. And the perception of a free cultural domain clearly serves the nation's long-term business and diplomatic goals. In short, the government, which once promoted mostly tradition-based work both as a compensation for the now-renounced Cultural Revolution and as an assertion of national identity, has today, however grudgingly, come to value avant-garde art as part of a soft power strategy to enhance China's global status.

Under Western Eyes

China's vanguard art is frequently seen from abroad (and sometimes at home) as merely illustrative of ethnography, politics, market trends, or critical theory. A series of short-lived styles and associations—such as Cynical Realism, Gaudy Art, Political Pop, and so on—has been promoted, in a process that scholar-curator Wu Hung, writing in the catalog of the First Guangzhou Triennial, identified with a Cultural Revolution–style fusion of agenda, propaganda, and organization (though it also bears eerie resemblance to a Western marketing blitz).

The focus of this book is more concrete, based on the conviction that artworks are generated by individuals, working with particular materials, under their own set of circumstances. Surveying progressive Chinese art from the end of the Cultural Revolution to the present, this account is tied to no single artist, exhibition, movement, or collection. Artists individually examined are of two frequently overlapping types: those who have, by critical consensus, emerged as essential to international understanding, and those I find to be the

most visually and conceptually compelling. For the reader's convenience, the text is segmented into chapters by medium, with artists assigned according to the type of work for which they are best known. It is important to note, however, that contemporary practitioners in China are extremely eclectic—appropriating whatever ideas and techniques they like, regardless of source, and often working with equal fluency in several diverse mediums. The PRC is full of painters who also make sculpture, performance artists who present their work in photographs and videos, and artists who use cameras but do not style themselves photographers.

In the three decades covered here (1978–2010), progressive Chinese art has been—like so much else in China—a veritable boys' club, accomodating only a few women artists, critics, and curators. So whenever a woman is named in this text, a gender-signaling pronoun will soon follow; all other subjects are male.

The titling and dating of works is another vexed issue. Until very recently, avant-garde artists in China, working without official recognition or gallery-system discipline, tended to be extremely lax in their record-keeping. Studios grew cluttered, and when rare exhibition opportunities arose, works were often identified from memory or on the whim of the moment. Moreover, many Chinese artists—particularly since the market has become superheated—tend to make numerous copies or variants of their signature pieces. Add to this the wrinkles of translation (Should Geng Jianyi's famous faces be called *Second Situation* or *Second State?*), and it is not unusual now to find the same work bearing two or three different names or dates in various sources. In most instances here, only the most commonly cited title and date are given, and the joys of one-upmanship are left to future investigators.

Indeed, the core concern of this book lies elsewhere—in the realm of the visual and interpretive. An implicit question—simple but hopefully enlightening—undergirds every page: Why do these Chinese works look the way they do? In each case—whether the prime determinant is formal, historical, sociological, philosophical, psychological, biographical, or aesthetic—the goal is one: to understand the art as art, in light of the artist's conscious and subliminal motives and the viewers' responses, as those factors translate into critical discourse in the world beyond China.

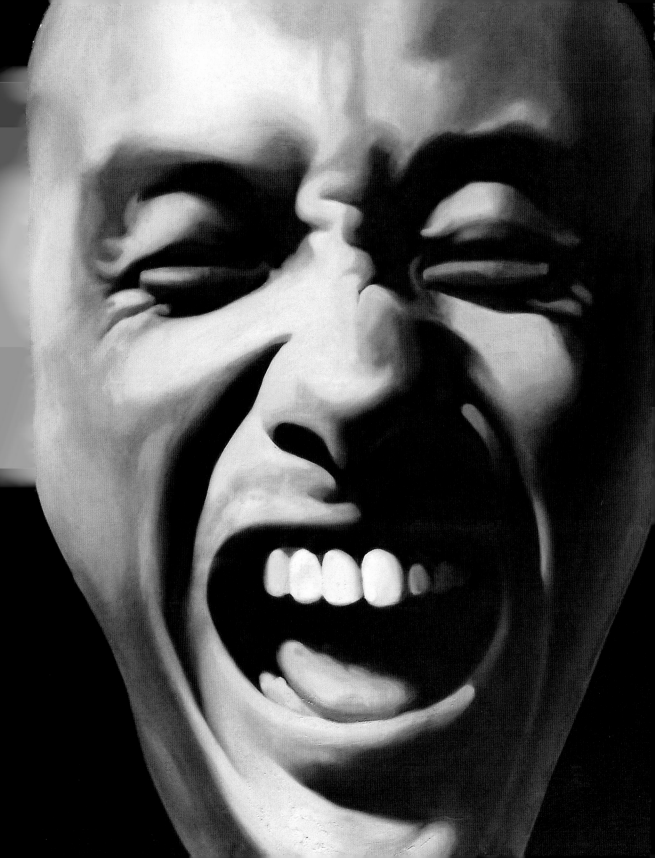

PAINTING

CHAPTER 1

Chen Yifei, *The Melody of Xunyang*, 1999. Oil on canvas, 129.6 x 149.8 cm

Painters in China today bear a dual historical burden. Behind them lies an indigenous tradition of almost unimaginable length and complexity, while thrust upon them is a foreign art history that culminates in a set of aggressively "modern" techniques. As a result, three basic options are available: subsume oneself to the venerable native conventions; abandon the old ways completely and embrace a Western aesthetic; or attempt somehow to reconcile the two. Each of these alternatives is sure to alienate a considerable portion of the potential audience. Many artists, for example, have chosen the "fusion" option—with results that are fully satisfactory to neither the traditionalists nor the modernists; a painting by a Chinese quasimodernist displaying the timeless lotus in a Blaue Reiter manner, let's say, may appear garish and undisciplined to traditionalists, yet overly controlled and too "beautiful" to Western critics.

This has led to the development of two distinct constellations of work: one popularly known as ink or Chinese painting, the other as oil or Western painting. Each has its adherents, university art departments, commentators, workshops, dealers, and buyers. Neither type, in practice, is always conservative or progressive. While some contemporary ink painters use the medium in unorthodox ways and exploit unconventional motifs (cartoon characters, motorbikes, electrical power stations) to the dismay of their conservative peers, some oil painters, like Chen Yifei (1946–2005)—known for his quaint city views, noble villagers, and slinky young beauties in ornate silks—depict a dream China that no longer exists, and perhaps never did (*above*). The artists who have recently caught the fancy of the international art world, however, are almost exclusively students of the Western avant-garde who deploy their Chinese references with cunning irony. These conceptually astute painters play with the signs of Chineseness in their art as deftly as they play against social and political strictures at home—and with the mechanics of cultural institutions and markets abroad.

Previous pages:
Geng Jianyi, *The Second State*, 1987. Oil on canvas, 170 x 132 cm

How did this come about? For millennia, Chinese artists, with rare and memorable exceptions, consciously chose a middle way—neither rigorously representational nor fully abstract. Their goal was to convey the inner, spiritual reality of a visual experience. At the extreme, this could mean not even looking at a given subject or its model while depicting it. In the words of the eighth-century painter Zhang Zao, "One should learn from nature and paint the image in one's mind."

In fact, these painters learned as much from each other as they did from nature. Accomplished works were frequently copied and widely circulated, and technical training took the form of a decades-long apprenticeship to an esteemed master—after which an artist might introduce some small formal variation in a bid to establish a distinct stylistic identity. Formal conventions (such as the foreground often reading closer in time as well as distance); motifs (mountainous landscape, air and water, select plants and birds, figures immersed in their setting); and techniques (a measured flick of the inked bristles denoting new leaves) evolved slowly. Observing such conventions, traditional painters strove to endow the work's surface with an engrossing flow of energy (qi). Frequently their visual efforts were accompanied by an inscribed text.

Western illusionism, which treats the picture as a window opening into a deep space inhabited by volumetric forms, began to flourish in China around the turn of the twentieth century, but it sadly devolved over several decades into the big lie of Socialist Realism. A key figure in that transition was the artist Lu Xun (1881–1936), a major social-activist writer and critic who in 1931 founded the Creative Print Movement. Employing European printmaking styles to rejuvenate Chinese woodblock practices, Lu turned them toward leftist social commentary and propaganda. His ideas also deeply influenced the All China Association of Anti-Enemy Woodcutters, established in 1938 to help unite Guomingdang and Communist forces against the invading Japanese.

Xu Beihong (1895–1953), a master of Chinese painting who also studied at the École Nationale Supérieure des Beaux-Arts in Paris, strongly advocated mixing European academicism with Eastern tradition. (He rejected radical modernism, dismissing Cézanne and

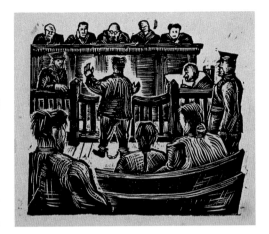

Jiang Feng, *The Trial*, 1936. Woodcut, 9.4 x 11 cm. Lu Xun Memorial, Shanghai. Published in: *Steel-Horse Woodcuts*, vol. 2 (1936)

Matisse as "shallow.") By 1949 he was director of the Central Academy of Fine Arts and first president of the Chinese Artists Association.

Jiang Feng (1910–82), a Communist cadre and founding member of the Creative Print Movement, fostered in both the Academy and the Association two somewhat antithetical methodologies that mixed the vernacular with the elitist (*above*). From his experience in Yan'an, the Red Army headquarters after 1936, he brought the conviction that artists should be thoroughly schooled in the thought of Marx and Mao and should spend considerable time working directly with peasants, laborers, and soldiers. (This, he reasoned, would make the artists more humane and the people more cultivated.) He also championed the mid-nineteenth-century Russian system of instruction that—with obvious debts to Renaissance theory and the French Academy—posited fine volumetric drawing as the basis for all convincing art and prescribed a regimen by which an artist would progress from rendering simple geometric forms to drawing tabletop arrangements, plaster casts, and finally live models.

Such are the principles that triumphed when, in 1942, Mao Zedong declared that art and literature should serve the people—that is, be readily comprehensible and morally salutary. Some thirty years later, with the closing of most art academies during the anti-intellectual frenzy of the Cultural Revolution, many artists were sent to do menial labor in the countryside, while others were assigned to create propagandistic paintings, big-character posters, or newsletter illustrations.

To be sure, many artists who had lived through the war years gladly adopted the prescribed realist imagery—showing a grim form of life before Mao's victory and a glorious hope since—because such a program matched their own experience of China.

When the art academies reopened in the late 1970s, the choice facing student painters was again between Chinese-ink stylization and Soviet-style oil-on-canvas representation. Both were well taught, and admissions standards were high. Consequently, many mid-career artists today have superb technical facility, which they

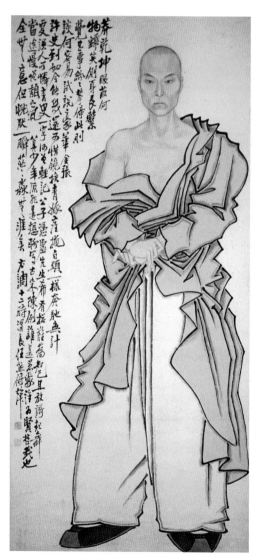

Ren Xiong, *Self-portrait*, undated. Ink and color on paper, 177.4 x 78.5 cm. Palace Museum, Beijing

subvert just as deliberately as they eschew mainstream loveliness and official portrait commissions. Recently, however, skill levels in the academies are said to have deteriorated somewhat, while kitsch modernism has gained increasing acceptance in government circles.

Big Faces

The essence of avant-garde painting in China can be described as the liberation of new, radically individualized visions. Certainly issues of social responsibility, formal beauty, abstraction, representation, intuition, reason, and expressiveness have been hotly debated in the country's art magazines and seminars since the end of the 1970s. The ability of artists to sort through such concepts, and to choose their own ends and means, bespeaks an upsurge of freedom. But the post-Tiananmen painting that has aroused the greatest international interest is work that focuses largely on the human figure, particularly the head and face—a true historical departure.

Apart from a few anomalies—one thinks of the series Confucian Sages and Worthies by Ma Lin (ca. 1180–1256)—little in the Chinese painting tradition compares to Western portraiture, with its attention not only to the status-signaling accoutrements of the sitter but to the individual's character and state of mind, communicated through minute facial subtleties. The Jesuit priest Giuseppe Castiglione's eighteenth-century portraits of the emperor and his court had considerable impact, prompting such indigenous works in the nineteenth century as Ren Xiong's powerful self-portrait scroll (*left*) and Ren Bonian's *Portrait of a Down-and-Out Man*. Yet even here there is a certain flat, caricatural broadness. Only briefly, in the early decades of the twentieth century, did a substantial number of oil painters such as Li Tiefu (1869–1952) and Feng Gangbei (1884–1984), both of whom had studied abroad, produce closely observed, veristic portraiture. Yet this pursuit was soon fatally corrupted by political didacticism under the Communist regime. There is, in short, no Chinese Rembrandt—nor any sustained lineage of intense psychological scrutiny that might have culminated in one.

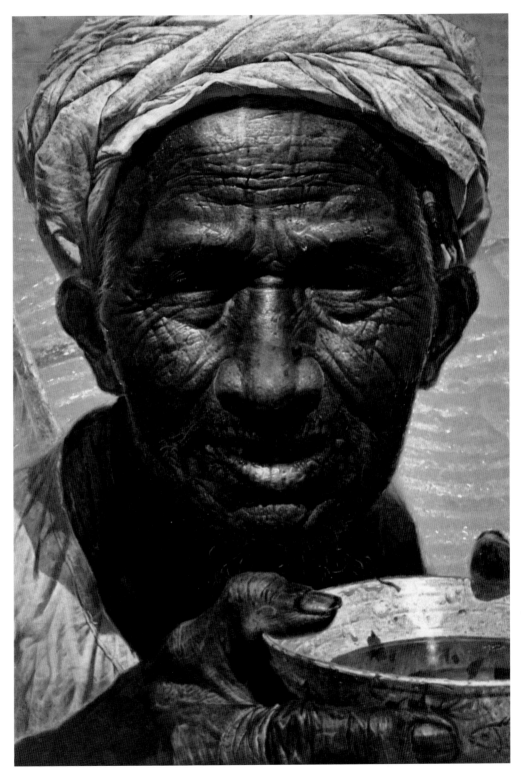

Luo Zhongli, *Father*, 1980.
Oil on canvas, 215 x 150 cm.
Chinese National Art
Gallery, Beijing

21

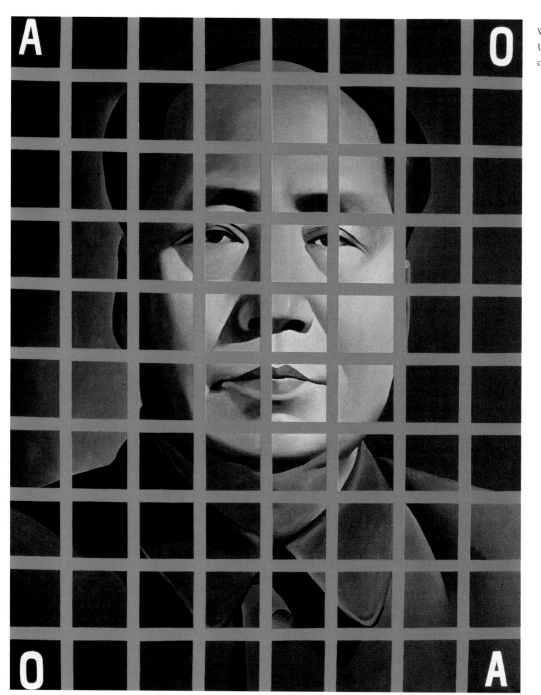

Wang Guangyi,
Untitled, 1986. Oil on
canvas, 150 x 130 cm

Instead, in art as in life, the face became largely a mask, more emblematic than expressive. Party officials, subject to continuous monitoring and purges, learned never to publicly signal their true thoughts and feelings through facial reactions. (Socialist Realist artists could instead memorialize the proper demeanor in works approved by the party.) Many citizens, when not consciously adopting the facial semaphores of propaganda, obscured their inner doubts behind a blank facial façade, a Confucian coping mechanism long employed in Chinese families and social groups.

Ultimately, with the burgeoning of Mao's personality cult, one portrait image dominated all others and appeared in virtually every public venue: the bland and enigmatic visage of the Great Leader himself. To this day, Mao's portrait presides over the entrance to the Forbidden City and visually monopolizes the currency. The function of other faces in China's high-period Socialist Realism was to express admiring gratitude to the chairman, to clench the jaw with revolutionary determination, or to beam openly—eyes upward, with full and ruddy cheeks agleam—for proud joy at the thought of the coming utopia. "Red, smooth, and bright" was the artistic catchphrase of the day.

Thus it was something of an eruption when, beginning in the late 1970s, two formerly unthinkable tendencies appeared: depictions of common faces marked by common human emotions, and satirical treatment of Mao Zedong's image. Scar Art, though primarily concerned with multifigure scenes expressing the ill effects of the Cultural Revolution on everyday people, also brought a new, formerly impermissible realism and sensitivity to the treatment of visages. Sadness, bewilderment, despair, even anger flowered where the inanely smiling mask had once prevailed. An outgrowth of this relative candor, the tendency called Rustic Realism, with its emphasis on harsh provincial life, gave rise to one of the most charged images of the new era. *Father* (1980), by Luo Zhongli (b. 1948), is a tight close-up of a sun-darkened, deeply wrinkled male peasant in a white tunic and headwrap, staring at the viewer as he raises a bowl toward his lips (*page 21*). At 7 by 5 feet (215 x 150 cm), it is on a scale once reserved for the chairman, and its power is enhanced by both its visual frankness and its dual import. Mainstream audiences could relish the work's verisimilitude and sentimentality—inducing

sympathy for a paternal figure ravaged by natural elements and hard labor—while members of the incipient avant-garde could find in it license for a new psychological honesty and a release from intimidation by the face of Mao. The picture debuted at the Sichuan Institute of Fine Arts as part of a show by the entering class of 1977 (the first registrants after the Cultural Revolution) and later won first prize in the 1981 Second National Youth Arts Exhibition. In response to criticism that the image failed to reflect modern advances in China, Luo (who years later became president of the Sichuan Institute) added a ballpoint pen behind the peasant's ear—the kind of wry and obliquely critical gesture that would soon become a mainstay of progressive painting in the People's Republic.

With the onset of the '85 New Wave movement, a number of artists began to toy with the face of Mao, previously a sacrosanct icon. Andy Warhol, it should be remembered, had painted Mao from photographs in 1972, shortly after Nixon's visit to China; in 1973, he

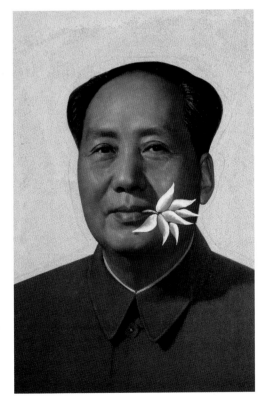

Li Shan, *Mao*, 1995. Acrylic and silkscreen on canvas, 57 x 34 cm

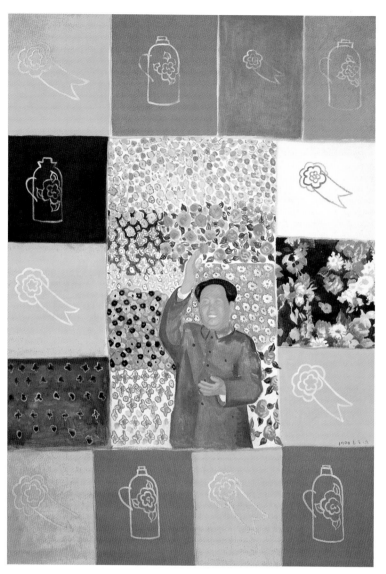

Yu Youhan, *The Fifties*,
1994. Oil on canvas,
145 x 100 cm

did a large series of multicolored silkscreens. These images were well known to artists in the PRC by the mid-1980s, after Deng Xiaoping's Open Door policy led to a massive wave of foreign information. (Warhol himself visited China, briefly and rather uneventfully, in 1982.) Wang Guangyi (b. 1957), a 1984 graduate of the Zhejiang Academy of Fine Arts, produced some of the earliest and most striking Mao parodies: a 1986–88 series of grisaille close-ups overlaid with a linear grid in black or red, an enlargement device used (but never shown) during the Cultural Revolution to square up photos into monumental paintings (*page 22*). Wang thus reveals the ploys of old-style heroization, while allowing his intrusive grid lines to suggest a more recent ideological containment, as though the gray ghost of Mao was being kept at bay by the mesh of an animal cage. The approach, though Wang described it in "rationalist" terms not unlike those applicable to the work of Chuck Close, elicited a sharp response from the general public and cultural authorities alike at the 1989 *China/Avant-Garde* exhibition. Undeniably, the game of sly irreverence was on.

Although Li Shan (b. 1942), schooled at Heilongjiang University and the Shanghai Theater Academy, disclaims any political intent for the 1990s Rouge series, the paintings are innately rife with ideological subversion. Familiar propaganda images of Mao appear in subtly altered form against a monochrome background, usually red. The face, rendered nearly androgynous, has been given full lips and a feminine softness (sometimes highlighted by thin, penciled brows). In some cases, the dictatorial strongman, long the master of one of the most powerful nations on earth, is shown with a flower in his teeth, like a gypsy dancer or some soft-eyed Latin gigolo (*page 23*).

A more obliterating floral motif runs through the 1990s works of Beijing Central Academy of Fine Arts graduate Yu Youhan (b. 1943), whose standing or sitting figures of Mao become little more than an organizing shape amid a flurry of conflicting patterns. The Great Leader, once routinely depicted at the forefront of struggle, is now subsumed by a quasipsychedelic background (*left*). In Yu's fabriclike works, and in those by many artists to follow, the chairman, gone but not forgotten, lingers on deprived of iconographic dominance. The man who was the living embodiment of China has been reduced to a marker for a bygone

political era, to be manipulated with impunity. (Or, rather, relative impunity. As recently as 2006, Gao Qiang's image of Mao swimming in a red river—which local censors deemed uncomfortably reminiscent of blood—was removed from a show in Beijing.)

In the turn from Mao to everyman, one of the most seminal works of the late 1980s is also one of the most enigmatic. Recalling a repetitive Warhol format, the four super-close-up grisaille faces of the 1986 *The Second State* by Geng Jianyi (b. 1962) show a male subject, head seemingly afloat against a black backdrop, variously grimacing with open-mouthed laughter (*pages 16–17*). His crinkled eyes and nose, like his savagely bared teeth, suggest a forced (or is it uncontainably explosive?) merriment verging on pain. Geng created this suite after his works portraying serious-looking individuals, submitted as a graduation project at the Zhejiang Academy of Fine Arts in Hangzhou in 1985, were criticized for not expressing a positive outlook. His response was to exaggerate a feel-good enthusiasm to the point of absurdity, verging on its own negation. (Today Geng is predominantly a conceptual artist, producing such works as a book with blank pages.)

This facial strategy has since been carried to the ultimate degree by Yue Minjun (b. 1962). His signature male figure—topped by a large head with pink flesh, closed eyes, cropped hair, and open-mouthed grin fully baring uniform teeth—came into being shortly after Yue read art magazine accounts of the sensation caused by Geng's *Second Situation* in the 1989 *China/Avant-Garde* show. At first, Yue's Asian caricature (one that transvalues the worst Western clichés about "Oriental" physiognomy) was based on his artist friends; later, it became a parodic self-portrait. In both cases, the joke was liberating.

Son of a military official assigned to the provincial oil fields, Yue was an electrician for a state oil company and then a teacher's college instructor before moving to Beijing's Yuanmingyuan artist village in 1991, thereby trading a life intimately controlled by his work unit for one of self-direction and artistic creation. Yue has said that his surrogate's eyes are kept closed against the ugliness and violence of the world around him—which results, apparently, in a kind of hermetic bliss. Commentators (including the artist himself)

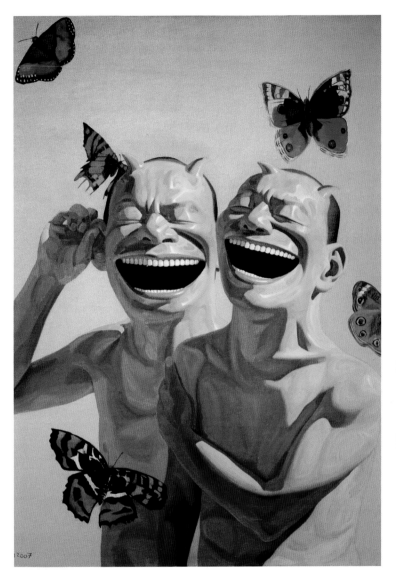

Yue Minjun, *Butterfly*, 2007. Oil on canvas, 100.3 x 80.8 cm

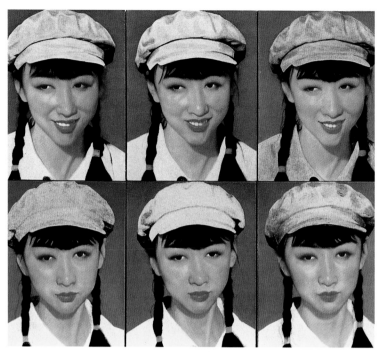

Qi Zhilong, Untitled, 1996, China Girl series. Oil on canvas, 41 x 33 cm each

contrived for ulterior purposes. This is poignantly clear in the portraits of young women painted by Central Academy graduate Qi Zhilong (b. 1962). Another veteran of Yuanmingyuan, the artist presents his beauties—some of them models or actresses—in the brown shirts, caps and pigtails of revolutionary stalwarts, yet with their faces as full-lipped and flawless as those of soignée cosmetics-ad vamps (*left*). Ironically, young female cadres, dutifully sans makeup, were among the most vicious participants in Cultural Revolution assaults.

An extreme version of the new consumerist aesthetic is found in the flat, stylized, billboard-ready glamour faces propagated by Beijing-based Feng Zhengjie (b. 1968). With their widely spaced eyes and unnatural color combinations (red and blue, red and green), these visages may indeed satirize the cult of the imperious fashion model, but they also convey the siren-like allure those artificial creatures can have for an artist who, in Feng's case, is a former high-school and college art teacher from Sichuan—as well as for countless fashion victims worldwide, both male and female (*opposite*).

The "mystery" purveyed by stage-and-screen beauties is simple, however, compared to the enigmas personified in works by two of China's most successful painters, Zhang Xiaogang (b. 1958) and Fang Lijun (b. 1963). Zhang is by far the more difficult for Westerners to fathom, since his faces seem to invite the cultural stereotype of Asian "inscrutability." Ghostly, doe-eyed, expressionless, and posed four-square against the picture plane as though staring at us through a window, the figures of his Bloodlines: The Big Family series (1993–present) reveal nothing of their emotions or thoughts (*page 28*). Yet at the time Zhang started producing them—after early works reminiscent of de Chirico and post-1989 scenes of dismemberment that got his paintings banned in China until the mid-1990s—they were considered strong reassertions of the personal. The adults, even when dressed as good comrades, forgo the facial pantomime of true belief in the socialist cause. They keep their own council, internally, except for the occasional lazy eye that suggests something is off-kilter. The children, stunned as they may seem, bridge the space between their parents as well as between present and future. Their very presence, whether by the governmentally prescribed number (one) or some

offer nearly as many interpretations of this idiot-grin motif, now ubiquitous thanks to countless paintings and sculptures produced at Yue's new studio in Songzhuang on the eastern edge of Beijing, as Melville does of Moby-Dick or Walter Pater of the *Mona Lisa*. Yue's clones, whether depicted singly or in groups, may represent an homage to the laughing Buddha, a rejection to Communist all-the-sameness, a mockery of industrial-age standardization and mass production, a cathartic self-irony, a refusal (in the manner of a Taoist sage) to take anything too seriously, an embrace of the fundamental mischievousness of human nature, a Warholian exercise in deadpan seriality, a protest against the disguises adopted under Mao, a repudiation of Cultural Revolution seriousness, a gleeful enjoyment of new liberties, a salute to the philosophical powers of the fool—you name it (*pages 10, 25*).

To many, Yue's work—simple, fast, and vivid—seems equally influenced by old-style propaganda and new-style advertising. And why not? The artist grew up between the demise of the Cultural Revolution and the advent of today's manic consumerism—part of a generation that has never known an art (except in museums and history books) that was *not* utterly

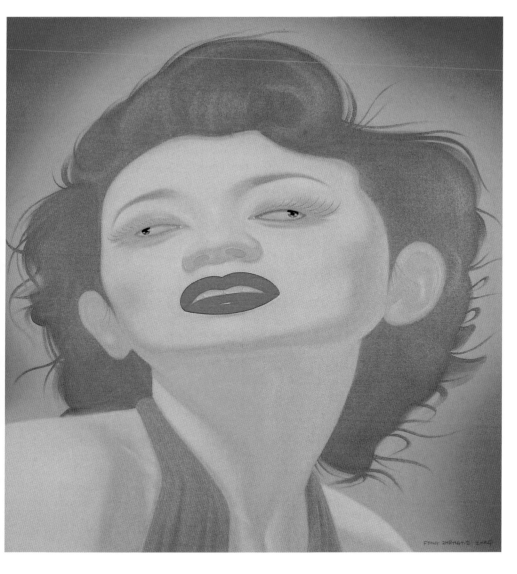

greater quantity, signifies the continuation of familial identity. The thin, spiky, red-painted "bloodlines" connecting the contemporary figures also evoke distant ancestral links. Odd splotches of random color recall spots of deterioration on old, stiffly posed family photographs—images of a sort lost in heartbreaking quantity during the Cultural Revolution and the war years before. Indeed, Zhang started the series after discovering a photo of his aged mother as an attractive (and, sadly, schizophrenic) young woman. The formula, endlessly repeated, has made the artist perhaps the most internationally recognized (and

salable) Chinese painter of our time. As such, he is a hero of the apolitical Sichuan School, having graduated from the Sichuan Institute in 1982, and a megastar of the art scene in Beijing, where he currently resides.

Fang Lijun, rising to notice after completing studies at the Central Academy in Beijing in 1989, could scarcely be more different in psychological intent. His signature subject—round-headed, thick-featured, and bald, slouching in shapeless garb against a monochrome expanse—is essentially a thug. To grasp his effect,

27

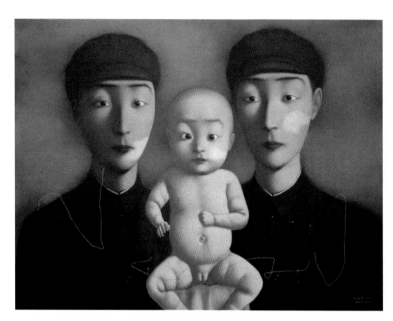

Zhang Xiaogang,
*Two Comrades with Red
Baby*, 1994, Bloodline:
The Big Family series, 1994.
Oil on canvas, 150 x 180 cm

contrary of dropouts. Indeed, in their light-colored suits or casual wear, often standing with easy camaraderie in groups, they appear at first glance to epitomize success in the new Chinese economy (*opposite, below*). They soon remind us, however, that "making it" comes at a price. Their hands are gnarled and oversized like those of laborers; their mouths are open in a forced laughter that verges on a shriek, and their faces are fused with white (i.e., Western-hued) masks that at once emphasize and disguise their overwrought expressions. They have adopted the look of foreigners without finding ease in their roles.

Changes Visible

No artist has more strikingly exploited the ironies of China's new mindset—a paradoxical embrace of nominal socialism and fervid everyday capitalism—than has Wang Guangyi. His ongoing Great Criticism series, begun in the 1990s, combines Communist propaganda iconography (soldiers, workers, and peasants clutching Mao's Little Red Book and hoisting salutes to the future) with advertising logos for Western brands (Chanel, Versace, Porsche), rendered in a graphic Pop-art manner and peppered with depersonalizing ciphers reminiscent of both government ID numbers and product serial codes (*page 31*). Wang's frequent juxtaposition of yellow and red defies traditional Chinese color theory, which associates these hues with the incompatible elements of earth and fire. The "great criticism" here, with its distinctly Maoist ring, applies to both the Communist and consumerist elements of this "double kitsch" hybrid, while also baiting anyone who thinks that the global triumph of fame and money can somehow be resisted. (Wang is known to be openly proud of his own success, and rather dismissive of those who don't—or can't—game the system as he does.) His recent Materialist sculptures (2001–present), Socialist Realist figures cut off below the waist, make their point through their abruptly diminished stature and, occasionally, a coating of millet—a much needed sustenance that, so used, can never grow (*page 30*).

especially for Chinese viewers, we must think about everything he is not. He is not a good Confucian son, not a loyal party member, not a productive farmer or worker, not a dutiful official or soldier, not a religious adherent, not even a newly rich entrepreneur. He seems to be, rather, a social dropout and potential troublemaker, devoid of any sign of aspiration, conviction, or loyalty. Whether he is shown singly or in multiples, his only discernible expressions are those of boredom, vague menace, and self-pity for his own blank fate. Inspired by *liumang* or hooligan-thug culture popularized by Wang Shuo's books, which became prominent in post-1989 pop culture, he is childless, adrift in a landscape populated by equally brutish men, with no women in sight. The nightmare of every traditional Chinese, this loner, because he is often shown against a "blue sky" reminiscent of Communist promises, constitutes, in addition, a latent threat to governmental order (*opposite, above*). As Fang's renown has grown, the artist has sometimes softened his approach; one recent image (*30th May, 2006*) shows little baldies in dresses swirling upward to the heavens—but the rude, slack-jawed character he invented in the 1990s remains the classic embodiment of Cynical Realism.

The masked personages in many works painted by Zeng Fanzhi (b. 1964) beginning in 1994 are the

Wang, often cited as a practitioner of Political Pop (akin in its fusions to the Sots Art that emerged with liberalization in the USSR of the 1970s and 1980s),

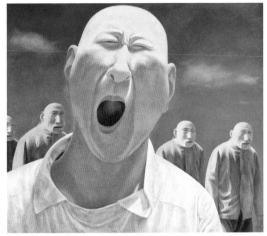

Fang Lijun, *Big Head
(Blue), Series 2: No. 2,
1991–2.* Oil on canvas,
200 x 230 cm

Zeng Fanzhi, *We, No. 6,
2002,* Mask series.
Oil on canvas, 180 x 150 cm

could seem reserved only in the company of the Luo Brothers (Luo Weidong, b. 1963; Luo Weiguo, b. 1964; and Luo Weibing, b. 1972). The Beijing threesome, originally from economically sluggish Guangxi Province, celebrate the onslaught of Western-style consumerism with a mix of cynicism and exuberance. Their compositions, brimming with hamburgers and Cokes, pizzas and beer, may mock their countrymen's heedless consumption of Western brand-name products, yet the brothers surround these cultural intrusions with familiar Chinese icons of (longed-for) well-being and abundance: dragons, flowers, plump and ruddy-cheeked children, and pretty young women from the days of prewar advertising (*page 32*). The colors of the madly busy scenarios (whether painted, collaged, or sculpted) are candy-bright and lacquered to a hallucinatory sheen. If Coca-Cola, with all it repre-

Wang Guangyi, Untitled, 2001–2, Materialist Sculpture series. Glass fiber, reinforced plastic, 200 x 120 x 80 cm

sents, is the new opium, the Luo Brothers—prime exemplars of Gaudy Art—seem to have imbibed it with gusto.

Zhou Tiehai (b. 1966), a lifelong resident of cosmopolitan Shanghai (where he attended the university's Fine Arts School), sends up West and East with equal glee, satirizing not only the content but also the techniques of both advertising and classic art. In his works since 1999, he often substitutes the head of Joe Camel—notorious in the U.S. for enticing adolescents to smoke (*page 33*)—in images ranging from aristocratic European portraits to scenes by international contemporary artists to a fake *Art in America* cover. His Tonic works (2001–present) feature details from traditional Chinese ink paintings blown up to billboard size. In both cases, the paintings are executed by assistants using airbrushes, doubly negating the touch of the master's hand so venerated by connoisseurs. Publicly (though how sincerely is hard to say, given Zhou's tricksterism), the artist has advocated exploiting the international art market as a means of personal and collective self-defense. "The relations in the art world are the same as the relations between states in the post Cold War era," reads a text emblazoned in English across a self-portrait (*Press Conference III*, 1996) in which he stands at a lectern in front of a row of various national flags. Thus, like many of his contemporaries in China, Zhou uses one form of superficiality to critique another—to predictable effect.

Much more subtle, but equally acerbic, is the work of Zeng Hao (b. 1963), whose 1995–97 interiors with figures draw existential angst out of the new Chinese mania for home furnishings. In these works, the well-dressed human characters float dreamlike amid disproportionately scaled possessions—couches, end tables, stereos, lamps—all of them chosen, like any interior decoration, to make a statement about the economic standing and cultural sophistication of the owners. Yet all remain disconnected and randomly strewn in an undefined monochrome space. Each scene is titled not for the objects or the residents but for a Twilight Zone of displaced time, eternity masquerading as a particular moment: *5:00 PM in the Afternoon*, or *In the Noon, 26 June* (*page 34*), or *Thursday Afternoon*. For all their worldly success, the people who own these domestic prizes remain pitifully small and lost in a world without boundaries.

Different Strokes

One cannot help but be struck by how nonpainterly much avant-garde Chinese painting is, relying more on graphic impact than on compositional complexity, more on flat blocks of color than on chromatic nuance. This is probably due to a confluence of historical influences—the shallow field and restricted palette of traditional ink-and-wash painting, the glaring simplicity of propaganda imagery, and the aggressiveness of modern advertising, as blatant to new Chinese eyes as the big-character posters it displaced. And for very young painters—those under thirty—the influence of cartoons, graphic novels, and Japanese "super flat" pop imagery is undeniable.

These visual stimuli were complemented, moreover, by a conscious rejection of the pseudorealism associated with party-approved art of the recent past. That

repudiation could not take the form of classic modernism for two reasons: first, because modernism was forbidden during a period of nearly thirty years (1949–76) when it might have grown naturally out of the Western aesthetic already implanted in China; second, because, in debased form, modernism was co-opted by official art during the post-Cultural Revolution reopening to the West. Tacky knockoffs of Brancusi and Kandinsky, Miró and David Smith can be seen everywhere in the PRC now and still fatally taint the Beijing Biennale, the government's showcase of supposedly up-to-date art. No wonder experimental artists like Yue Minjun and Wang Guangyi have essentially skipped modernism and plunged directly into postmodern, deconstructive pastiche.

There are, to be sure, intriguing new-art painters who depict the figure naturalistically, in perspectival depth surrounded by recognizable objects. Foremost among

Wang Guangyi, *Coca Cola*, 2004, from Great Criticism series. Oil on canvas, 200 x 300 cm

Luo Brothers, *Mao Burger
Monument,* ca. 2006.
Mixed media on panel

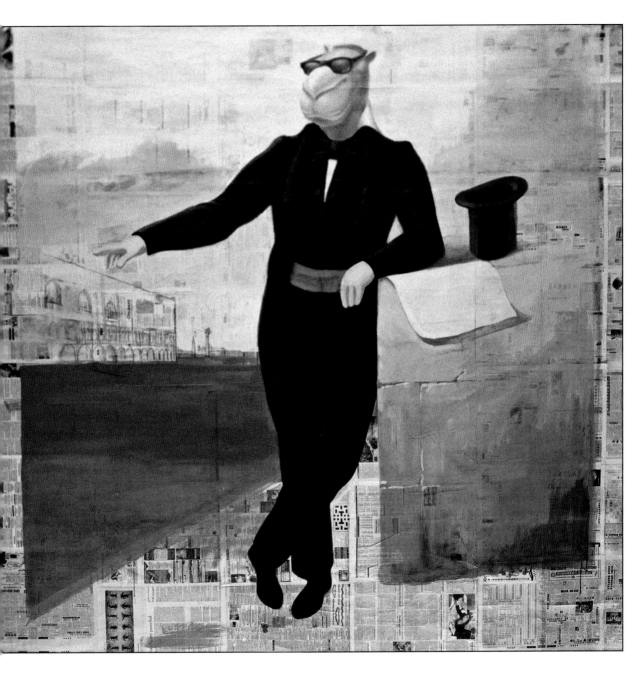

Zhou Tiehai, *You Are Not
a Hero Just Because You
Have Shown in Venice,*
from Placebo series, 1999.
Gouache on paper,
220 x 304 cm

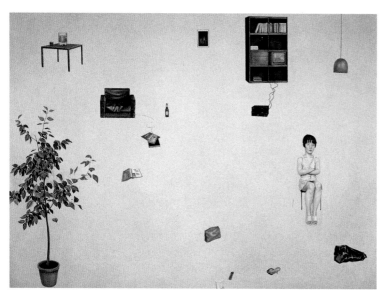

Zeng Hao, *In the Noon, June 26*, 2003. Oil on canvas, 200 x 260 cm

The strongest heir of Luo Zhongli and Geng Jianyi, in soulfulness if not in representational technique, is Yan Peiming (b. 1960), who trained at the École Nationale des Beaux-Arts in Dijon and has lived in France since 1980, following his rejection by the art academy in his native Shanghai. His best-known works—large, monochrome, thickly brushed, semi-abstract Heads (1987–present) that push out to the margins of the canvas—could easily place him among the Big Face painters (*opposite*), sometimes even taking Mao as his subject. But he has also produced many pulled-back views in his impastoed and/or dripping style: the Pope, statues of the Buddha, sex scenes, Bruce Lee, news images, airport vistas, currency. In every case, the viewer's interest hovers between the structural integrity of the thing represented—one of his many bandits or human skulls, perhaps—and the slashing energy with which it is portrayed.

them is Liu Xiaodong (b. 1963), who studied at the Central Academy of Fine Arts in Beijing, did further training in Spain, and now teaches at the academy. Once marginally associated with Cynical Realism as well as the more veristic New Generation movement, he is essentially a self-directed social observer whose subjects—often derived from snapshots and always sharply but empathically viewed—include seashore bathers, prostitutes, and children. A recent work depicts men leading horses on a windswept plain while a politically freighted train traverses the new 700-mile rail link between Qinghai Province and Tibet (*pages 36–37*).

Other painters have chosen to concentrate on the pleasures of the agitated surface. After his mask series, Zeng Fanzhi, who was schooled at the art academy in Wuhan, Hubei Province, and moved to Beijing in 1993, has gone on to create works in which figures ranging from Mao to anonymous individuals to himself are strangely elongated through deliberate vertical smears or shown half hidden behind brambles or pure, squiggling lines of paint. Influenced in his early work by Max Beckmann, he has come more recently under the spell of intuitive actionists such as Willem de Kooning—now working with two brushes in his right hand and allowing the drag and haphazard "mistakes" of the one to counterpoint the more directed marks of the other.

Influential mainland practitioners of a similar technique, taken to further expressionistic extremes, include Yang Shaobin (b. 1963) and Liu Wei (b. 1965), both noted for their gooey, pink-hued studies of distasteful creatures. Yang, a onetime porcelain designer denied admission to Beijing's Central Academy, began as a Cynical Realist working in Yuanmingyuan, like his friend and former Hebei Province compatriot Fang Lijun. Yang's paintings from the early to mid-1990s treat authority figures such as police officers and soldiers, as well as generalized acts of brutality. His most compelling images, though, are those of the late 1990s and shortly thereafter: close-up views of distorted, violently interacting beings resembling lunatic babies or porcine adults (*page 38*).

Liu Wei, a graduate of the Central Academy and a key Cynical Realist, literalizes that metaphor in his signature painting from the same period—vegetables, organ-like forms, dogs, pigs, and naked humans merging with or reacting to each other, sometimes in vaguely Italianate landscapes, all rendered with hyper-juicy brushwork in sickly bright colors (*page 39, right*). Frequently, mordant words and phrases—"I want pork, you want pork"—are inscribed across the thick, drippy surface in English, suggesting the artist's intended audience (foreigners and educated, new-era Chinese) and a grimly elemental view of human nature. Not surprisingly, Liu says that he works and reworks his surfaces until each disturbing image

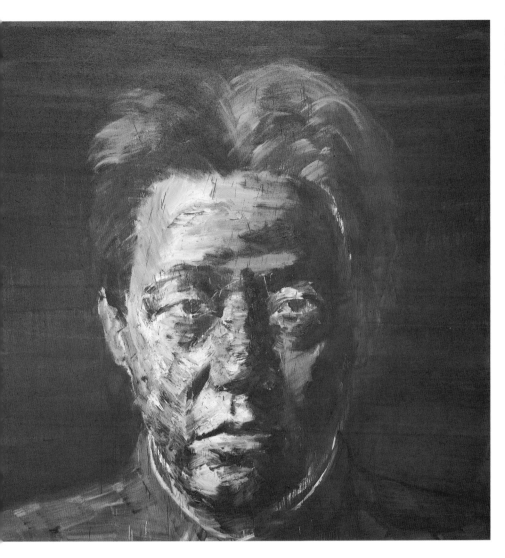

Yan Peiming,
Red Self-portrait, 2007.
Oil on canvas,
350 x 350 cm

rges from his psyche and affixes itself to the canvas, fusing to be obliterated.

much milder form of animality has preoccupied ou Chunya (b. 1955) since 1994. In that year, the tist—trained in art academies in Sichuan Province, here he is still considered a major light, and in ssel, Germany—was given a German shepherd. e dog became his companion and principal model, maining an identifying motif long after its death in 99. Evergreen in spirit, the somewhat feral-looking eature is repeatedly depicted, usually against a blank ckground, in bright green, expressionistic strokes

with pinkish-red mouth and belly (*page 40*). As with every canine, the pet's postures and expressions are purely doggish and yet, at the same time, reflect human parallels or wishful projections. This identification is particularly poignant, given the prevailing lack of sentiment about dogs in China, where, especially in remote areas, they can still turn up as menu items. Although Zhou has lately directed some of his attention to rocks, blossoms, and flowers (and to sculptural versions of the *Green Dog*), his artistic notoriety still rests on his indelible melding of a William Wegman-ish subject with chromatic boldness and free-flowing brushwork.

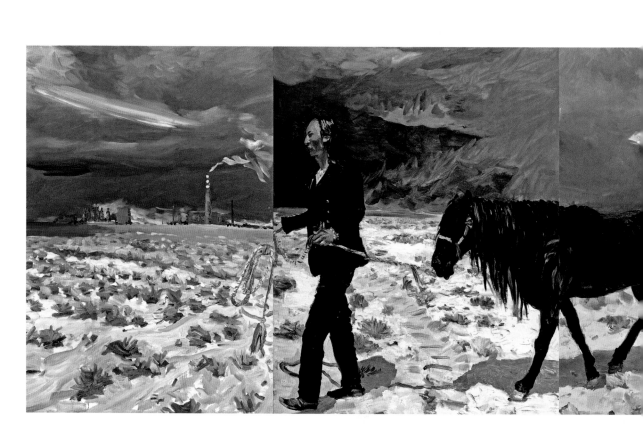

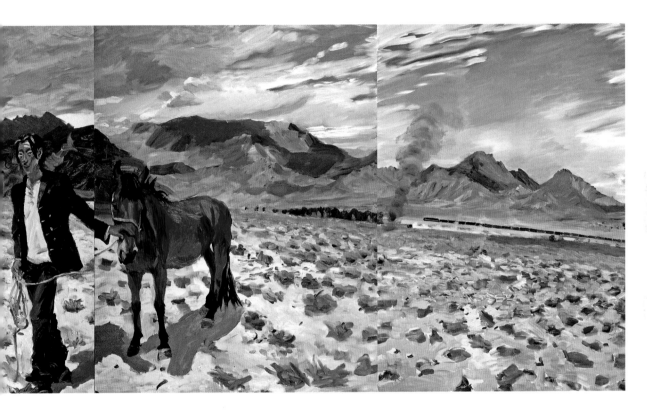

Liu Xiaodong,
Qinghai-Tibet Railway,
2007. Oil on canvas,
5 panels, 250 x 1000 cm

One notable exception is Ding Yi (b. 1962), whose Appearance of Crosses series (1988–present), featuring tiny crosses joined in highly colorful plaid-like patterns, is endlessly inventive and consistently sumptuous (*page 41*). A graduate of both the Shanghai Arts and Crafts Institute and the Fine Arts Department of Shanghai University, he offers his impersonal, mechanical-seeming though visually appealing works as a contemporary critique of the scholarly over-refinement that afflicts traditional Chinese painting. Just as noteworthy, his canvases are also utterly devoid of the political content required of his Mao-era predecessors. His liberty, formal and philosophic, is not announced but implicit.

A number of artists have pushed the calligraphic mark to near or actual illegibility, treating the picture plane as a site of stark, abstract drama à la Jackson Pollock and Franz Kline. Among these, Qin Feng (b. 1961)—a graduate of the art institute in Shandong Province and former resident of Germany and the U.S.—has succeeded well enough on the international circuit, where he does large-scale painting performances, to open his own museum, modestly titled the Beijing Museum of Contemporary Art (*page 39, left*).

We shouldn't be surprised. Painting sells—it's portable, it fits over the sofa, it's easy to store—and that fact leaves a number of China's new artists in mildly embarrassing straits. Their refusal of pictorial depth and illusionist detail may well stem from a more profound psychological refusal to be "sucked in." Yes, these painters certainly make the most of financial opportunity when it comes to them. They hire assistants, open restaurants, gift friends and family members, buy houses and cars, travel abroad. Yet a certain wariness persists—a fear that although the nature of the dream has changed since the high Communist era, China is once again being sold a pernicious ideal, now with a brand name attached.

This skepticism is even more evident when we turn to sculpture and installation, mediums somewhat encumbered in the marketplace by size, and especially to the less tradition-laden art forms of photography, performance, and video.

Yang Shaobin, Untitled, 2000. Oil on canvas, 160 x 140 cm

The Chinese avant-garde's quick leap over modernism has deprived abstraction of the pioneering status it holds in Western art history. For experimental painters in the PRC, coming onto the scene some eight decades after the emergence of such work abroad, abstraction was just one more handy option among many. It might be met, at first, by bewilderment from the general public and vague (though unconfirmable) suspicion from the censors, but it did not require a gut-wrenching formal breakthrough by individual artists. Consequently, virtually no abstract painters are counted among the major artistic provocateurs in China today.

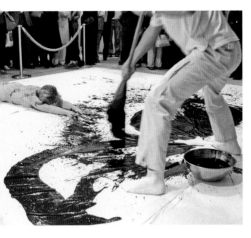

Qin Feng, *Zero Space Ink
Performance*, Asia Society &
Museum, New York,
November 21, 2003

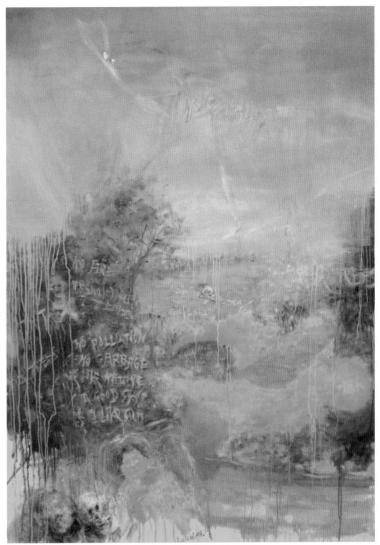

Liu Wei, *Landscape*,
1998. Oil on canvas,
199.5 x 148.5 cm. Private
collection, Switzerland

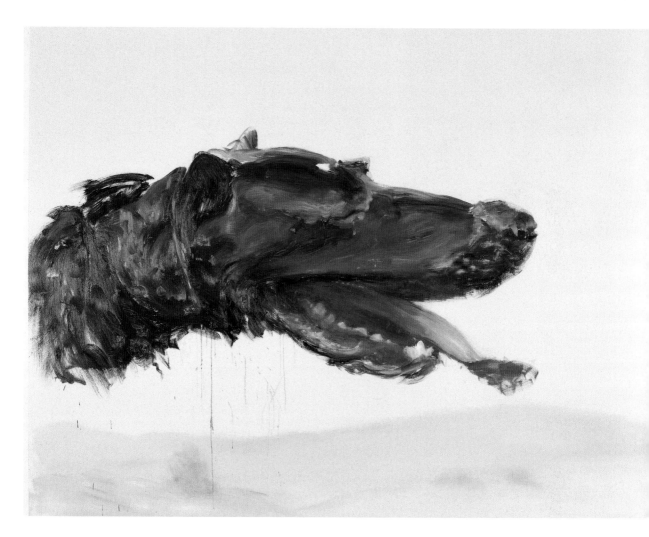

Zhou Chunya,
Green Dog No. 10,
2004. Oil on canvas,
200 x 250 cm

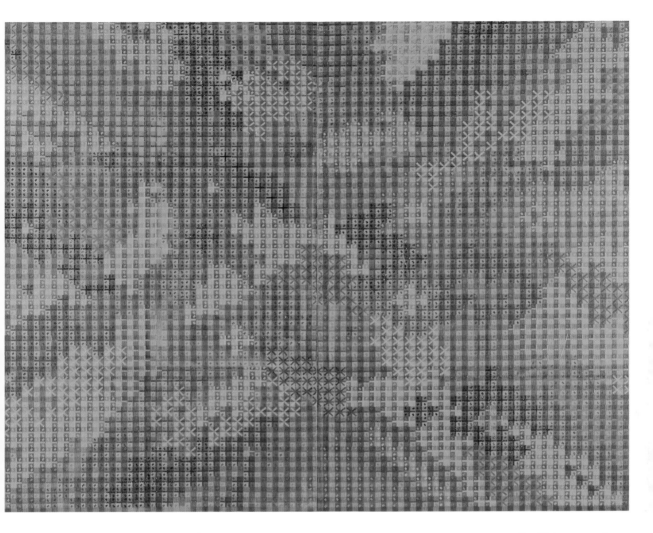

Ding Yi, *Appearance of Crosses*, 2005. Acrylic on fabric, 140 x 200 cm

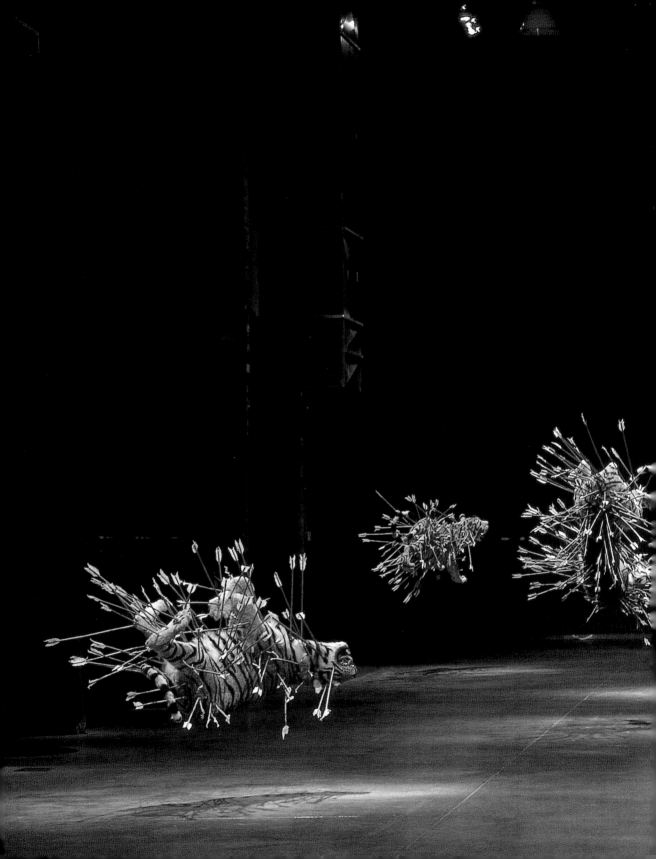

SCULPTURE & INSTALLATION

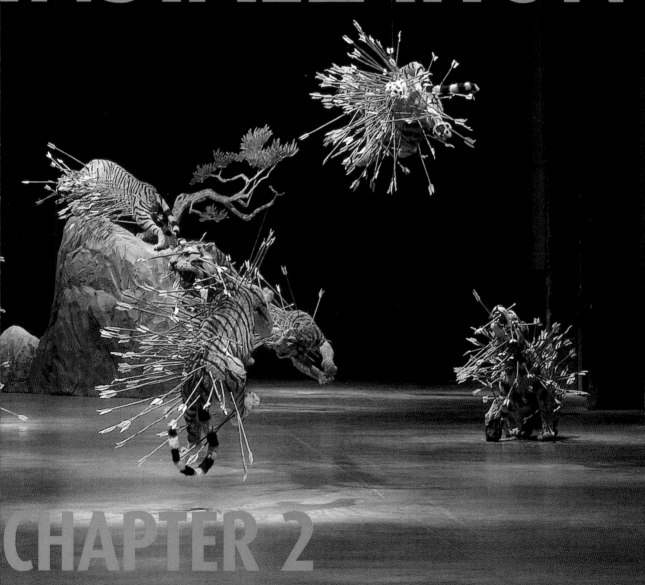

CHAPTER 2

Previous pages:

Cai Guo-Qiang, *Inopportune: Stage Two*, 2004. Nine life-sized tiger replicas, arrows, and mountain stage prop; tigers: papier-mâché, plaster, fiberglass, resin, and painted hide; arrows: brass, threaded bamboo shaft, and feathers; and stage prop: Styrofoam, wood, canvas, and acrylic paint; dimensions variable. Collection the artist. Installation view at Shawinigan Space, National Gallery of Canada, Quebec, 2006

Sculptural objects in China were long associated with practical uses, ceremonial functions, or both. Beginning in the late Neolithic period (third millennium A-B-), burials of high-ranking persons include large numbers of *bi*, wide jade disks with a round hole in the center, and *cong*, tubes with a cylindrical hole, usually squared on the outer sides. Later texts associate these forms with the heavens and earth, respectively, presumably because circularity can be seen as analogue for heavenly perfection. In the third century A-B-, Qin Shi Huang, the first emperor of China, famously surrounded his resting place with an army of an estimated eight thousand life-size terracotta soldiers. In many locales, tomb figures lined the routes to important burial sites. Incised stone steles stood in public places to promulgate classic wisdom, new laws, and the deeds of the mighty. Eventually, statues of every sort and size—ancestors, demons, cranes, dragons, gods, Confucius, royal officials, Buddha, Taoist saints—came to populate temples and palaces in profusion. Officials and connoisseurs contemplated scholar's rocks, tabletop ceramic horses and riders, and wood, jade, and ivory scene carvings of almost unimaginable complexity. Modest homes had family shrines occupied by wooden spirit tablets (infused with the souls of deities or departed ancestors), while at court and in the compounds of the wealthy, hyper-refined items were raised to an elevated and ambiguous status. For once such items as swords, vessels, fans, bells, mirrors, seals, gongs, furniture, brush holders, porcelain ware, and writing implements became objects of genuine decorative art, bespeaking reverence for cultural lineage and the distant past, their utilitarian purposes were largely superseded by their aesthetic worth.

This is the heritage and mindset that was repeatedly assaulted in the first three quarters of the twentieth century—mostly by happenstance during the civil war and the conflict with Japan, and with utter deliberateness during Mao's later campaign against the "four olds" (old ideas, old customs, old culture, and old habits). The 1966–76 Red Guard rampages destroyed buildings, books, paintings, genealogy records, statues, artifacts, and countless intellectual careers and lives.

For decades after the founding of the People's Republic, China's officially sanctioned sculptures, whatever their scale, were predominantly figurative

embodiments of Socialist Realist parables. The life-size figures of *Rent Collection Courtyard* (1965; opposite), for example, were commissioned by the Central Ministry of Propaganda from eighteen professional and amateur sculptors associated with the Sichuan Institute of Fine Arts, who were required to begin by living temporarily among local peasants in order to gather accounts of their experiences firsthand. Sited in the compound of former landlord Liu Wencai, the 119 carved clay figures portray, with theatrically broad gestures and expressions, the despotic merchant extracting grain payments from his suffering tenants, who are given hope only by the appearance of a placard-bearing Maoist cadre sweeping in from the rear. The immensely popular work was reproduced in many versions, sizes, materials, and locales. Meanwhile, across China, public spaces were graced with monumental revolutionary groups and/or figures of Mao standing with right arm raised in a gesture of salutation and forward-leading benediction.

Some restoration of the older aesthetic heritage was undertaken after the Cultural Revolution, and in time the newly condoned study of Western models generated a kitsch modernism as retardataire in sculpture as in the graphic arts. This academicism yielded works such as Chen Yungang's *Lao-tzu, a Chinese Thinker* (2003), a wavy fiberglass representation of the founder of Taoism, accompanied by abstract, undulating floor elements.

In the midst of this formalist reconciliation, a second major rupture transpired, in two waves. Following a 1985 exhibition of works by Robert Rauschenberg at the National Art Museum in Beijing, many artists were emboldened to turn away from traditional materials—stone, fine wood, clay, ivory, bronze, jade—toward everyday components and readymades, and to make the seemingly chaotic display of such elements part of the point of their work. Installation art, present in an incipient form since the late 1970s, began to flourish. Serious complications arose in February 1989, when the exhibition *China/Avant-Garde* at the National Art Museum was closed because Xiao Lu fired a pistol at her installation, a symbolic suicide by the lovelorn artist, who shot at her image in a mirror (*page 79*). Four months later, hundreds of demonstrators were gunned down in Tiananmen Square by troops suppressing pro-democracy demonstrations, leading to a merging of the personal and the political

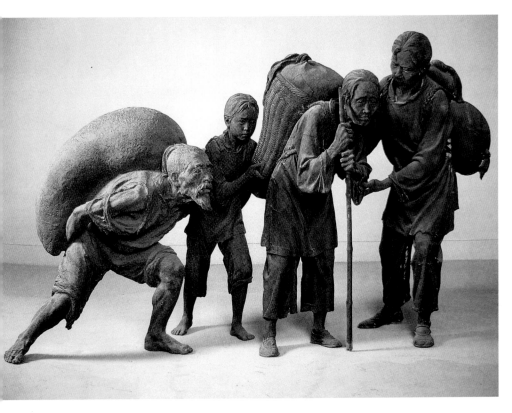

Ye Yushan and Sichuan Academy of Arts, *Rent Collection Courtyard* (detail), 1965–66. 119 life-size clay figures. Sichuan Institute of Fine Arts, Chongqing, China

in experimental Chinese art that would aggravate officials for years to come.

Displaced Objects

Progressive sculpture in post-Tiananmen China often involves displacement—a sense of parts missing or incongruously conjoined, of the whole work belonging to a realm beyond logic and social norms. This tendency first emerged in the work of artists like Stars group member Wang Keping (b. 1949), a former Red Guard who came to believe that a less doctrinaire, more genuinely emotive and formally experimental art could speak to "the people" more effectively than Socialist Realism. Self-taught, Wang works with the natural configurations of wood, retaining the basic form of the original block but shaping it—minimally and bizarrely—into haunting presences like his satiric *Idol* (1979; *page 247*), a fat-faced melding of the Buddha and Mao. He left China for France in 1984.

Of the sculptors who have not emigrated, none is more astutely responsive to the stupendous changes now sweeping the People's Republic than Sui Jianguo (b. 1956), who manages to be a leading member of the avant-garde while maintaining his position as a professor of sculpture at the Central Academy of Fine Arts in Beijing. With wry subtlety, he addresses the hollowness of past political schemes (empty Mao jackets, some on a monumental scale; *page 46*); the incursion of Western values into China (sculptures like the plaster casts of antique statuary studied at the Academy—the Discus Thrower, Michelangelo's Dying Slave, and so on—nattily attired in Mao suits; the cult of strongman leadership (Mao's famous raised arm, heroically proportioned but detached from his body, as Mao himself grew detached from the body politic); and the rapaciousness of global trade (toy dinosaurs painted red, the most Chinese of all colors, and comically enlarged, with "made in China" often embossed on the body; *pages 48–49*).

45

Sui Jianguo, *Legacy Mantle*,
1997. Painted fiberglass,
139.7 x 99 x 109.2 cm

Zhan Wang (b. 1962), a Central Academy graduate of working class origins, is best known for the reversal of traditional values in his highly polished cast stainless-steel "rocks." Some, resembling field boulders, evoke the dialogue between nature and artifice so common in the current Chinese construction boom. Others recall scholar's rocks, those jagged forms eroded by the elements (and the discreet hand of man) until, isolated in a garden or mounted on ornately carved wooden stands, they were deemed intricately fissured enough to aid philosophical rumination (*below*). Zhan's versions, tellingly, are all sheen, their sleek surfaces reflecting not cosmic or psychological forces but the flux and flash of the new China around them. As isolate as skyscrapers and eerily smooth, they resist the mental penetration into "worlds within worlds" that once gave scholar's rocks their mystery and grace.

This work, so successful in the current market, can easily appear a victim of its own glitz, especially when multiple pieces are brought together for exhibition. Yet other works by Zhan, who has long taught at the Central Academy, are unquestionably thoughtful. He has hand-cleaned a building façade in mid-demolition (*Ruin Cleaning*, 1994), littered cast nude figures among rubble (*Classroom Exercise*, 1995), launched a floating steel rock on the high seas (*Beyond Twelve Nautical Miles*, 2000), replaced missing blocks from the Great Wall with shiny metal substitutes (*Inlay Great Wall*, 2001), laid stiffened Mao suits in wooden coffins and buried them behind the Guang-dong Museum of Art (*Temptation: Mao Suit Series #1*, 2002), created a futuristic model of Beijing out of pots and pans (*Urban Landscape*, 2005), fashioned a capsule-shaped shrine to house Buddha statues made of pills (*Buddha Pharmacy*, 2006), and invented ATMs that dispense information about world religions (*Deity Query Machine*, 2008). At the Long March Space in Beijing, Zhan orchestrated the sledgehammer destruction, over a three-week period in spring 2008, of 86 over-life-size clay figures of a saintly ancestor.

The trickiness of such visual allusions is well illustrated by the figurines of Liu Jianhua (b. 1962), a veteran of the celebrated Jingdezhen porcelain works. He often presents his myriad female statuettes—provocatively lying, sitting, or crouching in form-fitting, high-slit *qipao*—on a ornate platters, like tempting culinary delights (*page 50*). Uniformly

armless and headless (and thus symbolically deprived of agency, thought, and identity), they are reduced to emblems of exoticism, figures of a Western erotic fantasy, linking pure libido to a neocolonial economic lust. One can ask, of course, if the artist—like many of his viewers—is not complicit in the very exploitation he purports to critique. But Liu manages to keep his critics at bay with such recent works as *Yiwu Investigation* (2006), which features tacky plastic goods spilling from the rear of a shipping container in a mockery of China's "dumping" of cheap products onto the world market. His *Can You Tell Me?* (2006), is composed of open-faced metal books and a DVD projection asking such hubris-tweaking questions as "Will Shanghai build the tallest building in the world, from which one can see Japan and Korea?"

More difficult to explain—and more frightening—are the perversely menacing creations of Shi Jinsong (b. 1969), who lives and works in Wuhan, capital of Hubei Province, where he was born and received his art academy training. The artist's expertly designed

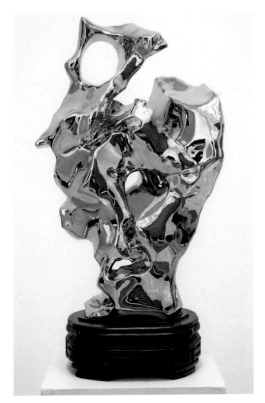

Zhan Wang, *Artificial Rock No. 92*, 2006. Stainless steel with base, 104.1 x 43.2 x 19.1 cm, edition of 4

Sui Jianguo, *Conversation*,
2007. Painted fiberglass and
reinforced plastic, height:
250 cm (man figure),
210 cm (dinosaur figure)

Liu Jianhua, Untitled, from
Color Ceramic series, 2002

office furnishings and baby-care items (desks, tables, strollers, walkers, and bassinets) are made of gleaming razor-edged steel, potentially dangerous to the touch (*opposite*). Named after a volatile child-warrior god, the "Na Zha Baby Boutique" products speak both to the inborn nature of human violence, manifest in a childish love of horror and the grotesque, and to the dark, even murderous impulses that can seize trapped and exasperated parents. His office equipment—notably a computer workstation with a guillotine, shackles, and other implements of torture—mutely protests our enslavement to commerce and technology while evoking political interrogation of the deadliest sort.

The phantasmagoric skeleton creatures of Shen Shaomin (b. 1956) also seem to arise from obscure origins—perhaps related to his childhood in the extreme northeastern province of Heilongjiang, bordering Inner Mongolia. Indeed, Shen's entire professional life, until quite recently, has been peripheral. Graduate of a teacher's college in his native Harbin, he began as a self-taught artist devoted to creating Cultural Revolution propaganda.

Following a one-man show at the National Art Museum in Beijing in 1989, the year of Tiananmen, Shen lived in self-imposed exile—and relative artistic neglect—for more than a decade in Australia. His Unknown Creature series, begun in 2002 after he took up part-time residence in China again, finally brought him to wide notice. These illogical skeletons—giant insects, dragons, fanciful dinosaurs, and animal-human hybrids—spring from a personal mix of folk tales, scientific illustrations, myths, and bad dreams, all made disturbingly realistic by an anatomically precise use of animal and human bones, assembled with bone-meal augmentations (*page 52*).

Lately, Shen Shaomin's workshop has fabricated scrupulously detailed models and reconstructions (of oilfield pumps, a bonsai tree farm, a jet fighter, the entranceway and palace facing Tiananmen Square), accompanied, like Shi Jingsong's design items, by obsessive schematic plans and specifications. Such works, slyly combining documentary and fictive elements, question the reliability of even the most technically convincing information.

One might imagine that Shen's skeletons reveal the inner structures of some of the wierd beasts made by Central Academy graduate Xiao Yu (b. 1965). Using sewn-together animal parts, this native of Inner Mongolia constructs eerie hybrids such as winged rabbits and a living, dual-bodied mouse (*page 52*).

Conversely, bodily architecture is negated by the inflated creatures fabricated by Yang Maoyuan (b. 1966). Formerly a printmaking major at the Central Institute of Fine Arts in Beijing, Yang, who hails from Dalian in Liaoning Province, has made his reputation with highly conceptual sculptures—carved logs erected in an arid wilderness, paint tubes filled with half-digested fodder from the bellies of slaughtered cattle, and classical-looking portrait busts with their most individuating features smoothed away. But his most noted works remain the bloated animal forms he fashions from sheep, goat, and horse hides, often daubed with or completely dyed an unnaturally bright color, and sprouting legs and one or more heads (*page 53*). It is hard to say which is more disturbing—their anatomic perversity or their taxidermic realism.

Shi Jinsong, *Na Zha Cradle*, 2005. Stainless steel, 61 x 81 x 62 cm

Heterogeneous Environments

Epistemological skepticism such as that expressed by the recent works of Shen Shaomin, described above, has long been a hallmark of Chinese installation art, in no small measure because the practice arose in the PRC during the post-Cultural Revolution reawakening, when much that was previously understood about modern life was thrown open to question. The erratically hostile response of officialdom to this process induced many of the most interesting first-generation installation artists to become émigrés.

Among the first to leave China was Chen Zhen (1955–2000), who went to Paris in 1986 to study at the École Nationale Supérieure des Beaux-Arts and the Institut des Hautes Études. His work thereafter united bodily concerns, social commentary, and spiritual longing in more or less equal measure. *Daily Incantations* (1996) features 101 wooden chamber pots, hung like musical bells, with a steel-banded globe of Western electronic

Xiao Yu, *Ruan* (detail), 1999. Installation, specimen of an aborted foetus, preserved body parts of animals (including pigeon, cat, rabbit, and rat), peeled prawn, formalin and four medical glass desiccators, dimensions variable. The Sigg Collection

Shen Shaomin,
Unknown Creature, 2002.
Bonemeal, glue

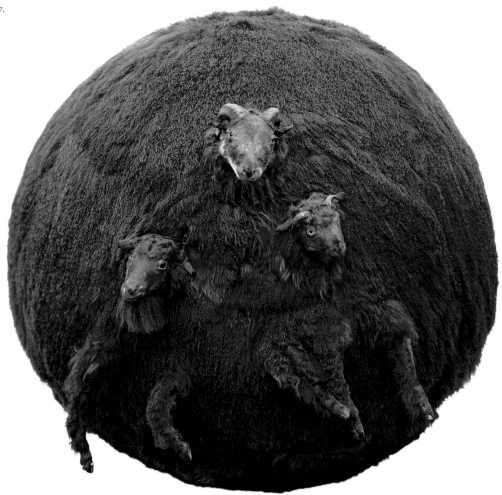

Yang Maoyuan, *Sheep No.7*,
2001. Goatskin inflated,
160 x 200 x 190 cm,

devices. The therapeutic *Jue Chang—Fifty Strokes Each* (1998) consists of chairs and bed frames converted into drums that audience members can play upon at will (*page 54*). *Crystal Landscape of the Inner Body* (2000) is a tabletop display of stylized glass organs (*page 55*), recalling the ancient Chinese metaphor of the viscera as an internal landscape to be kept well-tended and temperate—the basis for his model for the unrealized *Zen Garden*, a walled preserve in which trees and shrubs would share space with enormous organ-shaped sculptures pierced by metal probes. The artist died at age 45 from autoimmune hemolytic anemia.

In 1989, Huang Yong Ping (b. 1954), a graduate of the Zhejiang Academy of Fine Arts in Hangzhou and a founder of the Xiamen Dada Group (known for incinerating its members' own artworks), was invited to take part in Jean-Hubert Martin's famous *Magiciens de la Terre* roundup at the Centre Pompidou. Huang stayed on, eventually becoming identified as a "French" artist and generating work that is esteemed worldwide, especially in China.

While still in the PRC, Huang was one of the country's most radical art-makers and theoreticians, engaged in a campaign against both subjectivism and cultural

Chen Zhen,
*Jue Chang—Fifty Strokes
Each*, 1998. Installation of
chairs and bed frames
converted into drums

determination. By 1982, he had substituted industrial materials and methods, including the airbrush, for traditional painting techniques. Three years later he was making roulette-wheel paintings with the help of a spinning device inscribed with instructions—a randomization procedure later elaborated in his *Six Small Turntables* (1988), which alludes to ancient Chinese divination aids while looking much like Duchamp's roto-reliefs stacked in a valise. In 1986 the Xiamen Dada artists, five of whom had already caused a stir in 1983 with a show of deliberately ignoble scrap-material installations, staged their legendary group event—a notorious art bonfire in front of the Xiamen City Arts Gallery, creepily reminiscent of Cultural Revolution book burnings but meant to liberate art's spiritual essence from its material manifestations; a diagram with gamelike instructions and slogans

("Dada is dead," for example) on the grass of the Xiamen museum courtyard, and capriciously rearranging objects in the Fujian Art Museum in order to challenge taxonomic preconceptions. In 1987 Huang produced *"A History of Chinese Painting" and "A Concise History of Modern Painting" Washed in a Washing Machine for Two Minutes*, obliterating both texts and reducing these manuals, premised on cultural difference, to a heap of pulp.

Since his move to the West, issues of cultural identity and East-West dynamics seem never far from Huang's mind. He has created such works as a large wooden gourd-shaped structure, reminiscent of a Taoist priest's medicine bag, overflowing with traditional Chinese healing aids—herbs, reptile skins, powders, and bones—along with a barren chair and two electric

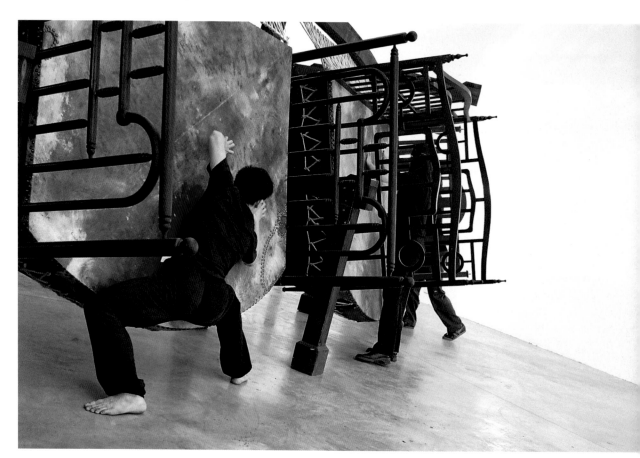

irons (*The Pharmacy*, 1995; *page 56*) several partial reconstructions of the American spy plane brought down over China in 2001 (*Bat Project*, 2001–5; *page 57*); a vehemently anticolonial stuffed tiger attacking the rider's basket, which bears the British royal crest, atop a capped-tusked elephant (*The Nightmare of George V*, 2002; *page 59*); and models of various historically freighted architectural structures— a customs house on Shanghai's Bund (*Bank of Sand/ Sand of Bank*, 2000–5), Rome's most famous amphi-theater (*Colosseum*, 2007) and Washington's military think tank (*Pentagon*, 2007).

Many of the same transcultural concerns are addressed by Gu Wenda (b. 1955), who studied at Shanghai's School of Arts and Crafts and later took an MFA—with concentrations in painting and philos-ophy—from the Zhejiang Academy of Fine Arts (now China Academy of Arts) in Hangzhou. While teaching at the latter school from 1981 to 1987, he made radical experiments in ink-painting on an enormous scale and soon became a leading figure in the '85 New Wave Movement. In 1986, at the Gallery of the Artists' Association of Shaanxi Province in the city of Xi'an, his first solo show was closed to the general public because his large-scale paintings of baffling pseudo-characters left Chinese political officials too uneasy. Granted a visa to study at the San Francisco Art Institute, he relocated to the U.S. in 1987 and began using the Western name order—Wenda Gu.

Controversy did not cease with his relocation. In the early 1990s, Gu's works using menstrual blood and placenta powder were derided by Western feminists.

Chen Zhen, *Crystal Landscape of the Inner Body*, 2000. Glass

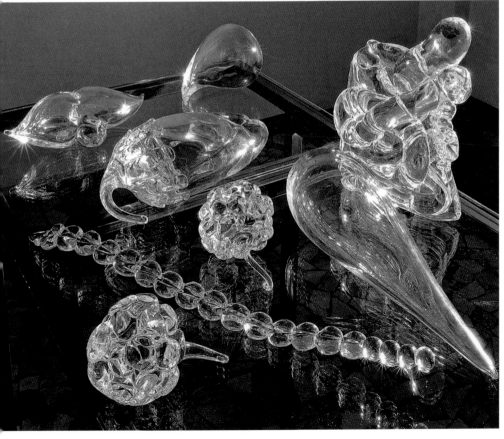

Huang Yong Ping,
The Pharmacy, 1995.
Birch and mahogany
plywood, bolts, with items
representing ancient
remedies

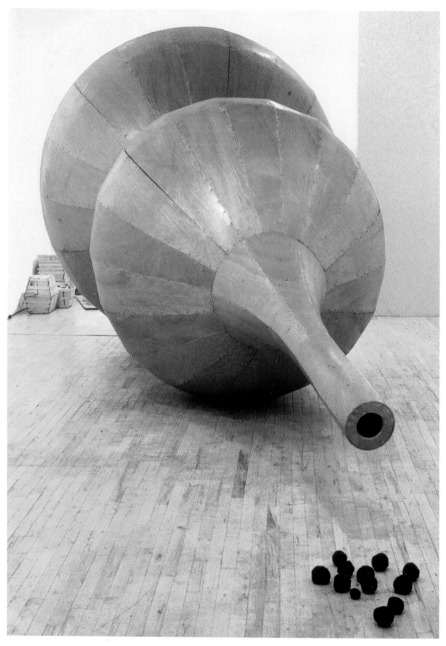

Huang Yong Ping, *Bat Project II*, 2002. Guangzhou, China

Bat Project IV, 2004–5. Airplane cockpit, bamboo scaffolding, plastic construction fence, taxidermic bats, documents, photographs. Installation view, Vancouver Art Gallery, 2007

During the same period, his United Nations project (*page 60*)—whose massive, internationally sited installations involve piles, blocks, and curtains of ethnically diverse human hair—drew objections in Poland and Israel from viewers who could not perceive the work's universal humanism, but rather associated the shorn locks with Nazi treatment of concentration camp inmates. In 1996 the Russian artist Alexander Brener, a fellow exhibitor in the multinational exhibition *Interpol* at the Färgfabriken Center for Contemporary Art and Architecture in Stockholm, wrecked Gu's tunnel installation of Swedish and Russian hair—reportedly because Brener disdained its politically conciliatory message. Even making ink from human hair, as Gu did in *Ink Alchemy* (2001), and showering tea onto huge swaths of handmade paper, as in his *Tea Alchemy* (2002), have been interpreted by some as disregard for cultural integrity and an aestheticized trafficking in stereotypes.

Little wonder, then, that one of Gu's most monumental installations to date, *Forest of Stone Steles* (1993–2005), focuses on the issue of cultural mistranslation. Fifty carved stone slabs, each weighing 1.3 tons, are displayed in a grid formation, lying flat as if toppled or "dead" and surrounded by vertical rubbings that reproduce their incised Chinese and English texts (*page 61*). In each case, a Tang dynasty poem is systematically transformed, on the basis of sound rather than sense, from Chinese to English and back to Chinese. The resulting hybrid gibberish, in Gu's view, suggests the larger distortions of history and civilization that underlie most East-West fusions. Despite such intellectual reservations, Gu seems to recognize the inevitability—and potential richness—of cultural blending in the contemporary world. His performances include a "wedding ceremony," held during the first Guangzhou Triennial in 2002, that centered on a live, large-scale calligraphy ritual performed by the traditionally attired Chinese artist and a Western bride. Gu maintains homes and studios in both New York and Shanghai, and exhibits his work worldwide.

Probably the most esteemed member of the exile generation—which also includes Cai Guo-Qiang (discussed below), as well as Zhang Huan and Ai Weiwei (examined in the following chapter on performance)—is the scholarly Xu Bing (b. 1955), whose works explore the powers and limitations of language. The artist was born in Chongqing, Sichuan Province, and raised in Beijing, where his father was head of the history department of Beijing University and his mother was a senior administrator in the science library. As a teenager, Xu witnessed his father, labeled a reactionary, being dragged away to perform forced manual labor. Xu himself, who had long performed daily calligraphy exercises under his father's direction, was set to producing big-character posters and propaganda broadsides before being sent, from 1974 to 1977, for "reeducation" in a farming commune in China's mountainous northwest. Having gained notice for his fine sketches and lettering for the local newsletter in Yanqing District, he was eventually tapped to attend Beijing's revolutionary May Seventh College of Arts, which by the time he arrived had reverted to its former name, the Central Academy of Fine Arts. There he studied printmaking, took an advanced degree, and was hired as an instructor who became known for his innovative teaching methods.

The cultural warming of the 1980s apparently both exhilarated and bewildered the young artist. He had already seen classical Chinese characters, which he had devotedly mastered in the thousands, replaced during the Cultural Revolution by simplified versions meant to extend literacy and convey the thoughts of Chairman Mao to the masses. Now, with the onslaught of new texts from the West, older Chinese works were exhumed and traditional characters reinstated in a bewildering variety of updated formats tailored for mass-market publications and advertising. In response, Xu, a student of Zen, developed a critical distance from language itself—regarding it somewhat suspiciously as a substitute for, or distraction from, direct engagement with the world and the inner self.

Xu's early works included *Big Wheel* (1986), an enormous truck tire and the long print made from its tread, a China-scaled homage to Rauschenberg's 1953 *Automobile Tire Print* and one of the first installation pieces ever made in Beijing. *Ghost Pounding the Wall* (1990), a 4,500-square-foot rubbing from the Great Wall whose title refers to a folk tale about a traveler who ends up walking in circles in the dark, was read by many as a critique of China's isolationism, ancient and modern (*page 62*).

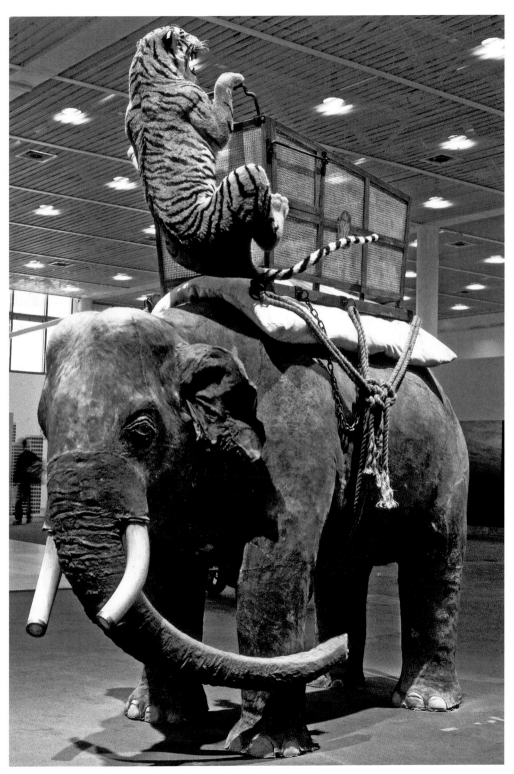

Huang Yong Ping, *11 June 2002—The Nightmare of George V*, 2002. Concrete, reinforced steel, animal skins, paint, fabric cushion, plastic, wood, and cane seat, 244 x 355.6 x 167.6 cm

But Xu's landmark creation was *Book from the Sky* (1987–91), a room-filling installation composed of scroll-like swaths of printed characters suspended above the carved pear-wood blocks from which they were printed (*page 63*). Xu invented and hand-carved every one of the work's 4,000 pseudo-characters, which look remarkably authentic but are in fact incomprehensible. In effect, a message descends from on high, but no one can read it. Beyond its critique of the limitations of language, *Book* clearly suggests a society experiencing a profound religious, political, and epistemological disconnect. The work's sheer physical

beauty, combined with its enigmatic nature (in Chinese, the title refers to something that cannot be accounted for), disturbed not only some avant-gardists, who found the work too refined, but also cultural authorities, who distrusted its indecipherable text and its impertinent liberties with classical forms. Following exhibition of the work in partial form in a one-man show at the National Art Museum in 1988 and in a complete version the next year in *China/ Avant-Garde*, Xu found his life in China growing increasingly problematic. In 1990 the artist took advantage of an honorary fellowship at the University

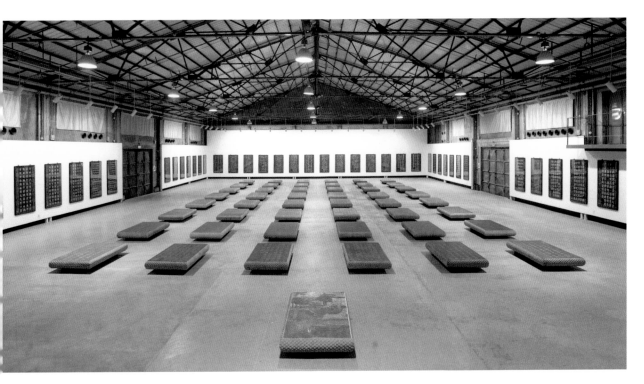

Gu Wenda, *Forest of Stone
Steles*, 1993–2005.
Stone, each stele:
20 x 110 x 190 cm.
Contemporary Art Terminal,
He Xiangming Art
Museum, Shenzhen, China

of Wisconsin–Madison to establish residency in the U.S., moving to New York in 1993.

After this shift, Xu—a 1999 MacArthur Award winner—produced many works that explore the capacity of words to both communicate and deceive. Best known are the installations in which viewers, practicing the "square-word calligraphy" that Xu invented in 1994, eventually find they are in fact inscribing English words in ideogram-like blocks. Xu's red tongue-in-cheek banner *Art for the People* (1999) (*page 64, above*) is another instance of the trick—one which deftly exposes the unreliability of much political discourse, while simultaneously proposing a new, more sophisticated rapport between art and the public. *A Case Study of Transference* (1994) features two breeding pigs—the male covered with pseudo-English words, the female marked with fake Chinese characters—in what may be understood as a parable of cultural insemination (*page 64, below*).

The sign, always in questionable relationship to the thing it represents, is sometimes nonverbal in Xu's work. For *Panda Zoo* (1998) he outfitted New

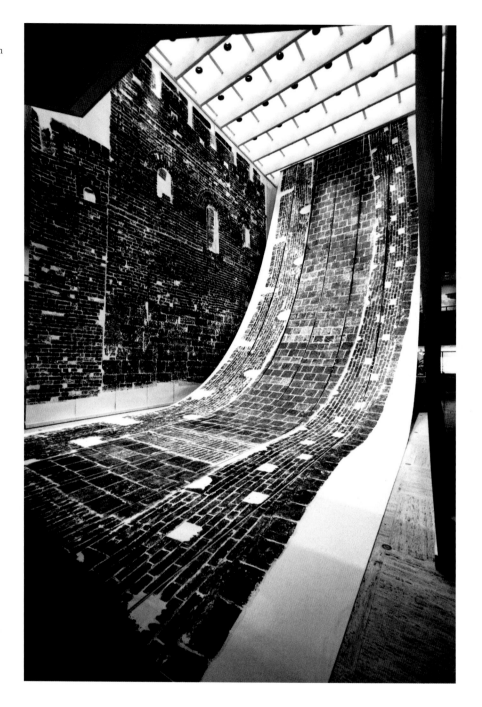

Xu Bing, *Ghost Pounding the Wall*, 1990. Installation

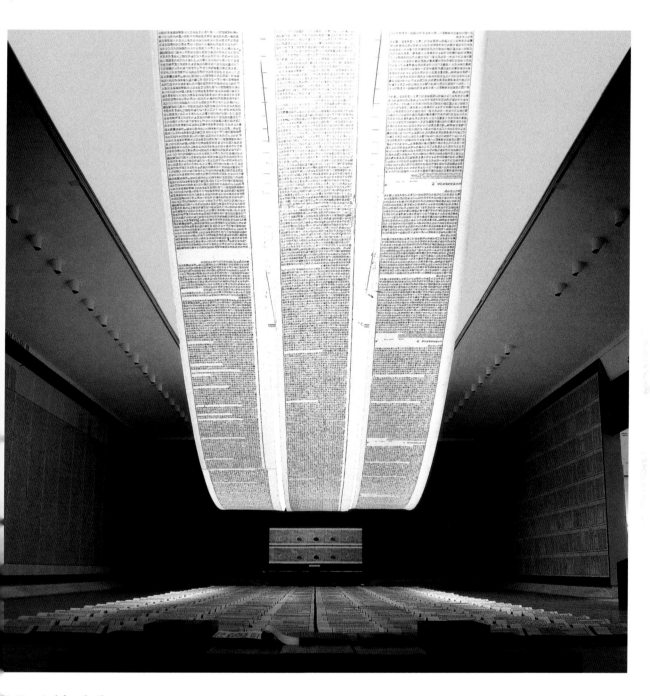

Xu Bing, *Book from the Sky*,
1987–91. Installation

Xu Bing, *Art for the People*, 1999. Dye sublimation on Dacron polyester, 27 x 11 m, Banner Project, Museum of Modern Art, New York

Hampshire pigs with panda masks, and in *Wild Zebras* (2002) donkeys were painted with black and white stripes. Subsequently, in a quest for linguistic stability, Xu sought to develop a computer software program that translates various languages into a single, supposedly universal pictographic system. In 2008, Xu was appointed vice president of the Central Academy of Fine Arts in Beijing, dividing his residential time and putting his transcultural proclivities into real-life practice.

The supreme emissary at present, however, is Cai Guo-Qiang (b. 1957). Arguably the most widely recognized Chinese artist of our day, he maintains a large studio in New York and a second in Beijing, producing pyrotechnic events, gunpowder drawings, and large-scale installations. Known to have the ear of ministry officials in the People's Republic, Cai was Art Director of Visual and Special Effects for the 2008 Beijing Olympics ceremonies. The same year, he was the first contemporary Chinese artist to have a full retrospective at New York's Guggenheim Museum.

Cai's path to prominence was circuitous. When the artist was a boy in the port city of Quanzhou in Fujian

Xu Bing, *A Case Study of Transference*, 1994. Male and female live pigs printed with false English and Chinese scripts, books and steel pig-pen, The Han Mo Art Center, Beijing

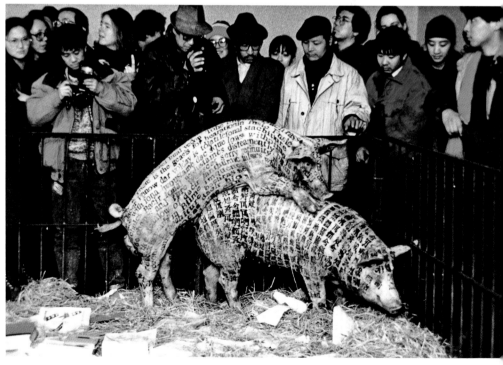

rovince, his father, a party member, worked in a ookstore and practiced calligraphy and ink painting. ix miles across the water, the island of Kinmen (also hinmen, Jinmen, or Quemoy), a bastion of Nation-ist forces, was periodically shelled from the Mainland—yielding sights and sounds the future fire-works artist would never forget. During the Cultural evolution (which ended its ten-year run when he was ineteen), the young Cai participated in noisy parades nd demonstrations. Later, intrigued with the exoti-ism and modernity of Western oil painting, he tudied set design from 1981 to 1985 at the Shanghai rama Institute, where he was befriended by the artist hen Zhen, then a teacher just two years his senior. s a student, Cai shared Chen's fascination with veryday aspects of traditional Chinese culture such as aoism, herbal medicines, and feng shui, and made orks—stick figures or abstract patterns in oil and urnt gunpowder—that gave him a place in the experi-mental ferment leading to the '85 New Wave. Yet in 986, just as the movement was building, Chen eparted for Paris and Cai moved to Japan.

Cai's skills as an organizer became evident when he gained the cooperation of Japanese locals for his Projects for Extraterrestrials. First seen in 1989, the works consisted of massive fireworks and trails of blazing gunpowder that streaked across landscapes and building fronts. The series title refers to Cai's belief in a need for a new perspective—a higher one in which earthly conflicts are replaced by celebrations of pure energy, and the material fuel of conflict, gunpowder, becomes a delivery system for beauty and joy.

Obviously indebted to the longstanding Chinese fasci-nation with firecrackers and pyrotechnics, Cai's explo-sions (*pages 8, 66*), as well as the gunpowder burns with which he draws on paper and fabric surfaces, highlight the elemental, transformative power of fire—its ability to change substances, sometimes instanta-neously, from one state to another and to take the observer (as in warfare) from calmness to mad excita-tion and back to an altered, memory-haunted calm.

In 1995 Cai moved to New York with help from the city's Asian Cultural Council, which funded his resi-dency at P.S.1 in Queens. At the Venice Biennale that

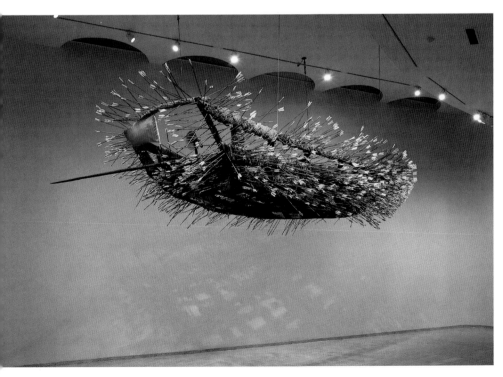

Cai Guo-Qiang, *Borrowing Your Enemy's Arrows*, 1998. Wooden boat, canvas sail, arrows, metal, rope, Chinese flag, and electic fan; boat approximately 152.4 x 720 x 230 cm; arrows approximately 62 cm each. The Museum of Modern Art, New York, Gift of Patricia Phelps de Cisneros in Honor of Glenn D. Lowry. Installed at Solomon R. Guggenheim Museum, New York, 2008

65

Cai Guo-Qiang, *Red Flag*, 2005. Gunpowder fuse and red flag; explosion area (flag): 640 x 960 cm; realized at Zacheta National Gallery of Art, Warsaw, June 17, 2005, 7:15 p.m., 2 seconds. Commissioned by Zacheta National Gallery of Art, Warsaw

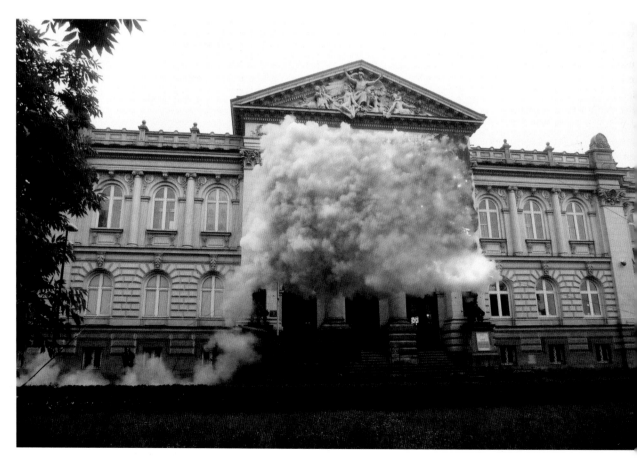

l, he arranged for a Chinese junk filled with herbs d other traditional goods to sail up the Grand Canal the event he called *Bringing to Venice What Marco lo Forgot*. Cai's hometown, long a departure point for igrés from southern China, is the port from which arco Polo sailed for his return to Venice in 1292.

anscultural tensions are also acknowledged in *rrowing Your Enemy's Arrows* (1998), a suspended at bristling with arrows that recall the strategy of an cient Chinese commander who duped his oppo- nts into firing countless arrows into empty boat lls, thus replenishing his own soldiers' depleted ck (*page 65*).

isunderstandings arose when Cai brought artisans to e 1999 Venice Biennale to reconstruct the famous *nt Collection Courtyard* (*page 45*). For him, the work's bject matter, style, and method of production were assaults on Western art-world complacency. (Un- e most of his avant-garde colleagues, Cai retains qualified admiration for Mao and a lively belief in e social utility of art.) The Biennale jury was so pressed with his exotic provocation—Socialist alism redux—that they awarded him the Golden on. But back in Sichuan, home to the original figure oup, Cai's act—individualistic, commercial, estern-based—was seen as a betrayal of socialist ctrine and aesthetics, and he was sued for plagia- m. The suit was eventually dismissed and Cai, with s usual diplomatic finesse, soon gained a commis-

Gu Dexin, *Meat*, ca. 1994–2001. Installation and performance

sion to design a fireworks extravaganza for the 2001 Asia Pacific Economic Cooperation conference in Shanghai, attended by U.S. president George W. Bush, Chinese chairman Jiang Zemin, and other heads of state. At the Shanghai Art Museum in 2002, Cai became the first experimental Chinese artist to receive a government-sanctioned retrospective in the People's Republic. In 2005, he was tapped to curate the first show for the newly inaugurated Chinese pavilion at the Venice Biennale.

Recognition has not dampened Cai's inventiveness. His 2004 solo at Mass MoCA in North Adams, Massachusetts, included *Inopportune: Stage One*, in

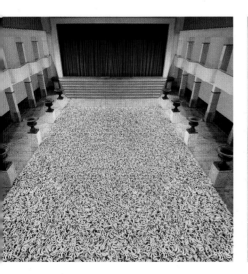 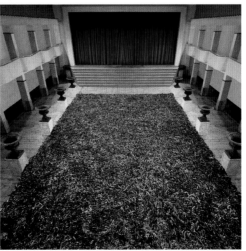

Gu Dexin, *2007-01-13*, 2007. Installation, bananas, cast iron, and marble. Gallery Continua, San Gimignano, Italy

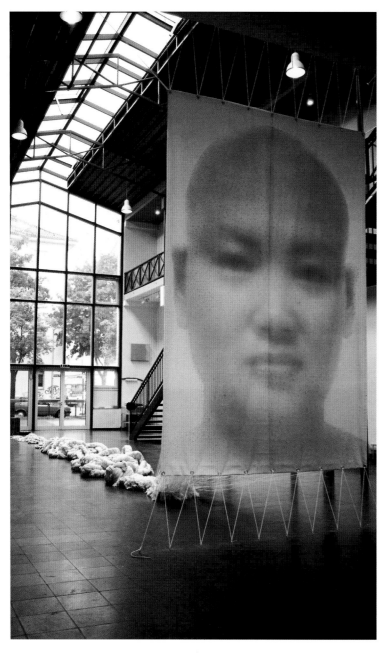

Lin Tianmiao, Wang
Gongxin, *Braiding*, 1999.
Installation

which nine cars spouting multicolored light tubes
formed a tumbling arc evocative of car-bomb violence
and *Inopportune: Stage Two*, boasting nine lifelike
tigers riddled with arrows—an allusion to a thirteenth
century bandit who saved a village from marauding
beasts (*pages 42–43*). (Tigers were often painted by
Cai's father, as an accompanying exhibit attested.)
Among his rooftop installations at the Metropolitan
Museum in New York in 2006 were a daily black-
cloud explosion and two resin crocodiles punctured
with knives, scissors, and other implements taken
from passengers during airport security checks. The
2006 *Head On* at the Deutsche Guggenheim Berlin,
complete with fireworks and a gunpowder drawing,
featured stuffed wolves arrayed in a flying arc that
ended with the pack smashing into a glass barrier
proportioned like the Berlin wall.

Of the many mainland figures who continue to focus on
installation, none does so more engrossingly, so to
speak, than Gu Dexin (b. 1962). A lifelong Beijing resi-
dent with no formal art training, Gu in 1984 began
using the methods he learned while working in a plastic
factory to create large-scale sculptural works of singed
partially melted shapes of mildly revolting appearance
Championed by critic Fei Dawei, Gu's work appeared in
China/Avant-Garde in Beijing and *Magiciens de la Terre*
Paris, both in 1989. By 1990 he was collaborating with
worker-artists Wang Luyan and Chen Shaoping under
the rubric Xinkedu, or New Analysts Group, in an effort
to counter the subjectivism of '85 New Wave work with
impersonal, formula-based diagrams on paper. These
schema they steadfastly refused to exhibit, despite ever-
growing curatorial interest at home and abroad, until the
group disbanded in 1995.

The previous year, Gu—who declines to discuss his
own artworks and typically titles them with their date
of completion—had begun employing raw meat in
installations that challenge the public to fully engage
with the works of art and with the material realities of
human life. (Gu's close-up photographs of a hand
proffering the viewer a hunk of animal flesh are icons
of the in-your-face sensibility of 1990s Chinese art
[*page 67, above*]). Encased in glass coffins, spread out
on floors or tables, formed into fake carpets or furni-
ture cushions, these uncooked slabs of meat (and
sometimes multiple whole animal brains) have been
present in Gu's installations for nearly fifteen years.

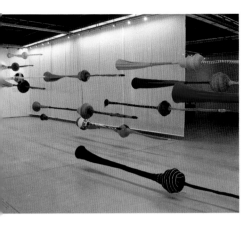

Yin Xiuzhen, *Weapons*,
2003. Installation

Yin Xiuzhen, *Portable Cities:
San Francisco*, 2003.
Suitcase, clothes,
city map, light, audio,
82 x 150 x 90 cm

Occasionally he instead employs myriad dolls (redolent less of mortality than of arrested development) or fruit, displayed by the ton and left to rot in mockery of widespread consumer wastefulness (*page 67, below*).

Materiality of a very different sort preoccupies Lin Tianmiao (b. 1961), who spent eight years (1986–94) in the U.S. after leaving her native Shanxi Province and graduating from Capital Normal University in Beijing. Originally a textile designer, she began her art career in 1995 by exhibiting household items obsessively—and beautifully—wrapped in white thread. Associations with traditional craft and female domesticity gave way to a broader critique of identity politics in works like a wrapped man's bicycle rendered unridable by square wheels and two facing seats, a vehicle perfect for those stuck in immobile self-regard.

With partner Wang Gongxin (b. 1960), himself a video artist of growing repute, Lin has pushed the inutility of high fashion to futuristic extremes in the bizarre, some-

times hairlike garments of works like *Here? Or There?* (2002). Most memorable of all is her 1999 installation *Braiding*, in which a soft thirteen-foot-high photographic self-portrait digitally divested of hair, transferred to fabric, connects by threads to a trailing, rope-like braid tangling back to a video monitor showing hands at work crisscrossing yarn (*opposite*). The piece seems to ask, Is there any escape from this "feminine" cycle? Must a woman desexualize herself in order to emerge as a free individual in a perpetually chauvinistic world?

Yin Xiuzhen (b. 1963), another artist concerned with the relation between private and public life, is also a graduate of Capital Normal University in her native Beijing. Originally a student of painting, she has, like Lin Tianmiao, made her reputation primarily with works incorporating fabric and thread. *Suitcase* (also titled *My Clothes* or *Dress Box*), 1995, consists of her own garments from childhood and adolescence neatly stacked in a trunk and held forever in place, virtually entombed, by cement. The installation *Building Game*

Yin Xiuzhen, *Washing the River*, 1995. Water from polluted river, brushes, ice, plastic pails, fresh water

(2000) was composed of large building models made from clothes stretched over frames and lit from within. A similar tentlike technique was used to construct the two approximately sixteen-foot-long airplanes that that hang above viewers in *International Flight* (2001–4). The various suitcases of the Portable Cities series (2001–present) open to reveal pop-up fabric cityscapes of such prominent cities as Berlin and San Francisco, fashioned from the old clothes of their residents (*page 69, right*). For *Weapons* (2003), Yin wrapped household items in discarded clothes from around the world, transforming them into colorful lancelike implements that hang horizontally in nonthreatening splendor (*page 69, left*). Her *International Airport Terminal* (2006) reacts in a sci-fi manner to air terrorism by encasing passengers in high-style jumpsuits that leave only the eyes exposed.

Yin has laid old roof tiles and building fragments out on the floor in tribute to China's rapidly vanishing architectural heritage, and she has used old shoes—some with her face imprinted on the inner soles—to represent stages of her journey from infancy to adulthood. Once, in the early solo performance *Washing the River* (1995), she even hand-laundered a frozen chunk of polluted Chengdu river water (*above*).

Wu Shanzhuan (b. 1960), a Zhejiang Academy graduate who has lived in Iceland and received a master's degree from the Hochschule für Bildende Künste in Hamburg, was known before his move to Europe for *Red Humor* (1986), a roomful of Chinese texts posted helter-skelter on ceiling and walls (*opposite*). Here Cultural Revolution slogans mixed freely with advertising pitches, ancient poems with pro-business catch phrases, and so on, while four large characters on the

Wu Shanzhuan, *Red Humor*, 1986 (installed in Hangzhou). Mixed media, installation with works on paper, dimensions variable

door proclaimed: "Nobody knows what it means." From such postmodern skepticism, Wu passed to pointed satire of living conditions in the midst of breakneck development (for example, several light-tube-and-painting environments lamenting broken water pipes and service delays) and shopping mania, as seen in *To Buy Is to Create* (2005–6), a nearly twenty-foot-wide bar code backed by fluorescent lamps.

Shi Yong (b. 1963), a Shanghai native who graduated from the city's Light Industry College, brings a calmer humor to the contemporary scene. Guided by responses to an online questionnaire, he concocted an ideal, upwardly mobile persona, endlessly cloned in digital photographs and small statuettes. With a mop of thick, stylishly reddened hair, expensive sunglasses, a dark bohemian-chic suit, and a briefcase, this embodiment of Shanghai cool is at once fiercely individualist and ubiquitous. Everywhere this alter ego goes in Shi's photos and figure groups, he meets himself—as the fashionable so often do.

That Shi gets his own joke on narcissism, individual and collective, is evident in his larger sculptural works and installations, which play knowingly with scale and subliminal aspirations: *The Moon Hues Are Teasing* (2002), a towering pair of pants from which, instead of feet, two hands protrude within grasping distance of a huge glowing bone (*page 72*), an inflatable version of a skyscraper, forever alternating between limpness and tumescence; *Flying Q* (2003), a metal, flying-saucer-shaped contraption in which six people at a time can insert their upper bodies and dream of floating through space (*page 73*).

Given such examples, it is not hard to see why vanguard sculpture and installation were long distrusted by cultural authorities in the People's Republic. How is one to read Sui Jianguo's Mao-suited Western figures? As emblems of China's cunning assimilation of and eventual triumph over foreign influences, or as personifications of Western values that must now fill the void left by a vanished leader and his outdated system? Wu Shanzhuan's *Red Humor* looks like nothing so much as a collision, a mental train wreck, of incompatible beliefs and discourses.

Such works embody ambiguity and disorder—two qualities greatly dreaded by those responsible for a one-party, centrally planned society in which rational decisions and clear directives are supposed to prevent chaos and dissolution. Given that the party's national goals are stability, sustained progress, and eventual attainment of global superpower status, works stressing heterogeneity are considered suspect at best. In this Alice in Wonderland reversal, to be artistically revolutionary is to be politically counterrevolutionary. And to the bohemian challenge posed via other media, performance—the subject of the next chapter—adds one more threatening complication: wordless, mystifying communication to assembled crowds.

71

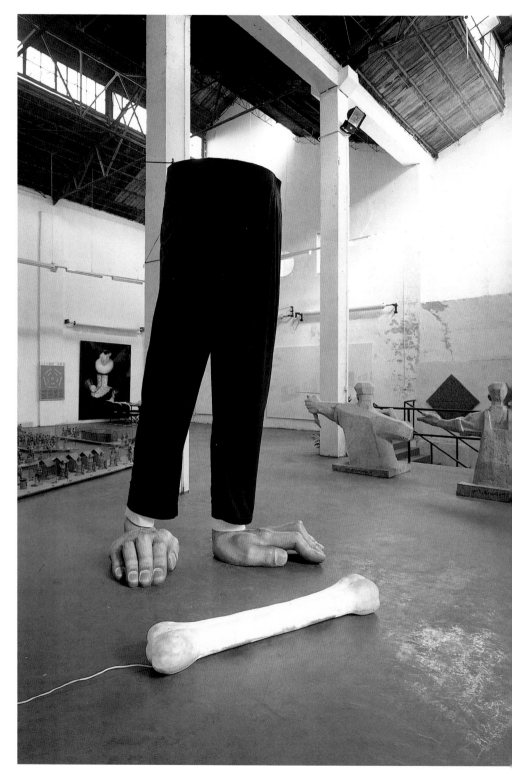

Shi Yong, *The Moon Hues Are Teasing*, 2002. Installation

Shi Yong, *Flying Q,* 2003.
Installation

PERFORMANCE

CHAPTER 3

Nowhere is contemporary Chinese art's rupture with tradition more pronounced than in the peculiar realm of art performance. To be sure, China has a long history of performing arts—courtly song and dance; roving troupes of actors, acrobats, and circus performers; puppet plays; elaborate operas mounted in both high-status and vernacular venues. The contemporary photographer Liu Zheng has captured vestiges of these ancient practices in two series, The Chinese (*page 140*) and Peking Opera (*page 141*); Wang Ningde has photographed snake handlers and carny dancers in his Dancing in Small Towns; and Wang Dongfeng has poignantly documented disused provincial opera houses. In the first half of the twentieth century, Western forms of live presentation—including classical music, jazz bands, and torch singers—also thrived in the major cities, especially Shanghai.

During the Cultural Revolution, such forms of entertainment, both indigenous and foreign, were systematically displaced by strident agitprop theater pieces. At the height of the purges, Mao's fourth wife, the former Shanghai actress Jiang Qing, banned all stage productions other than eight "model operas," didactic music-and-dance melodramas often featuring corps of stalwart young women who, worshipful in their allegiance to Mao, waved huge red banners and cavorted on pointe with rifles. In effect, all aspects of the propagandistic machine—speeches, rallies, troop reviews, public denunciations, show trials—became the theater of the Maoist state. After the reopening of the mainland in the late 1970s, most of the older performing arts returned—and were soon met with karaoke, bar bands, and raucous rock concerts. But these new forms, troubling enough to conservatives, are tame compared to performance art, whose origin, premises, techniques, and goals are so alien to the conventions and narrative logic of both Eastern and Western theater.

Performance art was born of rebelliousness and the absurd. Its conceptual origins lie in the Dada high jinks at Zurich's Café Voltaire and elsewhere during World War I, but the genre was first fully realized in the capricious Happenings initiated by Allan Kaprow at the height of the Cold War in 1959 and in the absurdist gestures of the Fluxus artists of the 1960s. Performance art is embroiled with the myth of the artist as culture hero, the genius who stands apart

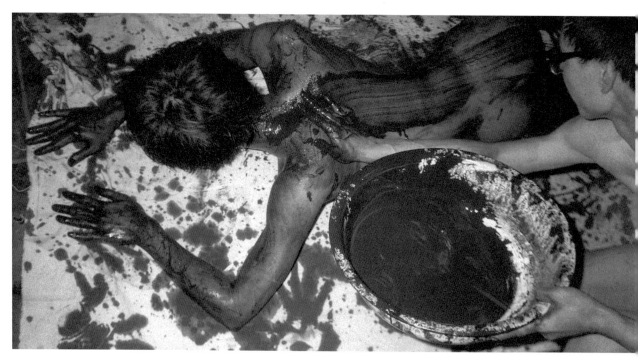

from conventional society and—through his work and his lifestyle—both critiques and leads, offering up an alternative vision. In Actionism, another 1960s movement, based in Vienna, the aesthetic emphasis shifted from the facture of objects to the production of redemptive states, from making to doing. Performance is thus linked to shamanism (which does have precedents in anicient China), since in both cases the essence of the spiritual cure is mystification. The magical event may or may not have narrative elements, but viewers are inevitably left asking, "Why would anyone do that, and what does it mean?" The shaman not only demonstrates and prescribes, he performs, leaving key motives unstated—compelled, it seems, by a need for personal and collective expiation. At its best, performance art mixes spectacle, protest, and absurdity with something more profound—a sense of penance. In this, it is akin to atonement rituals—the bullfight, the Catholic Mass, and all forms of blood sacrifice, the historic source of drama in the West.

Such imported notions—and along with them the Judeo-Christian proclivity for mortification of the flesh—melded in post-Mao China with a venerable Eastern tradition of worldly renunciation, practiced to varying degrees by literati, monks, and hermits. Performance could function as a *gong-an* (Zen koan), incarnate. According to Thomas J. Berghuis, the most common term for performance art in Chinese, *xingwei yishu*, transliterates as "behavioral art" or "conduct art." The term *oufa*, occasionally employed for some performance events taking place unannounced in public places, suggests an unanticipated assault, either verbal or physical.

Opening Moves

One might see the Stars group as forerunners of Chinese performance artists; as early as 1979 they staged outdoor exhibitions, street demonstrations, and public readings. But the first art performance per se in the PRC seems to have been by Wang Peng (b. 1964), who in 1984, at the prep school for Beijing's Central Academy of Fine Arts, created an untitled act of nude painting with his body (*opposite and below*). Frustrated with the school's conventional training and rigorous exams, the young student covered himself with ink and made multiple messy impressions on paper,

Opposite and below:
Wang Peng,
84's Performance,
Beijing, 1984

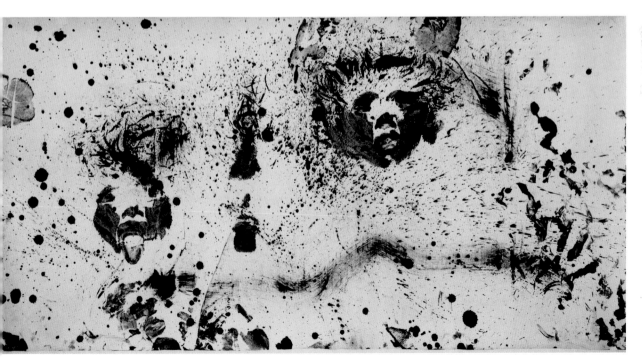

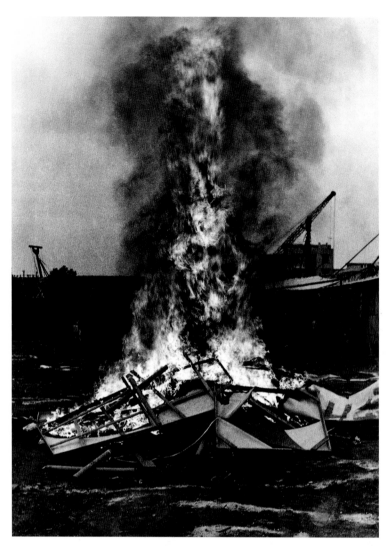

Xiamen Dada, Event,
Cultural Palace of Xiamen,
November 1986

rather as if one of Yves Klein's *Anthropometries* (1960) models had gone berserk.

In 1985, students visiting Beijing from the École des Beaux-Arts in Paris drew students and teachers from the Central Academy into public, formally liberating action-painting sessions that involved both conventional surfaces and the participants' bodies. This was the year that Wang Qiang, in head wrap and paint-splattered suit, posed as a living statue (*After Hours Artist*) and Li Han wore framed canvases on his neck and hands as though he had been put in stocks as punishment (the Painting Frame series).

Thereafter actions began to multiply; as abundantly attested in Berghuis's *Performance Art in China* (2006). The year 1986 saw the publication of a Chinese translation of Jerzy Grotowski's *Towards a Poor Theater* (a Polish treatise advocating drama stripped of sets and stagecraft in favor of a direct encounter between actor and audience) and an increase in confrontational actions. Among these performances were the Xiamen Dada bonfire, in which artists burned sixty of their works at the conclusion of an exhibition in the city of Xiamen in November 1986, hoping to liberate the art's spiritual essence from its material manifestations (*left*); artists in Shanghai wrapping themselves in yards of cloth and going out into public places to confound the citizenry (*Cloth Sculpture*); a nearly nude Tang Guangming having himself beaten with wooden switches (*Ritual*); Zhang Peili and Geng Jianyi binding themselves tightly from head to toe with newspaper and rope (*Wrapping Up—King and Queen*); Xu Yihui and Cai Xiaogang, dressed in white, digging through a landfill in Jiangsu Province; and members of the Concept 21st Century group pouring paint on themselves and chanting their way across the campus of Beijing University (*Art Before Your Eyes*).

The '85 New Wave movement, with its ringing credo "art forms are unlimited and nothing is prohibited" was under way, sparking some 150 performances in the 1985–7 period. Tellingly, an inordinate number of these early events featured artists wrapped in white, the Chinese color of mourning, like bandaged soldiers or revivified mummies. Scar Art had, in effect, left the canvas and taken to the streets.

In 1987 Concept 21st Century was on the Great Wall, with a host of performers—including Hou Hanru, now a world-renowned curator, and Fan Di'an, currently director of the National Art Museum—swaddled in white strips of cloth and tangling themselves in black streamers attached to the surrounding stone blocks. Wei Guangqing, meanwhile, persuaded Ma Liuming and other artists (swathed in white, of course) to join him in a series called Suicide—lying on railroad tracks or menacing their own bodies with nooses and knives. The following year in Shanghai, twelve artists (including Zhang Jian-jun, Yu Youhan, and Ding Yi) put on robes and hoods to enact a parody of Leonardo's *Last Supper*.

Clearly, by the time the exhibition *China/Avant-Garde* opened in February 1989, performance art was well established in China as a provocative new form—one in sync, in its own bizarre way, with the wave of economic and social liberalization that would peak in Tiananmen Square that June. Several performances, some planned and some "spontaneous," were mounted during the opening of the exhibition at the National Art Museum. Wu Shanzhuan set up a stand

Ma Liuming, *Fen-Ma Liuming*, 1993

Xiao Lu, *Dialogue*, 1989. Performance at the exhibition China/Avant-Garde, February 1989

79

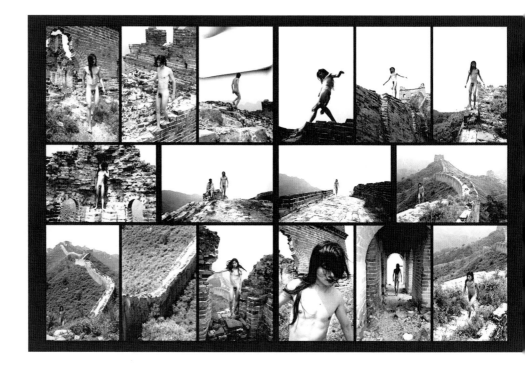

Mia Luming, *Fen-Ma Liuming Walks the Great Wall*, 1998

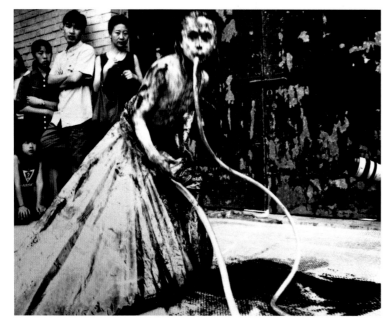

Zhu Ming, *8 May 1999.*

selling smelly shrimp; Li Shan washed his feet in a basin with Ronald Reagan's face imprinted on the bottom; Zhang Nan sat on a pile of eggs, draped with signage addressed to the coming decade; and, as described in the preceding chapter, Xiao Lu, less than two hours after the museum doors opened, fired two pistol shots at *Dialogue*, her installation of two telephone booths with life-size male and female figures separated by a mirror, causing the exhibition to be summarily closed by the police (*page 79*). (Lu and her assisting boyfriend, Tang Song, were arrested but then—probably due to family connections—released three days later.) *China/Avant-Garde* reopened after five days, only to be suspended for another three days when bomb threats were received. Whether the threats were real, a ruse by the authorities, or the work of another artist remains uncertain.

Once repressive measures were taken following the June "insurrection" in Tiananmen Square, performance art understandably wilted, as progressive artists withdrew from or were regularly denied access to public venues. Apartment art, the confinement of avant-garde activities to one's living space and a circle of trusted friends (a strategy long cultivated in the

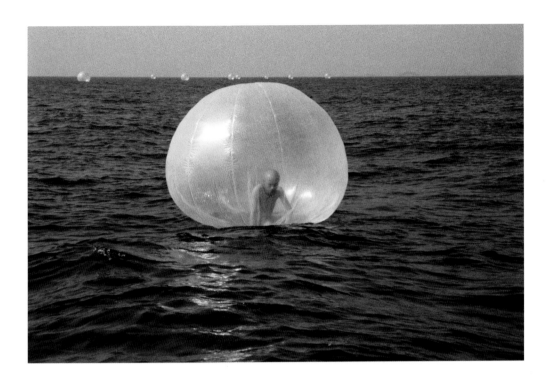

SSR), became the norm during the first few cautious ears after the violent suppression of the Tiananmen quare protests of 1989.

Fraternity of Flesh

hus, although performance art had flourished in the te 1980s, the genre did not become the basis for any tist's ongoing career until the mid–1990s. The key its revival at that time was a greater sense of soliarity in the aftermath of Tiananmen, a gradual loosning of censorial strictures (or a greater cunning in rcumventing them), and attainment of a critical ass within receptive bohemian communities in the ew decade. Chief among these enclaves was Beijing's gendary East Village (named after New York's riving alternative scene of the 1980s), where a score f impoverished artists lived alongside migrant orkers in a trash-strewn section of eastern Beijing. In ontrast to Yuanmingyuan, which drew a number of sing painters (including Fang Lijun, Qi Zhilong, Yue injun and Yang Shaobin) to a western sector of the ty, near the ruins of the Old Summer Palace

destroyed by invading Western powers in 1860, the East Village was a no-man's-land, which, lacking connections to government institutions or a market, spawned aggressively heterodox practices.

One early East Village denizen, Ma Liuming (b. 1969), arrived in 1993, two years after graduating with an oil painting major from the Academy of Fine Arts in his native Hubei. The happenings he created in Beijing were an implicit demand for personal and artistic validation. When the unflappable British performance duo Gilbert and George visited the East Village in October 1993, many of the young Chinese artists were frustrated by the pair's lack of reaction to the work they were shown. Ma stripped off his shirt, poured bloodlike red paint over his face and torso, and struck poses with the visitors. A few weeks later, the artist—who in those days was slim, long haired, and alluringly androgynous—performed in drag as his alter ego Fen-Ma Liuming (*page 79, above*) (*fen*, meaning "incense" or "fragrance" and sounding like the word for "separate," is sometimes used as a girl's name). Appearing in a slinky floral dress that evoked every cliché of the exotic oriental woman, the artist proceeded to masturbate and drink his semen. In

81

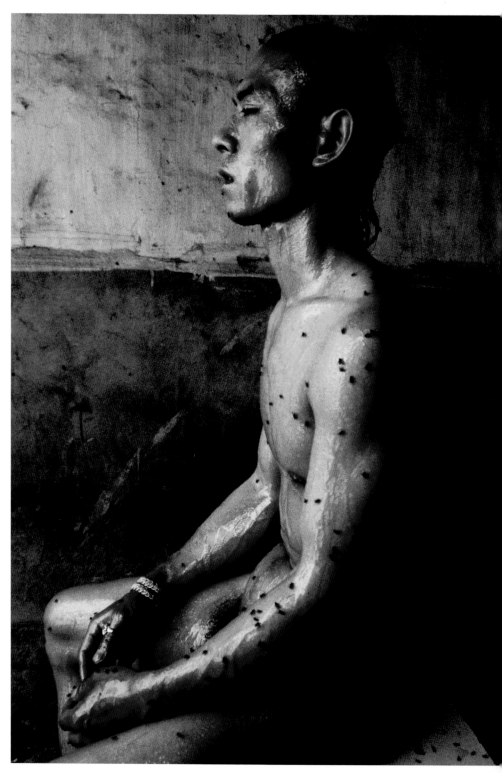

Zhang Huan, *12 Square Meters*, 1994. Beijing

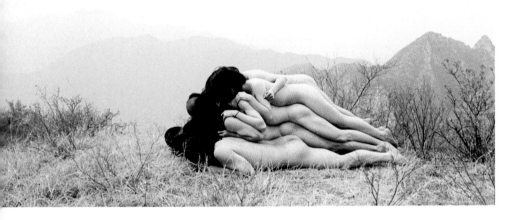

994 he performed *Fen-Ma Liuming's Lunch I* (in which he sat nude, sucking a long plastic tube attached to his penis) and *Fen-Ma Liuming's Lunch II*, standing unclothed while cooking and serving food in a courtyard—a literal naked lunch. He was soon arrested for this "indecent" behavior and spent two months in jail.

The punishment did not take, apparently. For the rest of the decade and slightly beyond, Ma appeared unclothed on the international exhibition circuit, inviting audience members to come to the platform and pose with him in any way they liked as he sat impassively in a chair. In 1998 he had himself photographed and videotaped as he walked nude along the top of the Great Wall (*page 80, above*). Thereafter, his artistic approach changed steadily with his body and life-style. Grown a bit pudgy in fatherhood, Ma these days makes paintings in which his own head appears, disproportionately large, atop the body of a bare, squirming infant.

Ma's East Village friends and companions included the physically slight Zhu Ming (b. 1972), who had endured a hard, fatherless life in Hunan, Mao's Zedong's home province, where the effects of the Cultural Revolution had been extreme. An untrained artist, he seems to have been in search of a protective bubble, both socially and in his work. In his studio in 1994, Zhu repeatedly created room-filling quantities of suds with which he covered his head and face—a transformation that echoes Marcel Duchamp's image on the *Monte Carlo Bond* (1924) and presages Zhang Huan's *Foam* (1998), a sequential photo action in which Zhang lathered his head and held various family photographs propped up in his mouth. Later that year, in Xiaopu Village, east of Beijing, Zhu had himself buried alive for two hours, breathing and blowing bubbles through a tube. Later the same day, he lay in a shallow "grave" next to a cemetery and was covered with suds. Zhu was subsequently jailed for two months for distributing pictures of his nude performances. Since 1997 he has participated in many international shows, occu-

83

Zhang Huan, *65 Kilograms*,
1994. Beijing

Zhang Huan, *25 mm*
Threading Steel, 1995.
Beijing

ng a tentlike plastic bubble, sometimes on land
l sometimes on open waters, lying much of the
e in a fetal position and sucking air through a tube
ges *80 below, 81*).

e most famous performance artist associated with
 East Village is Zhang Huan (b. 1965). Raised by
 grandmother in a rural hamlet in Henan Province,
 received an undergraduate degree from the art
artment of Henan University in 1988 and later
ght art and Western art history at the province's
engzhou College of Education. In 1991, at the age
twenty-six, he undertook graduate study at the
hly selective Central Academy of Fine Art in
jing.

ang's performance work began in 1993, when he
s photographed sprawling on the floor wearing
hing but some found mannequin parts that made
n look like a sexy three-legged man holding a post-
tal cigarette. Later that year, he presented his first
blic action in the courtyard of the National Art
seum of China. For *Angel*, a meditation on abor-
n, Zhang assembled various discarded doll parts
o a whole figure, doused the "baby" and himself in
od-red paint, and tied the doll to a rope.

1994 Zhang had moved to the East Village, where
 rent was sixteen dollars a month, and hit upon the
ments that would define his performance career for
rs to come: nudity, endurance, and self-absorption.
e was depressed much of the time, listening to Kurt
bain music and reading news accounts of the Hong
ng–born Tseng Kwong Chi, traveling the world in a
o suit and photographing himself in front of count-
s clichéd tourist sites.) For *12 Square Meters* (1994;
ge 82), his breakthrough work, Zhang smeared his
dy with fish oil and honey, then sat motionless for
hour in a sweltering, stench-ridden communal
thouse of that size (129 square feet), before stalking
tely away, step by step, to immerse his entire body
the brackish water of a nearby pond.

ang had a close working relationship with the
lowy, effeminate Ma Liuming—East Village chroni-
r Rong Rong photographed them lying side by side
a bed and reclining, eyes closed, at opposite ends of
athtub covered with freshly shorn hair—and he
veloped a persona that is, in effect, yang to Ma's yin.

Thus the Zhang Huan of record is bald, meaty,
pronouncedly masculine with a tight-lipped Yul
Brynner smolder. While his smooth head suggests, on
one level, a monklike devotion to art, it also echoes the
thuggish caricatures that certain peers, like Cynical
Realist painter Fang Lijun and graffiti artist Zhang
Dali, were then deploying as emblems of noncompli-
ance with authority and tradition.

Over the next four years, Zhang engaged in a number
of nude, endurance-based actions of galvanizing
psychological impact: for *65 Kilograms* (143 pounds,
his weight at the time), of 1994, he was suspended
from the ceiling by chains for an hour while a doctor
extracted 250cc of his blood and dribbled it onto a hot
steel pan (*opposite, above*); in *Original Sound* (1995) he
lay under a highway overpass on his thirtieth birthday,
with earthworms jammed into his mouth; in *25 mm
Threading Steel*, (1995) he stretched supine in a base-
ment for an hour as sparks from a steel-cutting tool
shot over his body and face (*opposite, below*); for *Cage*

He Yunchang, *Appointment
Grasping the Column*, 2003

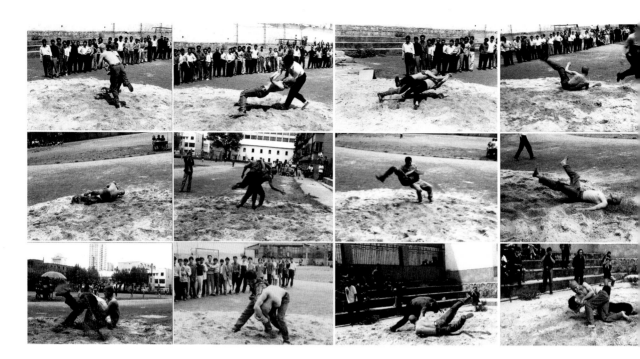

He Yunchang, *Wrestle: One and One Hundred*, 2001

(1996) he locked himself in an iron box with one narrow breathing slit; for *3006 Cubic Meters/65 Kilograms* (1997) he lashed himself to an old horse-carriage axle and symbolically attempted to pull down the Watari Museum in Tokyo.

Zhang also orchestrated group performances involving his East Village cronies. The now-famous *To Add One Meter to an Anonymous Mountain* (1995), for example, consisted of a meter-high body pile of ten naked artists (eight men and two women) on the summit of Miaofengshan Mountain west of Beijing (*page 83*). In *Nine Holes*, performed later the same day on a nearby peak, nine of the participants sexually humped the earth for ten minutes. Given China's recent history, from the Rape of Nanjing (1937–38) to the mass star-vations of the Great Leap Forward (1958–60), the stacked bodies of *One Meter* delivered not only an erotic tingle but also the more somber frisson associated with multiple anonymous deaths. For *To Raise the Level of a Fishpond* (1997) Zhang recruited about forty migrant workers between the ages of twenty and sixty to parade around an urban fishpond in their swim trunks before wading in to accomplish the task described by the title. The artist took part as well, with the pond owner's five-year-old son on his shoulders.

Symbolically (despite more complicated sociological facts), such works implied that independent Chinese artists in those days had, like the poor, only their bodies with which to make a small but measurable difference in the world.

The spirit of the young Zhang Huan lives on today i He Yunchang (b. 1967), a graduate of the Central Yunnan Art Institute now resident in Beijing, whose performances are extreme, bordering on masochisti He has dangled by his ankles from a crane while "cutting" the rushing current with an knife of ice (*Talking with Water*, 1999); hung suspended in front a wall and been slathered like the brick surface in go paint (*Golden Sunshine*, 1999); stared at a 10,000-wa bank of lights for an hour (*Eyesight Test*, 2000); consumed thirty-eight glasses of wine in a traditiona drinking game with changing opponents (*Passing Flowers to the Drum's Beat*, 2000); wrestled 100 succe sive challengers in an hour, winning eighteen match and losing eighty-two (*Wrestle: One and One Hundre 2001; above*); tried to stand up to body-pounding power hoses (*Gunman*, 2001); had his hand cast int towering cement block, trapping him in place (*Appointment Grasping the Column*, 2003; *page 85*); inhabited a purpose-built concrete monolith for

twenty-four hours (*Casting*, 2006); and carried a hefty stone on a 2,500-mile, 110-day hike (*Touring Around Britain with a Rock*, 2006; *below*).

Yet, unlikely as it seems, He Yunchang has been surpassed in defiance of physical suffering by Yang Zhichao (b. 1963), who lives and works in Beijing. An art department graduate of the Northwest Normal University in his native Gansu Province, Yang has had grass implanted in his shoulder (*Planting Grass*, 2000; *page 88, above*), been branded with his own citizen identification number by fellow artist Ai Weiwei (*Iron*, 2000; *page 88, below*), and had various items surgically inserted into his body (*Hide*, 2002).

The Never-Ending Show

Almost always tied to places and props, performance art inevitably moves beyond the body itself. Pioneer

Wang Peng's later actions include *Wall* (1993), in which he had the entrance of the contemporary art gallery of the affiliated middle school of the Central Academy of Fine Arts, Beijing, bricked up as a protest against censorship (*page 89, below*). (He had by then returned to the institution as an instructor.) *Three Days* (1995) entailed his illegal camping out in and photographing a pavilion in the Forbidden City, then slated for renovation. In 1997, while on a three-year sojourn in New York, Wang would occasionally anchor a piece of twine near his doorstep and, like Theseus entering the Minotaur's labyrinth with Ariadne's thread, proceed to take long walks with an ever-increasing length of string unspooling out the back of his jacket, passing numerous perplexed urbanites (*page 89, above*). This *Passing Through* performance was repeated in Beijing in 2006, with comparable results. In 2001, having invited people to a Beijing gallery exhibition, he chained and padlocked the door behind them (thus duplicating, unbeknownst to the artist, a 1968 action by Argentine conceptualist Graciela Carnevale). More

He Yunchang, *Touring Around Britain with a Rock*, 2006

Yang Zhichao, *Planting Grass*, 2000

Yang Zhichao, *Iron*, 2000

recently, Wang's practice has centered on conceptual painting, photography, and installation.

Song Dong (b. 1966) is that rarity on the contemporary art scene in China, an artist who is personally modest about a body of work that is in fact highly influential in China and worthy of greater critical esteem abroad. It was he who organized *Wildlife* (1997–98), a year-long, seven-city project with twenty-seven participating artists, that spurred such works as Zhang Huan's *Fishpond*. A native of Beijing, where he attended Capital Normal University, in 1995 Song began writing his diary on stone with water. The gesture harks back to the straitened circumstances of his childhood during the Cultural Revolution, when his father urged him to conserve precious writing materials by practicing calligraphy in this way (still a common practice in China's City parks) but it also allows him to write his most intimate thoughts unhampered by the fear of monitoring now or in the future, and—in Taoist fashion—to accede to the flow of our transitory existence.

In a similar vein, in 1996 Song entered the Lhasa River in Tibet and, sitting alone, repeatedly stamped the current with a large wooden seal bearing the character for "water" (*page 90*). Along with its Taoist connotations, *Water Seal* (also called *Stamping the Water*) suggests the inadequacy of language to capture a reality that perpetually exceeds and outruns it. Moreover, the act of attempting to impose an identity by verbal decree is politically resonant in a region whose claims to sovereignty have been forcibly suppressed by the Chinese government.

The subtlety of Song's approach is again evident in *Breath* (1996), a two-part performance in which he lay prone in the freezing cold—first in Tiananmen Square at night, then on Beijing's frozen Lake Houhai in daylight (*page 91, below*). The condensation of his breath created an icy patch on the stones of the square but had no effect on the lake. Photographs of the work suggest its implications; one shows an overlit palace hovering in the background as Song lies face down where so many were slaughtered in June 1989. Can one think of "breathing" without immediately thinking of "not breathing"?

More personal are works like *Touching My Father* (1998), a video projection of Song's hand onto his father's body, simulating a tender caress that would violate conventional Chinese mores. *Father and Son in the Ancestral Temple* (1998), from the censored group show *It's Me*, consists of three separate video projections: Song's face, his father's face, and Song's face with his father's superimposed upon it (*page 91, above*). The composite image is a concise metaphor for the issues of autonomy and unity, selfhood and shared heritage, that beset every family and nation.

Deceptive perceptions are exposed in a 1999 series of actions, documented in videos and photographs, as Song repeatedly strikes a mirror with a hammer, smashing one scene to reveal another. In another act of revelation, he has systematically laid out, category by category, all of the household items—old clothes and shoes, bottles, dinnerware, bars of soap, tote bags, blankets, even Styrofoam sandwich boxes—that his mother has accumulated in her house over five

Wang Peng, *Passing Through*, 1996–97. New York

Wang Peng, *Wall*, 1993. Gallery of Contemporary Art, affiliated middle school of the Central Academy of Fine Arts, Beijing

Song Dong, *Water Seal (Stamping the Water)*, 1996. Lhasa, Tibet

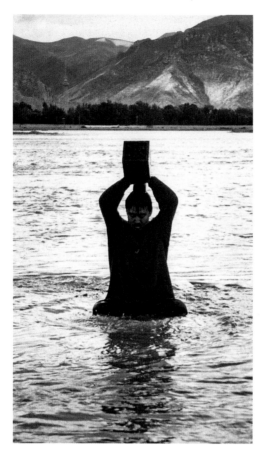
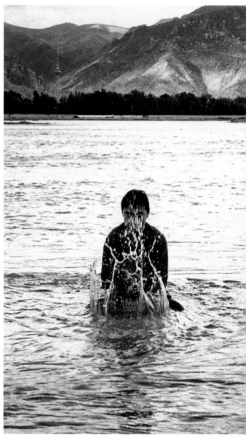

decades. The display (*Waste Not*, 2005), like the wall text recounting the frugal woman's war-and-disease-marked life, is an utter contrast (and perhaps a material rebuke) to the throwaway consumerism that now reigns in urban China.

The ongoing Long March project was launched in 2002 (following its organizational founding in 1999) by curator Lu Jie (b. 1964) and artist Qiu Zhijie (b. 1969), Beijing residents also affiliated with the China Academy of Art in Hangzhou. Scores of Chinese artists, including many of today's art stars, have participated in interactive events at various points along the five-thousand-mile route taken by Mao's battered forces in 1934–35. Activities intended to echo Mao's efforts to garner local support as his army made its way toward Yan'an have included readings, exhibitions, site-specific installations, performances, and interactive art-making endeavors, such as the project

by Qin Ga to have his back tattooed with a map of the successive stages of the artistic Long March (*page 92*).

Qiu Zhijie, born of a scholarly lineage in Zhangzhou, Fujian Province, and educated at the Zhejiang Academy of Fine Arts in Hangzhou, has made his mark—in several senses—as one of the most theoretically sophisticated artists in the PRC. From 1990 to 1997 he copied the fourth-century *Lantingxu* (Orchard Pavilion Preface), a classic calligraphy exercise, one thousand times on the same piece of paper, eventually producing a black, unreadable field (*page 93*).

This preoccupation with language—does it constitute meaning, merely transmit messages, or, if overly repeated (as in classical training, propaganda, and advertising), ultimately sabotage its own ends?—was given a more ontological twist in Qiu's ongoing series *Tattoo*, begun in 1994. Here the artist, standing shirt-

Song Dong, *Father and Son in the Ancestral Temple* (detail), 1998

less and stock-still, was photographed from the waist up against a monochrome backdrop (*page 94*). In one example, both his body and the backdrop are studded with small metal dots. In another, the character *bu*, a curt negation, is painted over Qiu's body and onto the background. (Perhaps the ideogram echoes the Maoist refrain *bu po bu li*—"no construction without destruction.") Does the image represent the denial of true selfhood, as society's regulatory "no" is imposed on the individual? Or does it signify the moment of self-assertion when the functionary revolts—like the slave who finally says "no" in Albert Camus's *The Rebel*—asserting a universal and inviolable value and so beginning to truly exist as a man? What we know for certain is that the slightest shift of position, the smallest movement, would break the image's defining pattern—a possibility of not only metaphysical but also social and political import in the New China.

Qiu's recent photo actions with a light-stick, such as the Twenty-four Seasons series (2005–6), find the artist coming at the problem of disjuncture between sign and referent in yet another way (*page 95*). The characters he inscribes in the air, recorded by a camera set to a slow exposure, do not so much denote the site of this language-act as dispute its applicability in a changing context. Thus *Jingzhe (Awakening of the Insects)*, whose title refers to the spring day when insect life revives, depicts an empty city street lined with brightly hooded telephone stands, looking like the heads of electronic-age beetles.

This cognitive dissonance is related to the strategy made famous in 1995–98 by Zhang Dali (b. 1964). Originally from Harbin, Zhang graduated from the Central Academy in Beijing before spending six years

Song Dong, *Breath*, 1996, Beijing Commune. Photographs each 48 x 96 cm

in Italy, where he first encountered graffiti art. Stunned upon his return in 1995 by the transformation of China's cityscapes and social structures (he had left in the crackdown year of 1989), the artist undertook a long series of anonymous guerrilla-art actions. All over Beijing, buildings were being marked for demolition with a single spray-painted character, *chai*, that had become, in effect, the sign of outdatedness (old edifices, old communal relations) in the PRC's headlong rush toward capitalist-driven modernity. In some two thousand locales, Zhang spray-painted his own bald-pated profile on the walls of condemned

Qin Ga, *Miniature Long March Sites 1–14* (detail), 2002

structures in the shadow of cultural monuments and glistening new highrises. If this seems at first like an identification with the Old China of the vanishing narrow-alley *hutongs*, the gesture was soon complicated by Zhang's hiring of migrant construction workers to chisel his profile outlines, sometimes breaking through the walls completely and revealing a futuristic view, as though the artist's mind itself were being opened to startling new possibilities (*page 96, below*).

Yet Zhang's awareness of the human cost of progress, and his empathy with those who pay it is seen in the 2003–5 Chinese Offspring series of body casts taken primarily from building-trades laborers (*page 96,*

above). More polished and realistic than George Segal's figures, they are at once personally specific and disturbingly anonymous—especially when, as is often the case, they dangle upside-down from a gallery ceiling like so many wiggling, tortured prisoners.

Mordant Pranksters

Many Chinese performance artists lace their work with humor, though often of the bitter variety. In 1992 Wang Jin (b. 1962)—a Zhejiang Academy graduate and former Beijing Institute of Fashion Design

Qiu Zhijie, *A One-thousand-time Copy of Lantingxu* ("Orchard Pavilion Preface"), 1990–7. Ink on rice paper

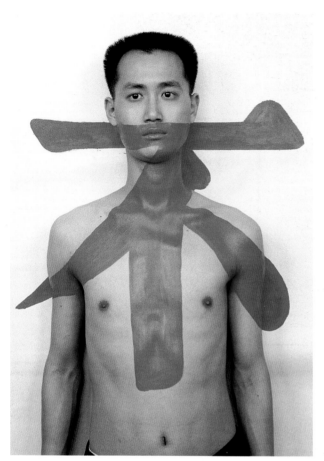
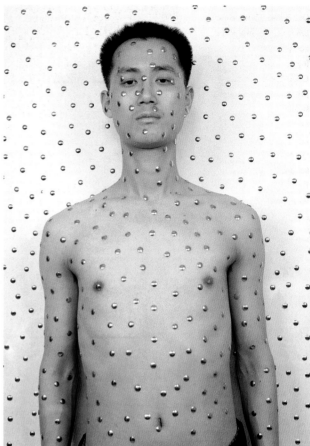

instructor originally from Liaoning Province—began his daily routine of painting U.S. currency designs on Forbidden City bricks and tiles that he finds in street markets. Two years later, he marked Britain's impending turnover of Hong Kong to the PRC by slathering a 200–yard stretch of the connecting railroad line with a bright red mixture of some seventy ingredients (*Beijing-Kowloon*). For *Red Flag Canal*, also done in 1994, he dumped red dye into a provincial canal constructed during the Great Leap Forward—a project endlessly celebrated in Cultural Revolution propaganda as an example of Mao Zedong Thought in action (*page 97, left*).

Wang's most widely known performance is *To Marry a Mule* (1995), wherein the artist, wearing a tuxedo and holding a bouquet, simulated a wedding ceremony with a white mule tricked out in black stockings,

rouge, and a white hat with a long pink veil (*page 97, right*). The piece, impelled psychologically by Wang's frustration over his eight failed attempts to obtain a visa to join his wife in the U.S. (the two eventually divorced), has since accumulated many interpretations, all of which the artist welcomes. Indeed, he says that his own take on the work has changed repeatedly over the years. Yet the image stands as an indelible reminder of a time when China's experimental artists were willing to challenge every convention.

China's whiplash shift to consumerism prompted two of Wang's most acerbic responses. In *Quick Stir-Frying Renminbi* (1995), he erected a food stall at a popular night market in Beijing and deftly cooked up Chinese coins in a wok. *Ice 96 Central China* consisted of a "great wall" of ice blocks erected, as part of a commercial promotion, in front of a new shopping complex in

Qiu Zhijie, *Twenty-Four Seasons: Time and Place,* 2005–6

Top:

Guyu (the Grain Rains), Jin Mao Tower, Shanghai

Middle:

Qiufen (the Autumnal Equinox), Yushuxin Village, Qinghai

Bottom:

Daxue (the Major Snow), Weiming Lake, Beijing University, Beijing

Zhang Dali, *Chinese Offspring*, 2003–5

Zhang Dali, *Dialogue: Forbidden City*, Beijing, 1998

Zhengzhou, Henan Province (*page 98*). The nearly one-hundred-foot-long curving barrier contained about a thousand consumer items (jewelry, toys, cell phones, cosmetics, watches, even TV sets) suspended in six hundred frozen blocks. A huge crowd gathered and, as soon as the opening ceremonies ended, attacked the wall with picks, knives, rocks, and hammers, extracting the booty—a development Wang purportedly had not foreseen.

Since 1996, the artist has produced the Chinese Dream series of Beijing Opera gowns made of transparent PVC embroidered in intricate traditional patterns with nylon thread (*page 99*). Ghostly reminders of the once rich and colorful Old China, they are also—when worn in performance—incitements to desire (like the blocks of ice in Zhengzhou) for what is tantalizingly visible yet shielded from us and withheld. Just how things half-hidden grow in the imagination is implied in such works as the $4^1/_2$-foot-high fired clay components of *My Teeth* (2001).

Tongue is often in cheek when Lin Yilin (b. 1964) interacts with cement blocks, ubiquitous in China since the onset of nonstop construction. Born in the southern metropolis of Guangzhou (formerly Canton) and educated at the art academy there, Lin joined the local art group Big-Tailed Elephant in 1991. With the other members (Chen Shaoxiong, Liang Juhui, and Xu Tan), he engaged in such self-generated art activities as their 1994 *No Room* exhibition in a deserted house. In *The Result of 1,000 Pieces* (1994), he stood in a man-shaped hollow inside a wall, as if he were one with the barrier—entrapped by blocks that might topple at any second if the viewer tried to extract the currency wedged in the crevicers (*page 100, above*). For *Maneuvering across Linhe Road* (1995), the artist moved a stretch of wall, brick by repositioned brick, across a busy thoroughfare in downtown Guangzhou (*page 100, below*). In 1997, in Breda, Holland, he donned hospital-style pajamas, covered himself in white powder, and rode in a wheelchair to the doorway of the Chassé-Kazerne, an old colonnaded building, commandeered as a German navy barracks during World War II, that today houses the city archives and the Breda Museum. There Lin mounted a plinth and perched on all fours like the Chinese guardian lion statues he had installed nearby (*page 101*). The piece, *I Am on the Right*, a Long March project, satirizes the

Wang Jin, *Red Flag Canal*, 1994

Wang Jin, *To Marry a Mule*, 1995

egradation of authority of these leonine symbols, nce reserved for imperial palaces and now used by estaurants and other popular venues in the New China as bogus emblems of historical continuity.

ocal color also pervades the early work of another Guangzhou Academy of Art graduate, Zheng Guogu b. 1970). In the photo action *Me and My Teacher* 1993), Zheng went about the streets talking, laughing, nd supposedly learning life's lessons with a mentally l man of cheerful disposition (*page 102, below*). His napshot series Life and Dreams of Yangjiang Youth 1995–98) depicts the artist's younger brother and his riends horsing around with guns and knives in lacker-style imitation of gang behavior and Hong ong action movies (*page 102, above*). Known for its nanufacture of knives and scissors, Yangjiang, heng's birthplace and continuing residence, is a city f two million people on the South China Sea. It was

incorporated in 1988 as part of the economic development push in southwest China and is, like photographer Yang Yong's nearby Shenzhen, a hangout for disaffected youths. In 2004 Zheng hired a local artisan to make ten small sculptures of these choreographic punching and slashing interactions.

Charming humor—to the point of silliness at times— is found in the work of Beijing native Zhao Bandi (b. 1966). Although he graduated from the Central Academy with a degree in oil painting, Zhao has made his reputation with staged photographs, videos, and live interactive projects involving himself and a stuffed panda doll, his symbol for China's commonweal.

The Zhao Bandi and Panda scenarios, preserved in brightly colors posters, prints, and light-box images, are of two types. One features Zhao and the coddled bear in idyllic settings with a seminude young beauty

Left and below:
Wang Jin, *Ice 96 Central
China*, 1996. Zhengzhou,
Henan Province

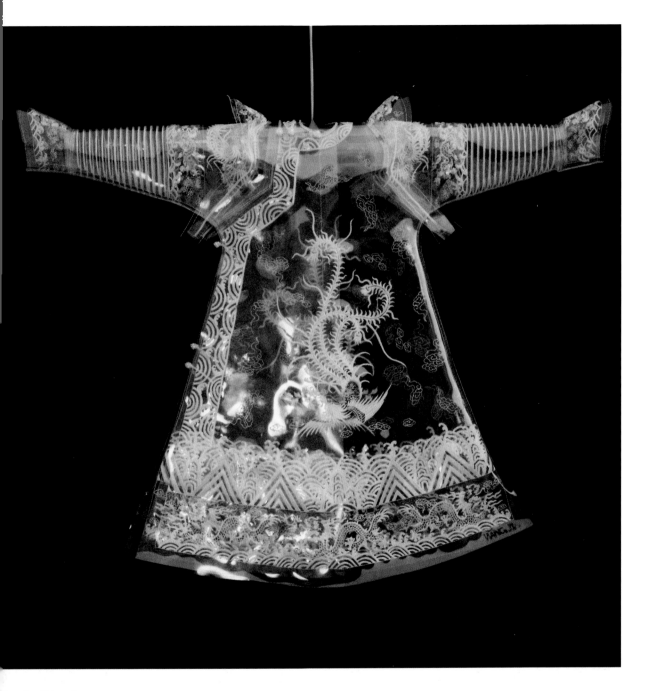

Wang Jin, *Chinese Dream*, 1996. PVC embroidered with fishing thread

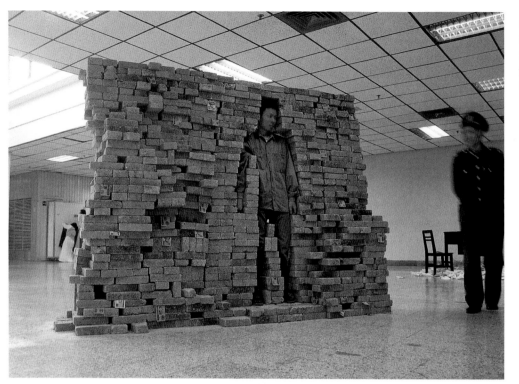

Lin Yilin, *The Result of 1,000 Pieces*, 1994. Installation and performance, wall 200 x 300 x 50 cm

Lin Yilin, *Maneuvering Across Linhe Road*, 1995

for example, *Am I Dreaming* and *Chinese Story*, both 1999; *page 103, right*). The other shows the man and doll pair acting out public-service messages (complete with Chinese/English cartoon-style speech bubbles) in an oblique, ludicrous form that subverts the carping verbal and visual rhetoric of government health-and-welfare campaigns. In a scene lamenting deforestation, we see Zhao (un)dressed and painted as a wary jungle primitive. In another, he lies gasping on a street while the panda asks, "Oh God! What happened to you?"—to which Zhao replies, "I'm killed by tail gas, revenge . . . for me" (*page 103, left*). The shaky translations only add to the dumb-cute appeal. (Indeed, the series enjoyed a period of wide popularity in subways and airports.)

In 2003 Zhao sued two media firms for pirating a poster design showing himself and the panda with surgical masks and toy guns, ensconced behind sandbags and bracketed by the logo "Block SARS, Defend the Homeland." Zhao videotaped the trial, at which he sat clutching his bear doll and eventually read a letter from an ex-girlfriend telling him that he had a perverse relationship with the toy and was too much of a wimp to play the part of a soldier. Somehow, Zhao won the case, and the video, *A Tale of Love Gone Wrong for the Pandaman*, became part of his oeuvre. At the Shanghai Museum of Contemporary Art in 2006, he exhibited snapshots from a traveling road show in which he chooses people he thinks look like pandas and paints their faces to enhance the effect—an ongoing project aimed at recruiting a peace delegation to visit Taiwan.

Regarding the Pain of Others

Live animals, as well as animal and human corpses, have been put to more disturbing uses by several other Chinese artists. There is very little sentimentality about livestock in China; and for a time at the turn of the twenty-first century, preserved human "medical specimens" were readily available—like just about anything else one cares to name—to anyone with the will and means to pay.

Live chickens, for example, were injected, hacked, and urinated on by Sheng Qi in the 1997 performance *Universal Happy Brand Chicken*. In 2000 in Nanjing, independent curator Gu Zhenqing caused a sensation with his group exhibition *Man and Animal*, featuring such actions as a nude Wu Gaozhong (b. 1962) emerging from the slit-open belly of a slaughtered water buffalo (Wu had earlier been sewn into the rose-petal-lined carcass and carried to the site in Qingliang Mountain Park). Wu, a former factory worker from Jiangsu Province, who trained as a painter in Beijing, has since gone on to produce traditional Chinese landscapes made of mold and surrealistic objects such as pear-wood scissors covered with boar bristles. Liu Jin (b. 1971) wrestled a bound pig to its death as the two struggled in a fire-heated vat of steaming soy sauce (*page 104, right*). Liu, from Jiangsu Province, where he took a degree at the Xuzhou Engineering Institute before moving to Beijing to become an artist, now specializes in staged photographs reflecting the anxieties of newly affluent youths.

Many of the most discomfiting events of this nature have been created by Sun Yuan (b. 1972) and Peng Yu

Lin Yilin, *I Am on the Right*, 1997

Zheng Guogu, *Life and Dreams of Yangjiang Youth*, 1995–98

Zheng Guogu, *Me and My Teacher*, 1993, 2007

(b. 1974), two Central Academy graduates who have been making work together since 2000. Sun's early efforts include an installation of live—which is to say dying—fish and crustaceans protruding from gallery walls, and Peng made a curtain of living snakes, frogs, lobsters, and eels strung together with wire. (This is less shocking than it sounds to anyone who has visited a Chinese fish market or dined in a Cantonese restaurant where one picks out the courses, live creature by live creature, from tanks and cages at the front door.)

Sun also concocted *Shepherd* (1998), a suite of three color photographs showing a cloaked human figure among bloody animal spines laid out in the snow; *Honey* (1999), a dead fetus snuggled against the face

of a deceased old man on a bed covered with ice; and *Solitary Animal* (2000), a dog skeleton encased in a vitrine allegedly containing poison gas. Peng performed *Oil of Human Being* (2000) by holding a child's corpse in her lap and dribbling oil into its mouth from a plastic tube (*page 105*).

Together, Sun and Peng have transfused blood from their arms into the mouths of dead Siamese-twin fetuses (*Linked Bodies*, 2000; *page 104, left*); positioned a huge magnifying glass to focus a spotlight beam on a frozen greyhound, making its head smolder (*Pursuing the Soul for a Kill*, 2000); caused frustrated fighting dogs to face off on nose-to-nose treadmills (*Controversy Model*, 2003); and covered an eleven-and-

Zhao Bandi, *Tail Gas*,
2000

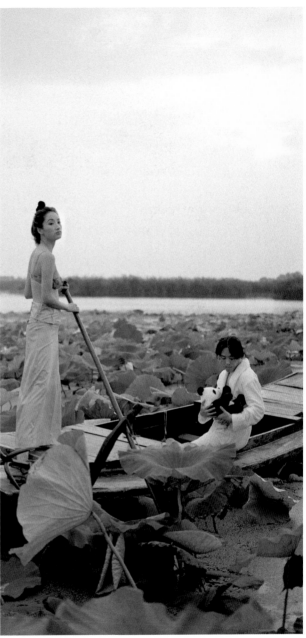

Zhao Bandi, *Chinese Story*,
1999

-half-foot steel column with a four-inch layer of human fat culled from beauty clinics (*Civilization Pillar*, 2001–5). The artists offer the rationale that only through such shocking actions can the brutality that undergirds everyday life be made vivid again.

f the imperative of the avant-garde is always to push he limit, someone had to take the notion of artists outdoing each other to its absurd extreme. Why not a Chinese artist, endowed like so many of his peers with he ability to see—and gleefully exploit—the inner workings of the global art system? In 1999 Zhu Yu b. 1970), a Chengdu native who graduated from the Affiliated High School of the Central Academy of Fine Arts in Beijing, covered a gallery floor with a long

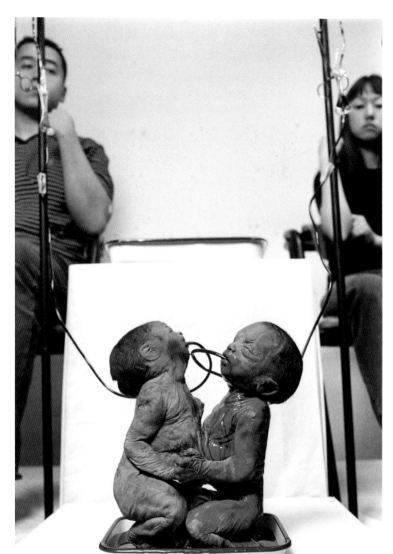

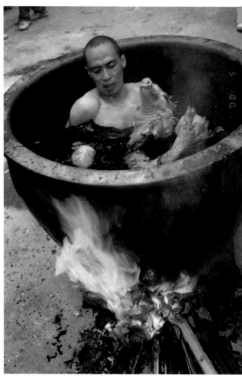

Liu Jin, *Large Soy Sauce Vat*,
2000. Nanjing, China

Sun Yuan and Peng Yu,
Linked Bodies, 2000

coiling rope that descended from the grip of a
preserved human arm strung to the ceiling by its
shoulder (*Pocket Theology*); one could not step into the
room without feeling a physical connection to the
dead. In 2000 Zhu had a patch of skin removed from
his own belly and grafted onto a side of pork (*Skin
Graft*; *page 107, left*). And that same year, describing the
gesture as a protest against groundless strictures
forbidding cannibalism, he cut a fetus specimen
into five handy pieces (two arms, two legs, one head-
and-torso) and gnawed—or at least pretended to

gnaw—the morsels for a still camera (*Eating People*;
page 107, right).

The photos resulting from Zhu's prank, shown in
sequence in the exhibition *Fuck Off*, stirred a small
journalistic furor and seem to have been the last straw
for officialdom. In 2001, citing a menace to social
order and the spiritual health of the Chinese people,
the Ministry of Culture banned exhibitions involving
torture, animal abuse, corpses, and overt violence and
sexuality. Any gallery or alternative space planning to

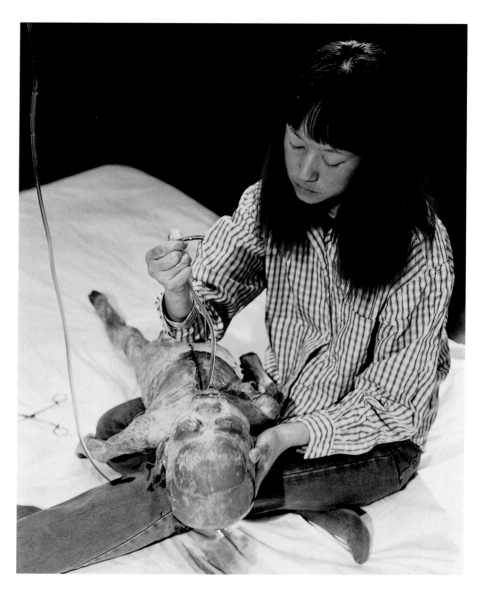

Sun Yuan and Peng Yu, *Oil of a Human Being*, 2000

mount a show during the run of the 2002 Shanghai Biennale was required to vet its contents with censors.

Exiles Return

A certain psychological arc is implicit in this development of mainland performance art—from utilization of one's own living body to the manipulation of objects to deployment of the dead bodies of others. The genre seems to have begun by claiming freedom and self-hood, passed into a critique of consumerism, and arrived at a commodification of others for the sake of notoriety and financial gain.

There is, however, another trajectory—a more triumphant one—that has carried several key Chinese performance artists to the West as self-exiles and brought them back, like returning global ambassadors, as art stars ready to re-embrace their native culture with a renewed understanding.

105

In 1998, Zhang Huan traveled to the U.S. to perform at *Inside Out*, the multivenue exhibition, curated by Gao Minglu, that belatedly opened American eyes to the full range of contemporary Chinese art. In the courtyard of P.S.1, the nude artist lay prone for ten minutes on a slab of ice that rested on a Ming-style daybed with seven dogs tethered to its frame (*Pilgrimage—Wind and Water in New York*). Zhang's original intention was to remain in place until the ice melted, gradually putting him in contact with a familiar cultural artifact, but the intense cold soon dissuaded him. The dogs, a late addition to the work's concept, were Zhang's comment on what he saw as the strangely intimate rapport New Yorkers have with their pets—one seemingly stronger than their human bonds with each other.

Zhang's sense of baffled suspension between two cultures would stay with him throughout his nearly eight-year sojourn in the West—despite a burgeoning career that took him to major galleries and museums around the world. *My America (Hard to Assimilate)*, first performed in 1999 at the Seattle Art Museum, involved sixty unclothed volunteers standing on a three-level scaffold and hurling pieces of bread at the seated artist (*page 108*). (Zhang was once, in New York, shocked to be mistaken for a homeless man and offered bread.) Related works in Australia, Belgium, Sweden, and elsewhere around the globe invariably combined conceptual audacity with psychological discomfort for Zhang, his audience, or both. *Pilgrimage to Santiago* (2001), for example, featured the artist swinging spread-eagle in a globular red metal cage in front of the cathedral in Santiago de Compostela, with a giant wall-relief cross looming behind him.

During this period, Zhang also undertook a number of high-intensity actions for the camera. *Skin* (1997) consists of twenty separate black-and-white close-ups of his visage. The viewer becomes, in effect, the artist's mirror, as he pokes, prods, and pulls at his own features like an overgrown adolescent making faces in a glass and asking, Who am I really? The photo sequence titled *1/2* (1998)—suggesting, perhaps, half Chinese or half human—presents him with face and torso spotted with black calligraphy and wearing the meat-flecked ribcage of a recently slaughtered pig (*page 110*). *Family Tree* (2000) consists of nine color close-ups, shot in changing light over the course of a day in Amherst, Massachusetts, showing Zhang's face progressively covered with calligraphic proverbs and folklore until his features meld at last into a Chinese version of blackface (*page 111, left*). Is the artist's self-hood obscured or affirmed by his cultural identity? It's a question repeatedly raised—and never definitively answered—by Zhang's slyly ambiguous work.

My New York, a performance conducted at the 2002 Whitney Biennial just seven months after the 9/11 attacks, found Zhang posing in a superhero suit of raw meat, then releasing white doves on the streets of the Upper East Side (*page 111, right*). The vulnerability of even the strongest flesh, or empire, was later reiterated in *My Rome* (2005), performed at the Capitoline Museum, where the artist, wearing only a white sarong, draped and balanced himself—in an implicit dialogue with Western classicism—on large-scale Roman deity sculptures. In the more peculiar *Window* (2004), shot in Shanghai, the marmoreal gods were replaced by a live donkey, a more elemental pairing. Zhang's involvement with sculpture dates from at least 2000, when he made a gilt cast of himself and festooned it with disconnected hands for the performance *Rubens* in Ghent. *Peace* (2001), commissioned by New York's Creative Time, included a bronze bell, covered with calligraphy, for which another gilt cast of the artist served as the striker. But it is with his return to China in 2006 that a giant leap in scale took place.

Zhang now presides over a 75,000-square-foot art production complex in Shanghai, where eighty to a hundred assistants—who live on-site in dormitory housing and are fed three meals a day—work in teams to produce the artist's woodcarvings, prints, paintings, and sculptures. Intrigued by the fragments of Buddhist statuary that he found in open markets during his travels to Tibet, Zhang has begun to create monumental hollow-copper versions of the holy sage's body parts. One example is a twenty-one-foot-long forearm and hand (*page 109, bottom*), another is a leg about nineteen feet long with an effigy of Zhang's head protruding from the foot. The Memory Doors series is relatively mundane: old photos, collaged and transferred to antique wooden doors that are then partially incised with scenes relating to the artist's provincial upbringing in China's precapitalist era.

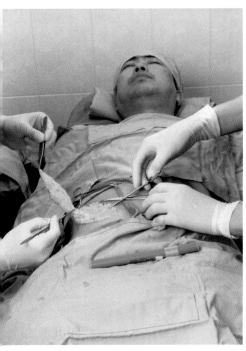

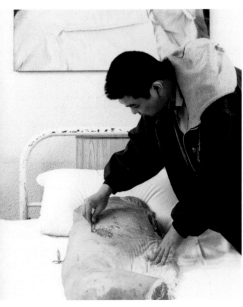

Zhu Yu, *Skin Graft*, 2000

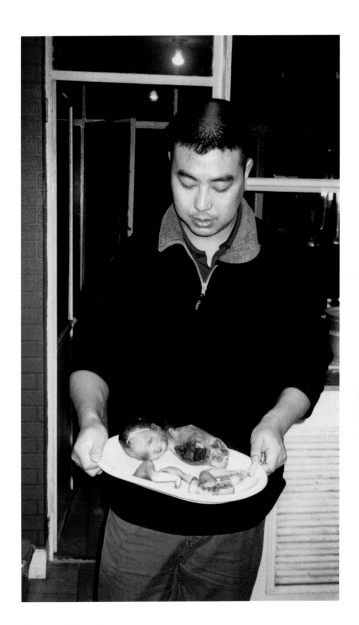

Zhu Yu, *Eating People*, 2000

107

Zhang Huan, *My America*
(Hard to Assimilate), 1999.
Seattle Art Museum

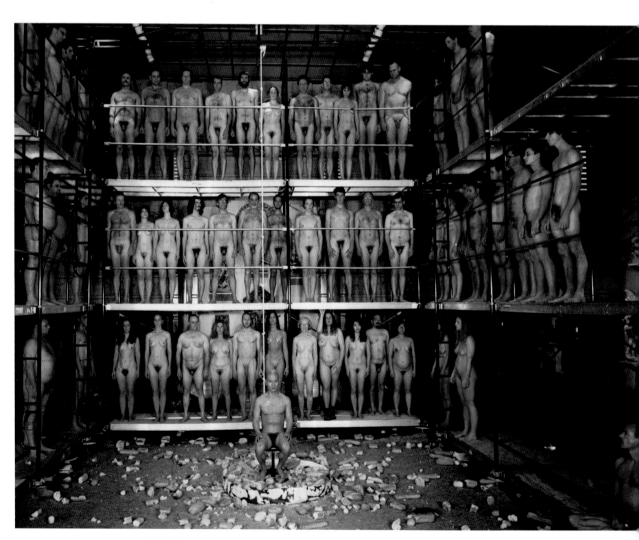

Zhang Huan, *Long Ear Ash Head*, 2007. Ash-covered steel

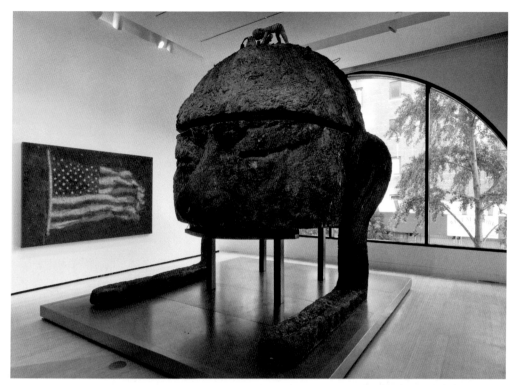

Zhang Huan, *Fresh Open Buddha Hand*, 2007. Copper, 142 x 640 x 170 cm

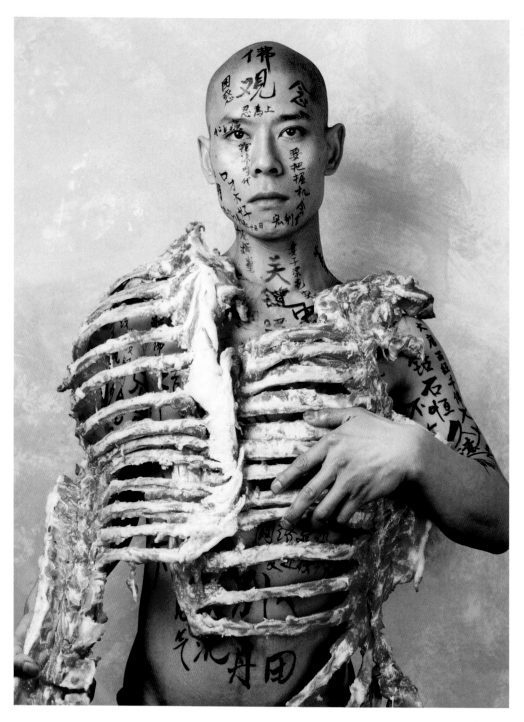

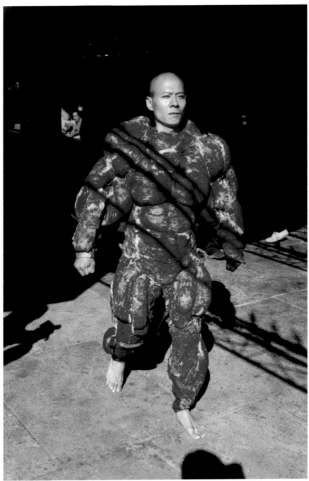

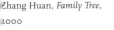
Zhang Huan, *Family Tree*, 2000

Zhang Huan, *My New York*, 2002

Much more arresting are works like *Ash Head No. 3* (2006), an eighteen-inch-high bust of Zhang in wood and iron covered with ash gathered from incense burners in Buddhist temples. More than twelve feet high, *Long Ear Ash Head* (2007), made of ash-covered steel in several sections like the slightly separated plates of a skull that houses an outsized brain, bears Zhang's facial features, along with the long earlobes associated with the Buddha's origins as an earring-wearing young noble, and a baby figure clambering on the gargantuan forehead (*page 109, above*). Bracketing the sculpture on the gallery walls in Zhang's 2007 retrospective at the Asia Society in New York were two ash-on-linen paintings—one depicting the Chinese flag, one the American. In this configuration of works, Zhang's self-identification as a spiritual messenger between two cultures seemed at last explicit and complete.

At an opposite pole from the earnest Zhang Huan is the witty Ai Weiwei (b. 1957) an artist, architect, designer, and social commentator whose works invariably carry an ironic charge. His "performance," in effect, is his life. (A modernist way of living, he has said, is China's potential salvation.) Son of the famed poet Ai Qing, who was sent into provincial exile during the late 1950s anti-rightist campaign, Ai returned with his family from the remote Xinjiang autonomous region (bordering Tibet, Mongolia, Russia, and Kazakhstan) to his natal Beijing in 1978. After a few terms at the Film Academy, he dropped out and joined the Stars group—displaying works that

111

Ai Weiwei, *June, 1994*

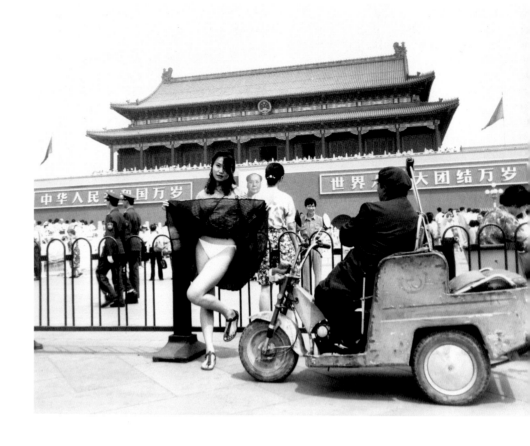

Ai Weiwei, *Droping a Han Dynasty Urn*, 1995

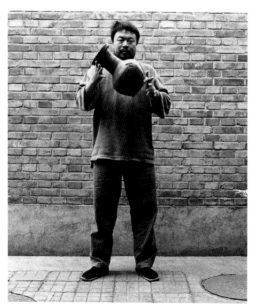
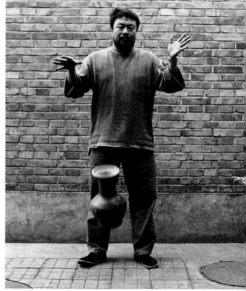

112

ielded traditional Chinese painting with Post-
impressionism, but above all enjoying the group's
insouciance and the ripples it caused in officialdom. In
1981 Ai went to New York, studying at Parsons School of
Design without taking a degree, living in an East 7th
street basement, hanging out with Hsieh Teching (the
Taiwanese artist known for endurance performances
such as voluntarily residing in a cage for a year), and
absorbing the influence of figures like Duchamp, Cage,
Beuys, Johns, and Allen Ginsberg (who befriended him
in gratitude for his father's hospitality during Ginsberg's
travels in the PRC). He returned to China in 1993.

Ai's first truly experimental works paid little heed to
the struggles of his Chinese compatriots during the
1980s. Instead, his pieces were conceptual and funny:
for example, a coat hanger twisted to yield the profile
of Duchamp (*Hanging Man/Duchamp*, 1985); a violin
with a shovel handle for a neck (*Violin*, 1985); a rain-
coat with a built-in condom flopped out though an
opening in the front (*Safe Sex*, 1986) and two sewn-
together shoes headed in opposing directions (*One-
Man Shoe*, 1987).

Yet once Ai was back in the People's Republic, a sense
of cultural specificity returned, only to be transgressed.
In 1993 he began a long installation series in which
ancient Chinese pots were covered with white or fluo-

rescent paint that obliterates their original markings, or
are updated with Coca-Cola and other global brand logos.

The provocative *June 1994* photo action, executed five
years to the month after the Tiananmen massacre,
shows leggy fellow artist Lu Qing (now Ai's wife)
lifting her nearly transparent skirt as she stands, bikini
panties revealed, in front of the Gate of Heavenly
Peace at the entrance to the Forbidden City (*opposite*).
The famous portrait of Mao—who was puritanical in
his social policies but known to frequently rejuvenate
himself with bevies of compliant young women—
stares out at us over her left shoulder. To one side, two
dutiful men in uniform walk away obliviously; to the
other, a disabled cadre in Cultural Revolution garb, his
crutches propped in the motorized cart he drives,
looks on in impotence. With the secret site of power
thus exposed and an emergent liberality calmly
flaunted, the viewer, like the outside world as a whole,
is at once welcomed and challenged by this embodi-
ment of the New China.

The same year, Ai issued his *Black Cover Book*, a
compendium of artists' documents solicited from
throughout the PRC and interlarded with texts from
Duchamp, Warhol, and other Western art figures.
Despite being menaced from official quarters, Ai went
on to produce the *White Cover Book* in 1995 and the
Gray Cover Book in 1997. His response to cultural
authority, and with it an overly venerated past, is
encapsulated in his 1995 photo action *Dropping a
Han Dynasty Urn*, in which he released his hold on a
valuable antique (or was it—this being China and the
artist being Ai Weiwei—a clever fake?), allowing the
pot to smash in fragments at his feet (*opposite*). In a
similar vein, the photo series A Study of Perspective
(1995–2003) documents Ai's hand flipping the bird
to such loci of overweening cultural-political pride
as Berlin's Reichstag, Tiananmen Square (*page 12*),
the Eiffel Tower, and the White House. Since 1997,
Ai has had various pieces of Ming and Qing dynasty
furniture cut and rejoined in ways that render them
useless and baffling—in other words, pure sculptural
objects that reflect present-day distortions of Chinese
tradition.

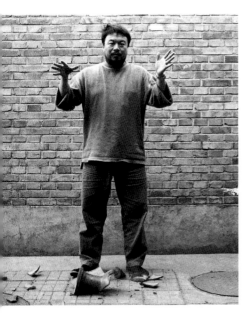

Ai began to have a direct effect on exhibitions in the
PRC when he founded the nonprofit China Art and
Archives Warehouse in Beijing in 1997, and on archi-

tecture when, in 1999, he designed his own house. In 2000, along with independent curator Feng Boyi (also his sidekick in the Black, White, Gray book endeavor), he organized the notorious *Fuck Off* exhibition. Today Ai's elegantly austere gray-brick structures, accomodating both residences and galleries, dot the trendy art districts of Beijing. His design firm, Fake—its Chinese pronunciation, *fa-ke*, sounds like "fuck" in English—churns out wide-ranging projects, and Ai has served as a consultant to the architectural firm Herzog & de Meuron on the "bird's nest" design of the Beijing Olympic Stadium.

While impishly playing the roles of senior artistic guru, advisor to visiting collectors, and prolific, outspoken blogger, Ai also continued to turn out conceptual sculpture of a high order. The self-referential *Concrete* (2000), a forty-foot-high concrete letter C,

recalls the architectural devices of Tadao Ando and Louis Kahn. *In Between* (2000) is a room-size cube inserted at a cocked angle between two floors of a residential building. Lighting fixtures of the sort ostentatiously illuminating new upscale hotels in China are spoofed in the seventeen-foot-high *Chandelier* (2002). Precious woods and venerable joinery techniques were used to make the thirty-one-inch-high *Map of China* (2003). *Forever* (2003), a three-tier circle of forty-two interlaced bicycles combines references to China's most popular bicycle brand and Duchamp's *Bicycle Wheel* with a visual pun on cyclical perpetuity (*below*). *Monumental Junkyard* (2006) looks like a pile of discarded doors replicated in noble white marble. A floating version of Tatlin's unbuilt *Monument to the Third International* is draped with glittering glass for the corkscrewed, twenty-three-foot-high *Fountain of Light* (2007).

Ai Weiwei, *Forever*, 2003.
Bicycles

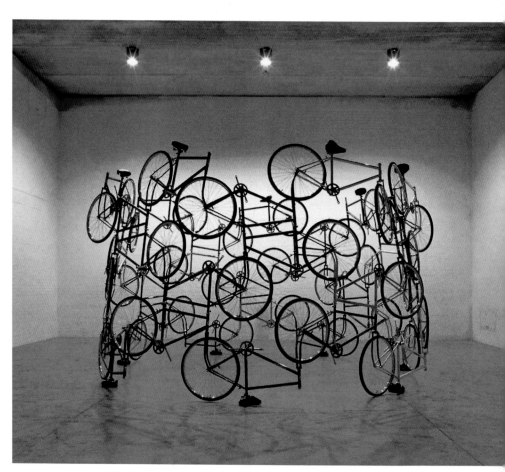

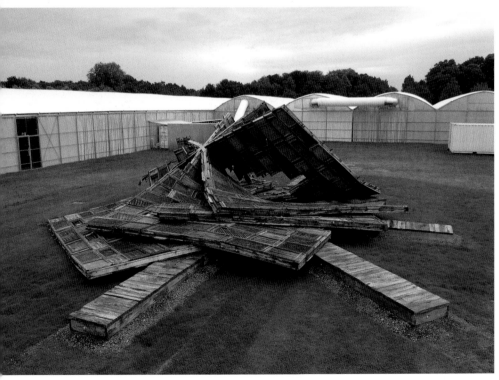

Ai Weiwei, *Template and Crashed Template*, 2007. Installation of windows and doors from demolished Ming and Qing Dynasty houses, Documenta 12, Kassel

Nevertheless, Ai's proclivity for concept over materiality, for performative gamesmanship over tangible artwork was clearly demonstrated in the summer of 2007 by his two major pieces for Documenta 12. When *Template* (his towering construct of wooden doors and latticework windows from Ming and Qing dynasty houses) collapsed in a windstorm, Ai responded by declaring the resultant whorl-shaped debris pile an aesthetic improvement (*page 115*). *Fairytale*, an even more ambitious project, consisted of 1,001 Chinese nationals brought to the Kassel, Germany, exhibition site in changing groups of 200 to 250 at a time. The visitors stayed in dormitory housing with Ai-designed furnishings, took communal meals,

sat in some of the 1,001 antique Chinese chairs Ai had installed throughout the premises, and generally just hung out. Their presence—and, equally, the very idea of their coming—was the performance: a mockery of the old Yellow Peril bugaboo and a preview for both Western and Eastern visitors of a major cultural mixing soon to come.

In 2009, Ai's provocations turned more somber with *Snake Ceiling*, a serpentine ceiling installation composed of backpacks like those found scattered in the ruins of schools following the Sichuan earthquake of the previous year (*opposite*). His *Sunflower Seeds* (2010; *below*), an installation comprising millions of ceramic seeds, evoked China's massive population, both living and dead—and the policies that affect birth and mortality. Virtually all of Ai's objects and acts argue that factuality is never more than half the story. Our experience and the meaning we derive from it depends equally on how we construe the facts—on interpretations that are not simply deduced but, in part, willfully constructed. This approach is especially—almost paradoxically—evident in the "conceptual" photography that predominates among avant-garde practitioners in the New China. Mind triumphs, as we will see in the next chapter, where the raw object and retinal passivity might otherwise be expected to prevail.

Ai Weiwei, *Sunflower Seeds*, 2010. Porcelain and paint; 100 million sunflower seeds. Installation view, Tate Modern, London, 2010

i Weiwei, *Snake Ceiling*,
009. Backpacks, approx.
8 cm (h.) x 900 cm (d.)
verall. Installation view,
Mori Museum, Japan, 2009

PHOTOGRAPHY

CHAPTER 4

Zhang Dali, *N.9.1952 the First Sport Meeting of the National Army*, 2006

Photography came to China in the mid-nineteenth century with the intruding Western powers. Despite efforts by the Qing authorities to stem its alien influence, there was little popular resistance to its magic. Foreign photographers (including a number from Japan) imitated traditional Chinese scene painting, made architectural studies, produced portraits of individuals and social types, and sometimes constructed fanciful tableaux. Soon Chinese practitioners were doing the same. By the early twentieth century, China had not only commercial studios but also photojournalism and art photography. But pure aesthetics were increasingly submerged from the 1930s onward, as first war and then party-directed "progress" and ideological purity imposed their imagistic regimes. From midcentury on, Mao's government controlled the country's illustrated magazines and its professional photographers' association.

Reality—past, present, and future—was extremely malleable under this system. Zhang Dali's installation *A Second History* (2005–6) (*left*) displays propaganda photos as they appeared in doctored form in publications such as *People's Pictorial*, *Liberation Army Journal*, and *China Pictorial*, matched with their unaltered source images. In every case, something crucial has been changed: a figure from one shot is transposed to the background of another; a smiling portrait of Mao is added to the wall of a factory school; distasteful sights or politically undesirable individuals are deleted from views of the PRC's Communist utopia. In one particularly memorable example, Mao's body lies in state before a semicircle of party dignitaries. In the original photo, the ranks of shoulder-to-shoulder comrades, their heads respectfully bowed, are unbroken. But in the published version, dark gaps appear. Certain disgraced individuals have disappeared, leaving only a smudgy darkness in their place. Almost as chilling as the juxtaposed photos themselves are the texts—sometimes from English or French editions of the Chinese journals—which either expand the deception or succumb to it completely. These passages are an implicit reminder of the political gullibility that once made Maoism a secular religion in China and a romantic creed among radical leftists in the West.

Just how ghastly that error was is brought home in the 2003 memoir *Red-Color News Soldier: A Chinese Photographer's Odyssey through the Cultural Revolution*

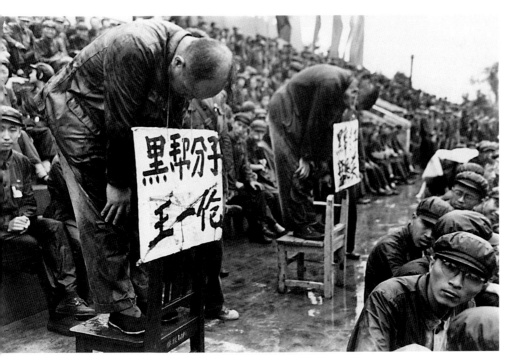

Li Zhensheng, *Denounced as a rich peasant, Deng Guoxing bows before a sea of accusers during a three-hour-long "struggle session."* Ashihe commune, Acheng county, Heilongjiang Province, May 12, 1965

121

Yuan Dongping, *Mental Patients in China*, Tianjing, 1989

Yuan Dongping, from the series Mental Hospitals, 1989

by Li Zhensheng (b. 1940), who worked for the *Heilongjiang Daily* for eighteen years starting in 1966, when the Cultural Revolution began. As a member of the Red Youth Fighting Team, he wore an access-granting armband emblazoned with the words appropriated for his book title. The pictures he took were, of course, carefully winnowed—and sometimes altered—by his editors in accord with party goals. At great personal risk, Li managed to secrete some 30,000 scrupulously catalogued negatives. The black-and-white images recently published with his personal account of the Cultural Revolution period are a chronicle of national psychosis. We see educated youths being trucked off to learn peasant virtues by laboring in the countryside; a man denounced as a rich peasant cringing before a massive crowd in the midst of a three-hour "struggle session" (*page 121*); a provincial governor humiliated for hoarding riches such as three wristwatches; monks forced to hold a banner that reads "to hell with the Buddhist scriptures—they are full of dog farts"; and various "criminals," illicit lovers, and political miscalculators led out to the fields and shot. Any individual found to be a rich peasant, landlord, rightist, counter-revolutionary, or criminal was classed as "black" and subjected to harassment and legal sanctions.

This state of affairs changed dramatically on January 8, 1976, when Premier Zhou Enlai, seen by many beleaguered Chinese as the one leader perhaps strong and sensible enough to rein in the Red Guards, died of bladder cancer. (Some historians contend that Mao deliberately denied Zhou proper medical treatment, not wanting to be succeeded—or immediately displaced in the people's affection—by his longtime comrade.) After the official funeral, Mao's wife and her accomplices in the Gang of Four tried to suppress any further commemoration of Zhou, whose statesmanship had been admired even by his staunchest adversaries in the West.

At least one white wreath appeared briefly at the base of the Monument to the People's Heroes in Tiananmen Square on March 23. But on April 4, the date of the Qingming Festival (tomb sweeping day, China's traditional Memorial Day), a crowd of over 100,000 gathered in the square to mourn Zhou and festooned the monument with hundreds of wreaths. Moving among them were many professional and

amateur photographers, availing themselves of equipment that had only recently become readily available in the PRC.

On April 5 armed police and militia swept into the square, arresting hundreds and seizing cameras, film, and tape recorders wherever they could. Their actions gave rise to a name and a memory—the April Fifth Movement—as well as an underground network among some of the photographers who had managed to hold onto their negatives of the events. As scholars Wu Hung and Christopher Phillips (discussed below) have vividly recounted, history was turning the protesters' way. Mao died on September 9, 1976, and the Gang of Four was arrested on October 6. By December 1978, with the approval of the newly elevated Deng Xiaoping, the maverick photographers were able to have an exhibition (*A Premier for the People, A People for the Premier*) at the National Art Museum. In January 1979, they published *People's Mourning*, a volume of 500 images, drawn from a pool of roughly 25,000, documenting the April 5 protests.

Tired of political buffeting—they were now welcomed into the official Association of Chinese Photographers and lionized by a political leadership trying to strengthen its own position by fostering criticism of the Cultural Revolution—principals Wang Zhiping and Li Xiaobin decided to forgo explicitly *engagé* work in the future, opting instead for a more broadly humanist art photography approach. They founded the April Photographic Society and mounted the immensely popular *Nature, Society and Man* exhibition—crammed with formalist and human-interest images—in a building in Zhongshan (also known as Sun Yat-sen) Park. The society's two subsequent shows, in 1980 and 1981 (the latter at the National Art Museum), along with several art-photography discussion groups thus fostered, provided precedents for the photographic innovators of the 1980s.

The emerging practitioners were much more sophisticated in both technique and pictorial thought, benefiting from the impact of the last two *Nature, Society and Man* shows, which traveled extensively throughout China, and from the country's new influx of visual and theoretical material. Clubs, groups, mini-movements, and illustrated publications of every persuasion proliferated, with documentary work gaining greater prominence during the course of the decade as a kind of photographic corollary of nativist painting and Scar Art. Some photographers even began to gain exposure in art venues abroad—only to have their impetus broken and their imagistic freedom curtailed following the June 4, 1989, Tiananmen Square massacre.

As was the case with other mediums, photography began to regain its avant-garde momentum after three or four years, when restrictions slackened somewhat and experimental artists began to find their confidence—and each other—in marginal locales such as Beijing's East Village. An especially close rapport developed between photographers and performance artists, since dramatic images taken by the performers

and their friends—or by peers who increasingly considered themselves to be camera artists—helped promulgate the actionists' works and semimythic reputations.

Regrettably, as critical and commercial response built over the decade, a number of bitter disputes erupted regarding these pictures, with both actor and photographer laying claim to authorship, critical merit, and profits. Which was the work of art—the performance or the photograph? If both, then who owns the image? In practical terms, the solution was that a few photographers who established a name for themselves (for example, Rong Rong) were able to control the images they had taken of their audacious bohemian friends, while the performance artists who gained renown (for example, Zhang Huan) started relying on spouses and assistants, or making formal contracts with hired photographers.

The other great struggle was—and is—with the pressures of officialdom, commercialism, and social propriety. Every photo artist in China today must decide whether to cast his lot with tradition, perhaps "updated" by the kitsch-modernist tastes of the central government, or to sacrifice career safety (academic positions, official commissions) and take a wild ride with the avant-garde. For photographers this choice was cast in stark terms not long ago by the evolution of the Pingyao International Photography (PIP) Festival, held annually in the 2,800-year-old walled city of that name, a UNESCO-listed world heritage site in Shanxi Province.

Cofounded in 2001 by eminent PRC practitioner and *People's Photography* editor Si Sushi together with French independent curator Alain Jullien, the festival began as an effort to place recent Chinese photography in a global context and grew sharply in stature in 2002 when Gao Bo, a photographer and architectural designer, was invited to organize a large section of new experimental work by Chinese artists. The results, though impressive to foreign critics, so dismayed local officials and conservative photo unionists that in 2003 the so-called conceptual photography component was eliminated and replaced by a massive resurgence of historical, news, fashion, travel, and "beautiful scene" images. When it became clear that the 2004 installment of the PIP would follow the same model, Jullien withdrew to start an alternative event, an international biennial devoted exclusively to progressive fine-art photography, inaugurated in 2005 at the Guangdong Museum of Art in Guangzhou.

By then, however, China's experimental photographers had gained international attention, and their newfound market viability liberated them to pursue their conceptual projects without undue livelihood concerns. In 2004 University of Chicago scholar Wu Hung (whose expertise encompasses both classical and contemporary Chinese art) and Christopher Phillips, curator at the International Center of Photography in New York, co-organized the groundbreaking *Between Past and Future: New Photography and Video from China*, a sixty-artist survey that toured seven international venues over a two-year period. In general terms, post-Tiananmen experimental photography

Zhuang Hui, *Factory Floor*,
2003. Polystyrene
installation

Zhuang Hui, *Military
Officers and Soldiers,
PLA Regiment 51410, Fourth
Artillery Squadron, Hebei
Province, Handan City*, 1997

公元一九九七年七月二十三日河北省邯郸市

Wang Ningde, *Dancing in the Outskirts of the City*, from Dancing in Small Towns series, 2001

tends to shift individually and collectively from documentation to artifice, from candid reportage to elaborately staged mise-en-scène. Photographers no longer merely wish to record, or even savor, life as it is; they seek to make a visual statement, to interpret and envision. Their striving for individual control is understandable given China's overwhelming social changes and lack of political redress. At times, these photographers may too closely emulate that of such Western artists as Andreas Gursky, Jeff Wall, and Gregory Crewdson, or dally a little too coyly with the tastes of international collectors. Yet their work, by virtue of its personal idiosyncrasy, continues to be a subtle protest against the regimentation of vision and thought, whether by Communist authorities or the global market.

Constructed Documents

A critical outlook—a quality systematically denied to red-color news soldier Li Zhensheng and his comrades—could be expressed in public photography only in the post-Mao era. The difference is blatantly clear in the work of a figure like Yuan Dongping (b. 1958), who grew up in Beijing during the Cultural Revolution and eventually—after graduating from the Central Academy high school, serving in China's navy, taking a degree from Beijing Normal University, and working for two years in the Chairman Mao Zedong Memorial Hall—became an editor at *Minorities Pictorial*, where he began by documenting everyday city life in the series Beijing Streets (1987–88). In 1989, along with Lü Nan (his partner in the earlier project), he undertook Mental Hospitals (*page 122*), a photographic investigation of the country's nearly five hundred asylums, engaging the patients with great empathy while

126

Wang Ningde, *Some Days No. 25*, 1999

exposing their wretched living conditions. He repeated this approach in The Rural Poor, though, this time, with greater self-consciousness on the part of his stiffly posed subjects.

Like Yuan at his best, letting the oddly charming naturalness of the mentally afflicted play out before his lens, Song Yongping (b. 1961) compels the viewer's respect for his subjects through an extreme, unblinking candor. A graduate of the painting department of the Tianjin Academy of Fine Arts and long a resident of Taiyuan, Shanxi Province, Song is best known for his mercilessly frank black-and-white series My Parents of 1998–2000 (*page 123*), which contrasts portraits of his father and mother at the time of their marriage with shots of them, years later, suffering the ravages of illness and age in a cramped, desolate apartment, with Song as their dutiful caretaker. So morose are the two (though touchingly tender with each other), so inured to the blandishments of the Cultural Revolutionary past as well as the go-go capitalist present, that they can show virtually anything about their life without shame or loss of innate dignity: sitting on a toilet; standing side by side, sad-faced, in outlandish wedding gown and tux; or stripped to their underpants, displaying sagging breasts, flabby knees, swollen bellies, surgery scars, and a man's oversized catheter. These are ancestor figures for a bleak, non-Confucian age.

More jocund, in a deadpan way, is the work of Beijing-based Zhuang Hui (b. 1963), the son of a workaday photographer in Gansu Province, bordering Inner Mongolia. Zhuang, who was seven when his father died, eventually took on the role of visual chronicler—but with his own sardonic twist. His best-known works are black-and-white panoramic sweeps of assembled villagers, soldiers, or work-unit members, with

Hong Lei, *Chinese Landscape—Zhouzheng Garden, Suzhou II*, 1998

Hong Lei, *Autumn in the Forbidden City (East Veranda)*, 1997

Zhuang himself inserted at the right-hand extreme of the strip (*pages 124–25*). The images are shot with an old rotating camera while the subjects pose in curved formation around it. The resulting prints combine the format of an old-time horizontal scroll with the kind of working-for-the-Revolution content that Zhuang's father gathered in the post-1949 Liberation years. The irony is that the collectivism and solidarity implied by the depicted gatherings is already passé, as Zhuang's own incongruous presence attests. Indeed, during the same period that he was taking the Group Photo pictures (roughly 1993–2003), Zhuang was also shooting hundreds upon hundreds of bright-colored images for his Ten Years project: subway riders, shopkeepers, waitresses, farmers; tourist sites, factories, bridges—everyone and everything that makes up the ordinary, more individualistic New China. Additionally, Zhuang has created a kind of typology of his fellow citizens, with himself standing next to various workers, farmers, soldiers (*pages 124–25*), and children, both in loose-leaf series and in grid works.

A similar degree of intervention is evident in the work of Wang Ningde (b. 1972), a photography graduate of the Luxun Art Institute who now divides his time between the cities of Shenzhen and Guangzhou in semitropical Guangdong Province, bordering the South China Sea. While Dancing in Small Towns (2001) is a relatively straight black-and-white series documenting provincial entertainments (*page 126*), the series Some Days (1999–present) features people clearly instructed to perform for the camera: a Mao-suited man with rouged cheeks and dangling cigarette standing before a cumulus-cloud backdrop; a nubile girl covering one barely budding breast while huge flower images blossom behind her; a family apparently sleeping on an empty train (*page 127*); groups of identically dressed schoolchildren, eyes closed, all turning their heads in the same direction.

With an artist such as Hong Lei (b. 1960), we enter a different world altogether. In 1997, the native of Jiangsu Province, who had graduated from the Nanjing Academy of Arts and studied printmaking at Beijing's Central Academy, produced two color photographs of a dead bird, wrapped in a necklace, lying on the verandas of the Forbidden City (*left, below*). The deliberately scratched images, evoking old glass-nega-

ve prints, are eidetic. Employing a ground-level vantage point and a shallow depth of field, Hong has created the sense of infinitely receding space and time, as though the dead bird in the foreground—the only part of the composition in focus—were suspended in the long continuum of Chinese history.

Anyone familiar with tradition knows, however, that the birds repeatedly depicted in the past have been very much alive—tokens of earthly beauty and joy, delivering hints of an enviable fate. Hong's bejeweled creature, lying in its own blood in front of receding columns that open onto an empty courtyard and a distant imperial palace, is like a canary that has died in an eerily decadent mineshaft. As beautiful as a lost illusion, the picture—like the sacrificed bird itself (shades of ancient divination)—bodes ill. Something is rotten in the halls of power beyond Tiananmen Square.

The theme of loss and foreboding has continued throughout Hong's career, as his pictures become ever more skillfully contrived. Among the image groupings he has produced while still living in his native Changzhou are flowers with dead birds and oversize insects (ca. 1998, 2005); traditional pavilions and gardens hand-tinted with blood-red waterways and skies (his Chinese Landscape series, 1998; *opposite, above*); and scholar's rocks seemingly slashed and oozing blood (the series Taihu Stones, 2006).

In his oft-expressed abhorrence for the modern, globalized world, Hong has also staged costumed scenarios whose titles are as elaborate as their melding of present and past, for example, *An Imitation of Song Dynasty Painter Liang Kai's "Painting of Sakyamuni Coming out of Retirement"* (1998), featuring a decidedly frazzled-looking Buddha cloaked in red.

Xing Danwen, two untitled works, disCONNEXION series, 2002–3

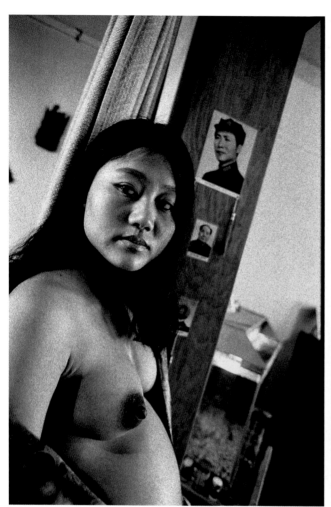

From Record to Dream

Many of China's most interesting "new" photographers occupy a territory between disclosure and invention, or have made a transition in their own practice from documentation to self-conscious image construction. Xing Danwen (b. 1967), who taught herself photography after graduating from Beijing's Central Academy in oil painting in 1992, began by shooting incisive studies of Tibetan villagers, Chinese coal miners, performance artists in Beijing's East Village, and various educated individuals who, like herself, were, as noted in the title of a 1995 series, Born with the Cultural Revolution. But her depicted peers have

only a vague, emotionally distant rapport with that era's history. In a typical "Born" image, a nude pregnant woman lies on a couch beneath a half-fallen Chinese flag and a tacked-up picture of Mao (*above*).

Alienation of a different sort permeated the black-and-white Dislocation project (2002), which incorporated such elements as the 1999–2000 Scroll series of blurry, filmstrip-like images from Beijing—moody swimming scenes, shots of nearly empty streets—shown with a ten-minute video, *Sleepwalking* (2000), composed of equally meditative stills from New York, fading in and out of each other to a mix of traditional Chinese and electronic music. (Xing studied at the

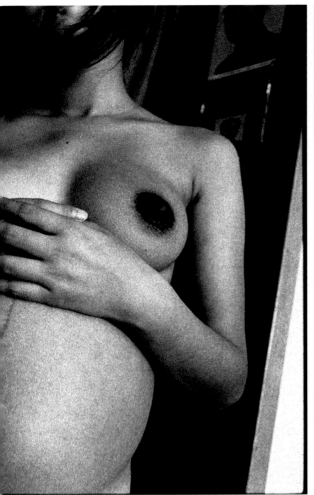

Xing Danwen, Untitled,
from Born with the Cultural
Revolution series (triptych),
1995

chool of Visual Arts in Manhattan from 1998 to
001, receiving an MFA.)

olor and social critique burst into the artist's oeuvre
ith the 2002–3 disCONNEXION series of sharp-
ocus closeups of high-tech, nondegradable waste
ircuit boards, plastic cords, computer housings)
outinely shipped from the West for disposal in Asia,
here many of the products were originally assembled
age 129). Strangely, the protest against global
conomic disparities is almost lost in the sheer beauty
f the images.

Rong Rong (b. 1968), Beijing's premier East Village
documentarian, is a former Fujian Province farm boy
and grocery-store clerk, originally named Li Zhirong,
who has become one of the most refined and influen-
tial art photographers in the People's Republic. His
portfolio *Rong Rong's East Village 1993–1998* contains
stark black-and-white images of the wretched environs
and the torturous 1993–94 performances of Zhang
Huan, Zhu Ming, Cang Xin, and others. In 1996–97
he photographed partially demolished Beijing resi-
dences still retaining, here and there, tattered rem-
nants of the glamour-girl pinups that once brightened
their dark interiors and the desolate lives spent in
them (*page 132*).

131

Rong Rong, *Ruin Picture no. 5*, 1996

Concurrently, Rong Rong co-produced with Liu Zheng the journal *New Photo* (1996–98), which in its four issues presented some of the best experimental photography of the day, including works by Zhuang Hui, Gao Bo, Qiu Zhijie, and Zhang Guogu as well as Hong Lei's epochal Autumn in the Forbidden City images. With no external funding and no distribution permit, the pair would make twenty or thirty black-and-white photocopies of each issue and hand them out to friends.

In 1999 Rong Rong met (and soon married) the Japanese beauty Inri (b. 1973), who had graduated from the Nippon Photography Institute in 1994 and quickly established herself as both an on-staff news photographer and an artist. Working together since 2000, the two have made archetypical nude studies of themselves in Beijing industrial interiors, in snowy fields near Mount Fuji, and at various dramatic locales in Europe and Scandinavia. The eroticized compositions, with nude bodies elegantly posed amid overpow-

ering settings, are often hand-dyed to haunting effect (*opposite*). The much less theatrical series Liulitun (2006) wistfully examines another now-defunct low-rent "village" in eastern Beijing, where the two lived from 2000 to 2002. In 2007 Rong Rong and Inri, as they are known, opened the Three Shadows Photography Art Center in the Caochangdi district of Beijing.

Another husband-and-wife team whose work has evolved well beyond reportage is Shao Yinong and Mu Chen (b. 1961, 1970), trained, respectively, at the Normal University, Qinghai, and People's University of China, Beijing. They, too, live in Beijing and have worked together since 2000. Their most notable early project is *Family Register* (2000), a nearly 150-foot-long, sepia-toned photo scroll portraying myriad frontally posed relatives at various stages of life.

Jarring for most viewers, then, are the hand-dyed Childhood Memento images produced in 2001: lone, naked young children, male and female (the Adams and Eves of the New China?), digitally inserted—out of scale, sometimes with their clothes at their feet—standing before cultural monuments of the sort every good parent in China is urged to visit with their (preferably only) child. The sense of something being subtly amiss is further conveyed, in historical retrospect, in the series Fairy Tales in Red Times (2001), in which one can just make out Mao reading a speech to assembled masses or white-shirted stalwarts marching with red banners, the colorful scenes pixelized to the point of near-abstraction. The 42-foot-long *Return to 1994*, also from 2001, strings together tattered and chemically aged close-ups of young artists and intellectuals, the kind of individuals—disdained in Mao's heyday—who gave birth to post-Tiananmen experimental culture.

Shao Yinong and Mu Chen's finest images are the 2002–4 Assembly Hall series (*pages 134–35*) which consists of interior studies of former Cultural Revolution meeting places, once the center of daily collectivist life (including production quota reviews, propaganda talks, cultural events, and grueling "self-criticism" sessions), now abandoned or put to more benign uses. The halls—some derelict, some richly refurbished—bear, by contrast and implication, mute testament to the utter transformation of a world.

Rong Rong and Inri,
n Fujisan, Japan, no. 1,
001

Shao Yinong and Mu Chen,
The Assembly Hall—
Wenchang Temple in Xingguo,
2003

Hai Bo (b. 1962) has practically patented the theme of life's transience. Perfectly balancing documentation with invention, the Beijing artist (originally from Jilin Province, where he graduated from the Fine Arts Institute) has developed a signature procedure: he finds old group portraits depicting families, school classes, or military squads, then he rounds up the surviving subjects into a perfectly matching composition, shot decades later (*page 136*). The contrast between the original, often sepia-hued, image and its more recent reconstruction bespeaks not merely

changing fashions (many of the sitters wear Mao garb in the early shots and Western-style attire in the new) but the ravages of time itself, as smooth young faces have become furrowed, sallow, and careworn. Most poignantly, the diptychs occasionally isolate death itself, admitting a void among the aging subjects where one of the shining youths once stood.

Hai clearly knows that parallel compositions can make details eloquent. *Dusk* (2002) juxtaposes three black-and-white triptychs, one each of his moribund grand-

134

Shao Yinong and Mu Chen,
*The Assembly Hall—
Renzhaiqian*, 2003

mother, ailing father, and healthy son, with each set of images combining head-and-shoulder shots with associated scenes: grandma's yard, dad walking down a country lane long ago, the semi-industrial view from the teenager's window. The Four Seasons (2003), a quartet of color images, shows the artist sitting under a spreading tree in a park as time has its way—spring, summer, fall, and winter (*page 137*)—with the leaves and vegetation around him. We are thus reminded, of course, that the same glorious but lethal process is at work within the human subject.

Yang Yong (b. 1975), by contrast, seems to specialize in the denial of mortality—or in channeling his horror at the thought into a desperate, fashionable revolt. A graduate of the Art Institute in his native Sichuan, Yang now lives in Shenzhen, a former fishing village that became an ultramodern metropolis virtually overnight, after China's central government decided in 1980 that a relatively laissez-faire Special Economic Zone was needed to offset—psychologically and commercially—the glittering success of nearby Hong Kong. Today Shenzhen, with a population of 10

million, is a welter of highrises and expressways, whose urban anomie is well captured in Yang's color photographs of jaded youths hanging out in hypernew interiors and soaring streetscapes that are somehow at once antiseptic and louche (*page 138*). The images in his Cruel Diary of Youth (2002–3) and related series, occasionally cluttered with construction materials and the vestiges of street-market life, are part Nan Goldin exposé, part *Vogue*-style drug-chic fantasy. Improvising their scenes, his models express both longing for a better life (equated with ever-greater affluence) and a willingness to wallow in an imperfect present, so long they can do so stylishly and with no discernible labor on their part.

Yang is a member of the first generation to be too young to have any memory of the Cultural Revolution. To them, it is as abstract as World War II is to American baby-boomers: an idea, not an experience. Even the later Tiananmen Square massacre may seem a strange anomaly of their teenage years. But for somewhat older artists like Mo Yi (b. 1958), authoritarianism is concrete. Born of Chinese parents in Lhasa, Tibet, and living now in the prefecture city of Tianjin, Mo expressed his solidarity with the students of the June Fourth Movement by parading through the streets with a white text-festooned banner and robe, his act a one-man lament (*It's Gone*, 1989). He was quickly fired from his job and placed under house arrest for four years.

Self-taught as a photographer—he played professional soccer for twelve years instead of completing high school—Mo has learned to get maximum pictorial effect from basic technical ploys. Nine years after Tiananmen Square he commemorated the event with two multi-image grids in which his identity is split and obscured by a pole inscribed on one side with the work's titular phrase, *Made by the Police Department*. At the other formal extreme, he has clicked away in black-and-white, using cocked angles, at people on the street and at fellow passengers on public buses, and even made random pictures every five steps with a camera strapped to his back. In the series It Is I (2003), a sad-eyed Mo, as if to deliberately refute any suggestion of self-effacement, placed his red-lit, bearded, sagelike visage front and center in multiple street scenes. Dog's Eye View-Red Scenes (2003; *page 139*) is a collection of shots from a low, doglike perspective, capturing bicycle wheels, women's legs, and so on, lit starkly red against a background of busy street life. Formalist exercise or political commentary? The now chastened and wary Mo is not likely to say.

The most accomplished photographer to move from reportage to pure image-construction, sometimes blurring the line between the two, is Liu Zheng (b. 1969), who was born in Hebei Province, grew up in the mining town of Datong in Shanxi Province, and studied optics at the Beijing Institute of Technology. From 1991 to 1997, he was a staff photographer for the *Workers' Daily*, published by the All China Federation of Trade Unions. His breakthrough independent series The Chinese (1994–2001), comprising 100 black-and-white images, manifests a composi-

Hai Bo, *They No. 5*, (diptych), 2000

Hai Bo, *Four Seasons:*
Winter, 2003

Yang Yong, *Orectic Hotel*,
2003

Mo Yi, *Dog's Eye View-Red Scenes, No. 6*, 2003

Liu Zheng, *Two Rich Men on New Year's Eve*, 1999, The Chinese series

tional finesse and a grasp of non-studio lighting effects that transcends photojournalism, in a manner reminiscent of W. Eugene Smith. Some of the pictures present vestiges of tradition: kneeling, white-garbed women mourning in a field; garishly made-up male opera singers. Others offer a hint of social exposé: nouveau-riche Chinese businessmen celebrating New Year's Eve in feathered masks (*left, above*); prisoners lining up for their daily ration of water; and a handsome, one-armed miner, his torso bared, standing alone in a field. Still other images focus on artifice employed to convey historical truth: waxwork museum displays showing an emperor in bed with a courtesan, or victims strewn on the streets of Nanjing during the Japanese atrocities of 1937 (*left, below*).

Since his collaboration with Rong Rong on *New Photo*, Liu has moved steadily in the direction of theatrical stagecraft. Ornately costumed and choreographed—with no shortage of bare female breasts and pudenda—the series Peking Opera of 1997 (*opposite*) and Four Beauties (2004, *pages 142–43*) portray, respectively, sexy versions of theater scenes drenched in historical and mythological references, and episodes relating to the "four famous beauties" in early Chinese history (Xi Shi, Wang Zhaojun, Diao Chan, and Yang Yuhuan)—their stories rife with lust, political betrayal, and blood.

Enacted Images

The drive toward being the author of something wholly imaginary has led many of China's conceptual photographers to outright theatricality. Cang Xin (b. 1967), a Beijing artist originally from Heilongjiang Province (bordering Russia), can be considered either a photographer who performs or a performance artist who records his feats with exceptional photographic skill. As a denizen of the East Village, he made the large installation *Trample the Face* (1994), consisting of plaster casts of his face that were then shattered by being walked on (thus occasioning one of Rong Rong's most memorable images, Ma Liuming holding a broken plaster mask to his face), and participated—with Zhang Huan, Ma Liuming, Zhu Ming, and others—in *To Add One Meter to an Anonymous Mountain* (1995).

Liu Zheng, *Waxwork in the Nanjing Massacre Memorial Museum*, 2000, The Chinese series

Liu Zheng, *Peking Opera—*
Beating The Princess, 1997

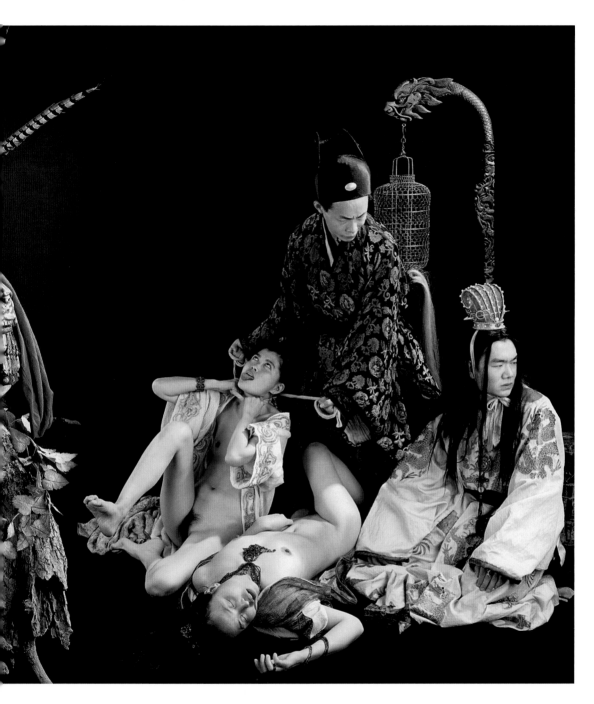

iu Zheng, *Four Beauties—*
Diao Chan, 2004

143

Since 1996, Cang has exercised his own form of shamanism (purportedly based on his belief that all things, living and inanimate, are endowed with souls) through ritualistic acts preserved in sporadic color series. For the Identity Exchange project, a semicomic update of August Sander's survey of human types, he stands side by side with people who have distinct social roles—junkman, bride, chef, restaurant hostess—wearing their identifying attire while they are stripped to underwear and bare skin (*opposite*). Each image is a visual inquiry concerning where the self truly lies—in the flesh, in such outward accoutre-

ments as dress and environs, in the roles we adopt and drop, or somewhere else entirely.

The series Communication finds Cang tasting, with extended tongue, literally anything he is presented: paper, candle flame, a handgun, or (in shots of the artist lying prone and spread-eagle) the pavement of London, Berlin, or Tiananmen Square (*below*). Besides playing on the notion that Chinese have the most diverse palette known to man, this radical gesture suggests that essences can be apprehended through our most culturally underrated sense. Moreover, the

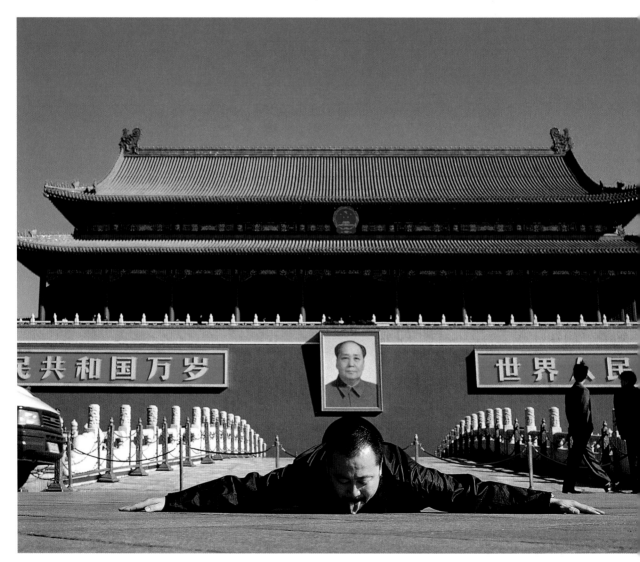

Cang Xin, *Beijing Opera: Identity Exchange*, 2006

Cang Xin, *Wedding Dress: Identity Exchange*, 2006

145

Chen Lingyang, *The Seventh Month*, Twelve Flower Months series, 2000

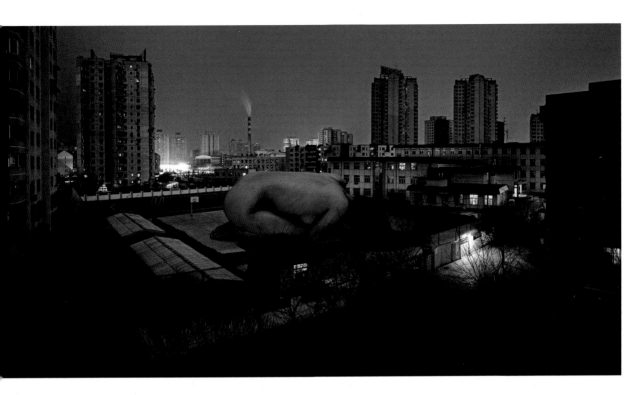

Chen Lingyang, *25:00, No. 1*, 2002

cenarios in which people are encouraged to present items for Cang to lick have some of the same challenging psychological dynamic as the nude Ma Liuming's invitations to pose with him, or Yoko Ono's classic *Cut Piece* (1964), in which audience members were prompted to come up and snip away portions of her clothing. The series called "Unification of Heaven and Earth" or "Man and Sky as One" (since 2002) centers on Cang's nude reclining body, shot from a considerable distance, communing with the elements in unlikely locales, such as a circle of fire on the glistening tundra under a radiant blue sky. Here the ethos of extremist performance is photographically enshrined in images that formally transcend their documentary function.

The body is also cannily employed by Chen Lingyang (b. 1975), a Zhejiang Province native who attended the Central Academy of Fine Arts and continues to live in Beijing. Having attained a succès de scandale upon her graduation with *Scroll* (1999), a nearly twenty-foot-long sequence of menstrual blood blots, she went on to produce her best-known photographic series, the calendrical Twelve Flower Months of 2000 (*opposite*).

Each of the twelve individually shaped images (except one) juxtaposes a different flower with a mirror of one kind or another, each mirror reflecting Chen's genitalia oozing with her monthly blood flow. Self-examination, linking up with traditional flower painting, becomes self-assertion: a declaration of the beauty and strength to be found in overcoming shame and celebrating one's natural cycles.

Chen's sense of the power innate in the female body, as well as its suppression in the male-dominated workaday world, is conveyed in the suite *25:00* from 2002 (*above*). These digital images, cast in a luscious day-for-night blue, depict her nude body draped, face down, over the roofs of buildings in cityscapes so dark and deserted that the giant figure is almost imperceptible at first glance. Great as the woman's potential power is here, she remains prostrate and perhaps is only dreaming: the twenty-fifth-hour time designation of the title, though easily translatable as 1:00 A.M., does not officially exist.

Huang Yan (b. 1966), living in Beijing and occasionally lecturing at his alma mater, Changchun Normal

147

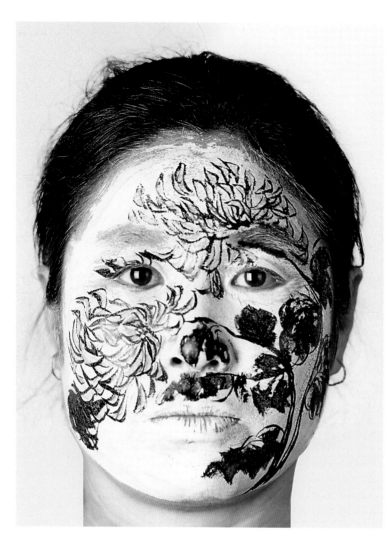

Huang Yan, *Face Chrysanthemum*, 2004

Academy, in the capital of his native Jilin Province, makes even more direct use of the body. A conceptual artist whose works range from mail-art hoaxes to paintings on ceramic to ideograms formed from pieces of decaying meat, he is now inescapably identified with his color photographs of people whose bodies or faces have been painted with traditional Chinese landscapes. In all these frontally posed images—whether the subjects are schoolchildren, voluptuous nude women, older adults, or whole families—personal identity seems locked in struggle with cultural signifiers that are inscribed on the flesh (*left*).

The most iconic series, Chinese Landscape: Tattoo (1999), comprises twelve shots of the artist's bare torso exquisitely painted in classical style by his wife, Zhang Tiemei (*opposite*). In artist's statements, Huang claims that the natural scenes represent for him a place of inner Zen-like peace, recalling the venerable metaphor of the healthy body as a well-tended garden. Yet viewers cannot help but be subliminally affected by certain formal peculiarities, perhaps reflective of psychological discomforts in China's new circumstances. The figure is no longer in the landscape; the landscape—like a national identifier—has been superimposed on the figure. Indeed, the face and head, those prime sites of selfhood, are outside the frame (or, in some works, painted over), and the cropping is so tight that the figure, while scrutinized and fetishized, is visually confined; even bent-elbow extension of the arms is cut by the frame. Are we seeing a person or an embodiment of the New China, proud of an ancient heritage but no longer content to be circumscribed either by tradition or by an outsider's gaze?

Sheng Qi (b. 1965) has taken psychological conflict to a bodily extreme. Having come to Beijing from his birthplace in Anhui Province, he graduated from the Central Academy of Art and Design in 1988 and left for Europe the following year, after Tiananmen. He claims to have cut off the little finger of his left hand out of grief and protest, leaving it buried in a flowerpot while he journeyed abroad. (A more cynical account, which circulates in the Chinese art world, is that he flipped out, van Gogh–style, over the loss of an Italian girlfriend.)

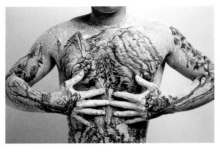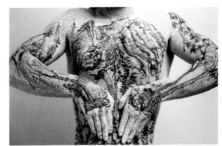

Huang Yan, selections from
the series Chinese
Landscape: Tattoo, 1999

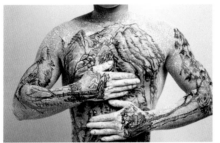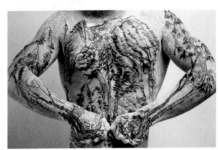

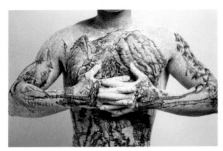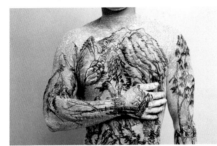

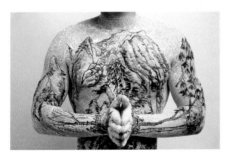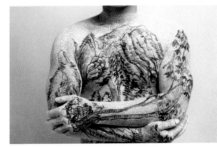

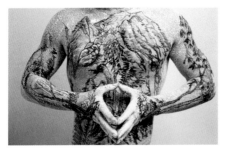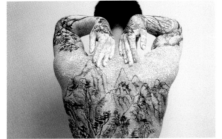

149

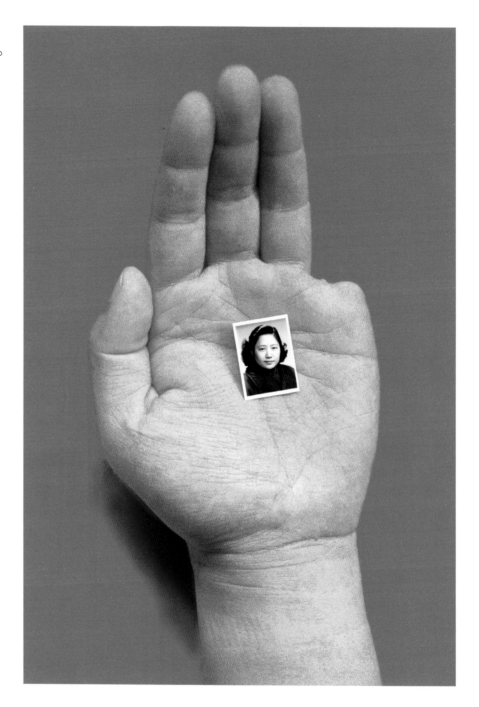

Sheng Qi, Untitled, from
the series Memories, 2000

150

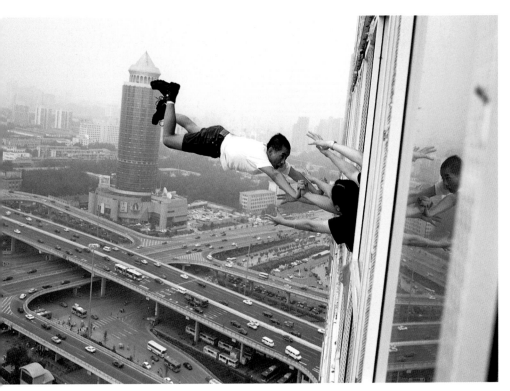

Li Wei, *Free Degree over 29th Story*, 2003

Sheng lived in Italy for three years (1989–92), then studied at Central St. Martins College of Art and Design, London, receiving an MFA in 1998. Returning to Beijing, he soon produced the photographic series that has overshadowed all his other works (such as drippy contemporary-scene paintings, performance videos, and tabletop Tiananmen palace sculptures doused in red). Memories (2000), excruciatingly simple and direct, presents close-up images of his mutilated hand, propped against a China-red backdrop and cradling a tiny photographic portrait in its palm: himself as a child, his mother in her youth (*opposite*), Mao. The sense that we lose a part of ourselves with every personal and societal change is—for once the expression precisely applies—almost palpable.

Other body photographers are absurdist gamesters, chief among them Beijing-based Li Wei (b. 1970), a self-taught artist originally from Hubei Province, where his father was head of the Communist Party in the local village. Combining live performance with a number of visual tricks—including, most notably, a large plate mirror with a hole in the center for his

protruding head as well as digital cut-and-paste techniques (*page 13*)—he creates fantasy scenarios that seem to defy nature: his detached head being used, alternately, as a teddy bear and a soccer ball by a lovely young woman; his body planted headfirst, legs straight upward, in a building side, a car windshield, or a roadway; his body spread-eagle on a flapping flag hoisted high on a pole, or zooming horizontally out of a skyscraper window while desperate arms try to hold him (*above*). These color images, created in profusion since 2000, express not only the heady dislocations of today's China but the power of the mind to create its own realities, untethered by facts.

Chen Shaoxiong (b. 1962), a member of the experimental Big Tailed Elephant group in Guangzhou, where he attended the Academy of Fine Arts, makes his devices more apparent. His signature works, the ongoing series Streets (begun in 1997), feature cutouts of urban scenes held up at arm's length and reshot against other city milieus (*page 152*). The jumble of times, places, and cultures echoes life in fast-growing Guangzhou and the Pearl River Delta, as well as

Chen's natal city of Shantou on the eastern coast, one
of the ports forced open by Western powers in the
nineteenth century and a Special Economic Zone
since the 1980s.

Chen's variations on the mad-urbanization theme
include his Ink City (2005–present) wash drawings,
slide projections and videos, and his *Homescape* instal-
lation of room interior cutouts placed in a grid of one
hundred identically sized boxes. Aware that globalism
brings physical danger along with it social changes, he
has made numerous post-9/11 photographs and videos
in which tall buildings in China bend or part in order
to avoid being smashed by an onrushing jetliner (*oppo-
site, above*). In other cases, structures that do not react
are digitally exploded.

The foregrounding of technique is most pronounced
in the work of Beijing artist Shi Guorui (b. 1965), a

photography graduate of Nanjing Normal University,
who makes large-scale camera obscura images of
culturally freighted sites such as the Great Wall, the
Himalayas (*pages 154–55*), and the cityscapes of
Shanghai (*frontispiece*), Hong Kong, and Shenzhen.
The black-and-white negatives, ghostly and unpeopled,
make these locales look like ephemeral specters within
a dark, enduring void.

Self-taught photographer Bai Yiluo (b. 1968), a former
Henan Province factory hand now based in Beijing,
works at the opposite extreme—with hundreds of
ID-style headshots (evoking China's overwhelmingly
large population) sewn into the form of garments,
human figures, or mosaic-like grids, some with emer-
gent patterns depicting U.S. currency, a skull (*opposite,
below*), or classic Communist leaders. In these
works individuals are submerged in larger formal
entities, recalling the immense, depersonalized social

Chen Shaoxiong, *Anti-Terrorism Variety*, 2002. Two–channel video

Bai Yiluo, *Fate No. 1*, 2005

153

Shi Guorui, *The Himalaya,*
20th November 2005, 2005.
Unique camera obscura
gelatin silver print,
126 x 330 cm

structures that make up Chinese life. With equal
aplomb, Bai photographs broken housefly bodies
arranged to resemble calligraphy.

Miao Xiaochun (b. 1964) raised in the canal city of
Wuxi, graduated from Nanjing University in Jiangsu
Province and the Central Academy of Fine Arts in
Beijing before studying for four years (1995–99) at the
Kunsthochschule in Kassel. While still in Germany, he
fabricated a life-size mannequin that resembles an
ancient Chinese scholar bearing his own features.
Upon his return to China in 1999, he used this figure
as a photographic stand-in to express the shock of

cultural difference abroad and the shock of societal
transformation in China.

Originally a painter, Miao has created black-and-white
and color photo compositions that underplay the robed
sage's physical status in the larger surroundings, while
they maximize the incongruity of his still, thoughtful
presence. The scholar appears (apparently in a faint) at
the feet of a woman tourist on the Great Wall, alone in
a cable car rising over the urban sprawl of today's
Wuxi, and receiving treatment under a piece of futur-
istic medical equipment. With his elegant gown and
thoughtful demeanor, he seems to incarnate a cultur-

ally rooted wisdom that is lost to the more frenetic, generically modern world around him.

Many of Miao's images are panoramic views—some photographed as such and some assembled digitally out of discrete shots that echo the multiple perspectives and timeframes of traditional scrolls. *Opera* (2002), which shows people looking down into a zoo's monkey area, combines several individual exposures into one seamless horizontal sweep (*page 156, above*), while *Capital* (2003) layers urban views vertically into a composite that soars from foreground shopper to traffic commotion to distant building top. Of late,

Miao has experimented with much more radical computer-assisted imaging—producing results like *H2O—Martyrdom* (2007; *see page 156, below*), a work that replicates Antonio and Piero del Pollaiuolo's 1475 masterpiece *The Martyrdom of St. Sebastian,* minus defined muscles, hair, clothing, color, and individual countenances. Apparently our high-tech present can effectively denude Western as well as Eastern tradition.

In Hong Hao (b. 1964) we encounter an artist of broad formal and conceptual interests. Born in Beijing and schooled at the Central Academy, he began his career

Miao Xiaochun, *Opera*,
2002

Miao Xiaochun, *H2O –
Martyrdom (F)*, 2007

by making altered world maps and his own idiosyn-
cratic compendium of essays on Chinese culture. In
1997, with fellow artist Yan Lei, he assaulted the inter-
national art-star system (and exposed his country-
men's susceptibility to its glitz) by sending official-
looking letters to a hundred Chinese artists, falsely
inviting them to participate in Documenta 10 in
Kassel. By the year following this hoax, he had moved
on to color photography, capturing architectural views
that he titled as iconic representations of Beijing and
Shanghai. Other works done at the same time—such
as *Mr. Hong, Please Come In* (opposite) and *I Usually
Wait Under the Arched Roof for Sunshine*—satirize
China's now ubiquitous lifestyle ads. Hong poses,
amid expensive collectibles or with a Caucasian pool-
side waiter, as a member of China's new entrepre-
neurial class quietly enjoying his acquisitions and his
leisure. He peers out at the viewer half-cautiously, half-
disdainfully, as if to ask, "Why don't you join me?" The
Tour Guide series (1999–2000) has him in an equally
cagey role for foreign visitors at routine tourist spots.

Hong Hao, *Mr. Hong Please Come In*, 1998

Hong uses the new digital technology to move both forward and backward in time. Since 2000, he has been making photo collages of classical scroll landscapes peopled with contemporary cutout figures. And for the contemporaneous My Things series, he scans individual items that he owns—pens, paint cans, books, currency, CDs, ashtrays—arranged into affinity groups of intricate formal and chromatic complexity.

Ready on the Set

Some Chinese photographers have pushed theatricality beyond performing personally for the lens, opting to direct elaborate scenes from which they themselves may be absent. Weng Fen (b. 1961)—a Guangzhou Academy graduate, originally named Weng Peijun, from tropical Hainan Island off the southern coast—first gained wide attention with a series of staged color photos (2000–3) showing himself, his wife, and his young daughter rigidly posed, three abreast, as a family group exemplifying China's recent social transition (*page 159*): from traditionally garbed patriots to robed school graduates to business-suited yuppies. But Weng's reputation went truly global with his much-exhibited On the Wall series (1999–2002): large color images of lone uniformed schoolgirls looking out at cityscapes dense with phallic skyscrapers (*pages 118–19*)—an environment where, once they pass the wall barriers they now only straddle, the wondering youths will soon live their outwardly Westernized adult lives.

We always see these youths from the back, at a mid-distance. Our viewpoint, consequently, is theirs but also encompasses them as they gaze. For Weng's subjects, the story lies in the vista; for us, it is in his subjects' contemplation of the vista. The images are, in effect, pictures of dual consciousness: we are looking at looking. The schoolgirls, in their anonymity and incipient sexuality, seem at once vulnerable yet

fearless. Nothing is more globally consequential, we realize, than what these New Chinese youths will make of the future.

Weng's concern over the homogeneity of contemporary urban life is manifest in subsequent series, also cunningly composed and lushly shot, in which families or groups of schoolgirls stare at distant unspoiled lakes, mountains, or seas. Among his most recent works are two installations, both 2005, indicating that he finds China's likely prospects predictably commercial. One work is a shiny egg-shaped chamber inside which visitors can lounge and watch videos. The other is a sprawling, stylized model of Shanghai made of thousands of glued-together eggshells; when viewed from above, the city duplicates the face of a fifty-yuan note.

The reigning master of photographic mise-en-scène (and high-quality printing) in China today is Wang Qingsong (b. 1966). Born in Heilongjiang Province, he spent a stint in the oil fields, graduated from the Sichuan Academy of Fine Arts and moved to Beijing in 1993. Originally a painter, Wang hung out in several low-rent Beijing districts, including Yuanmingyuan, and participated in shows like the first-ever Gaudy Art exhibition of 1996, where he displayed paintings on velvet. Also in 1996, he began to experiment with photography—initially making collages, then generating his own stylized, parodic images.

The digitally manipulated Requesting Buddha series (1999) pictures the artist himself as a nude, multi-armed (and sometimes androgynous) religious figure with each hand grasping some token of China's new consumerist culture: cell phone, CD, Marlboro pack, cash (page 163). In a similar spirit, the 2001 suite Another Battle portrays Wang, his head bound with bloody bandages, leading camouflaged soldiers in an infantry attack on a rural McDonald's franchise.

The more conceptually complex Night Revels of Lao Li of 2000 (pages 160–61) is a contemporary version of Gu Hongzhong's episodic ink-and-color scroll Night Revels of Han Xizai (ca. 970). Han, a minister of the Southern Tang emperor Li Yu, had a habit of missing the grueling dawn audiences with his sovereign, a consequence of long nights of drinking with friends and singsong girls. Han may have been deliberately

avoiding service to a ruler he no longer respected (and might betray), he may have feared making a fatal error in governance, or he may simply have been dissolute. In any case, Li Yu sent an artist to observe the nocturnal goings-on and record them afterwards in pictures, with which the emperor then tried, without much success, to shame his minister into courtly compliance. Wang's 31-foot-long photo remake (in its largest of three print sizes) is intended, somewhat differently, to bemoan the marginal status of intellectuals in modern-day China. Updating each scene of the original scroll, Wang presents hedonism as both a form of protest and the best available consolation for the powerless. Lao Li (Old Li, an honorific in traditional parlance) is here the gray-bearded Li Xianting, a well-known experimental-art curator and critic who has had more than one run-in with the authorities.

The shooting session, Wang's first on this ambitious scale, was a seat-of-the pants operation: the film was put in the camera backward; everything had to be reshot at the last minute; and the subjects therefore had to wear the same costumes throughout rather than changing into appropriate attire for each segment of the "scroll." (Wang himself appears in the picture, sometimes as the artist, sometimes as the fool.) Ironically, too, Wang's models have none of the grace and allure of actual salon girls, then or now—although this may well reflect the day-rate he could afford to pay early in his career. Dumpy, garishly dressed and made up, short on smiles, these women plod through the five scenes without discernible charm. Maybe it's part of Wang's joke that in the New China of inside connections and under-the-table money, this is the best a poor, ineffectual egghead can do.

The monumental triptych Past, Present, and Future of 2001 (page 162), takes off on the heroic statuary that stands outside Mao Zedong Memorial Hall (where the embalmed Great Leader lies in state, wrapped in a red Communist Party flag, inside a crystal coffin). Taken aback to see tourists, both foreign and domestic, mimicking the poses of the monuments' Revolutionary figures, Wang used live models to duplicate the two statue groups and invent a third. In Past, soldiers covered with mud and brandishing 1940s-era weapons mount upward behind a streaming flag, while a battered, disproportionately small civilian looks on. Present, on a similarly tiered base, offers upward-

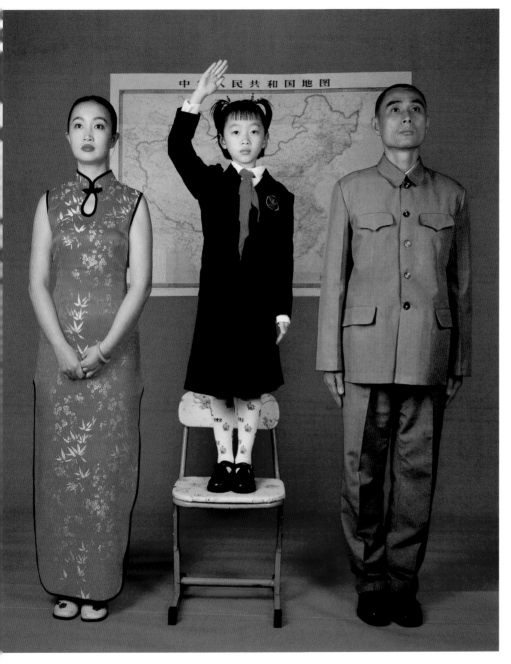

Weng Fen, *Wish for Patriotism*, 2000

159

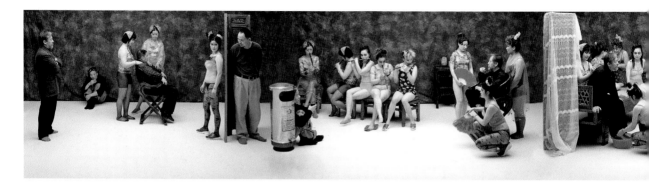

striving workers in head-to-toe silver, with a leisure-capped spectator and his pet dog below. The dreamed-up *Future*, circular and golden, is populated by oddly less-than-happy-looking folks bearing flowers, fruit baskets, pot-lid cymbals (the artist), a book and—just in case—a rifle. No one, contemplating these course-of-empire tableaux, would accuse Wang of excessive optimism.

Despite the satire of *Art Express* (2002)—two buses, so labeled, stranded amid billowing smoke at a country intersection—Wang seems to be most at ease in the domain of pure art and nude girls. Witness the cluster of works he shot in 2003. One is an Asian version of

Ingres's *Fountain*, another of the anonymous sixteenth-century School of Fontainebleau image of one woman squeezing another's nipple in the bath. The enormous photo-scrolls *Romantique* (over twenty-one feet long; *below*) and *China Mansion* (over thirty-nine feet) replicate multiple classics of Western art history—Botticelli's *Birth of Venus*, Manet's *Olympia*, Ingres's *La Grande Odalisque*, and others—in horizontal, multiscene panoramas with all Chinese models.

In these and other recent photo shoots, Wang has employed cinematic facilities and techniques. *Competition* (2004) is a Jeff Wall–like study of people

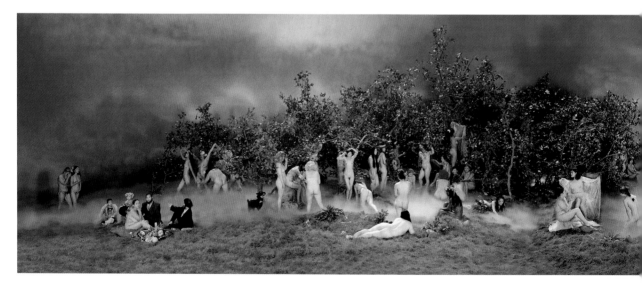

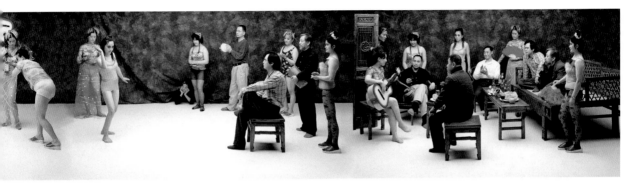

Wang Qingsong, *Night Revels of Lao Li*, 2000

anging hundreds of rival posters in a soaring interior pace with movie-studio lighting. *Dormitory* (2005) hows mostly naked people inhabiting seven tiers of eds, like workers or students in a hive of communal ousing. The triptych *Come! Come!* (2005) involves undreds of participants carrying banners in a fake olitical demonstration in the countryside. Videos ocumenting these productions catch Wang in the role f a kind of Chinese Fellini, directing his actors with hysical prods and a megaphone. It is here that onceptual, staged, highly controlled photography lends into video, the latest major medium to be dopted by experimental artists in China.

Wang Qingsong, *Romantique*, 2003

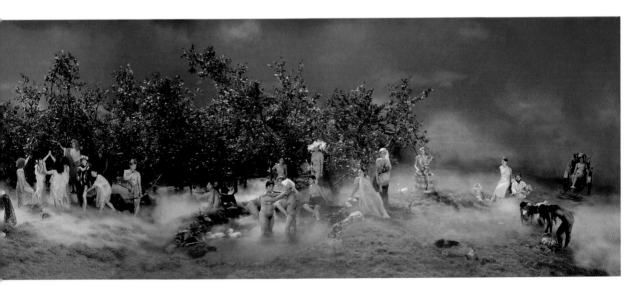

Wang Qingsong, *Past,*
Present, and *Future,* 2001

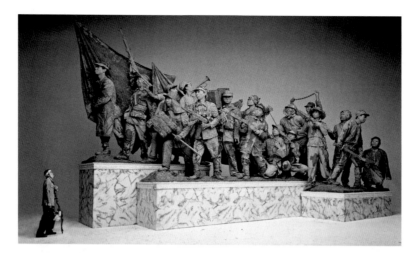

Past

Present

Future

VIDEO

From Film to Video

Like photographs, the moving image was imported into China in the nineteenth century. Indigenous film production, mostly centered in Shanghai, burgeoned in the 1920s, much influenced by foreign—especially American—methods and models. The 1930s, a time of multiple Shanghai studios and glamorous stars, also generated an emphasis on class issues and ordinary people, political struggles, and the threat posed by Japan. With the 1937 invasion, production companies evacuated, notably to Hong Kong, but Shanghai (whose foreign concessions mitigated Japanese control) continued to create a number of films that eluded the usual proselytizing mode fostered by the occupying power. After Japan's 1945 defeat, Shanghai cinema briefly and gloriously revived, only to be commandeered by Mao's propaganda machine four years later. Some filmmakers fled to Taiwan, while those who remained faced tough new restrictions against pre-Liberation (1949) films and all non-Soviet imports. Film students and young industry professionals were sent to the USSR for training. In the mid-1950s, the national film school was founded in Beijing, where ideological oversight was strict.

Gong Li in *Raise the Red Lantern* (1991), directed by Zhang Yimou

Following a slight easing of party scrutiny in the first half of the 1960s, the Cultural Revolution slammed the industry to a virtual halt. Distribution of earlier Chinese films (to say nothing of foreign imports) was forbidden, and the few new productions were politically didactic and woodenly acted. But after 1976, Chinese cinema—like every other art form in the country—came to life again, returning to genuine populist entertainment that reacted to the influx of competitive influences from abroad and even occasionally dramatized the woes of the Cultural Revolution.

The famous Fifth Generation of Chinese filmmakers graduated from the Beijing Film Academy in the early 1980s, the same period as many '85 New Wave artists emerged, including those such as Zhang Peili and Wang Jianwei, who pioneered the use of video as an art medium in the PRC. With such works as *Raise the Red Lantern* (Zhang Yimou, 1991; *below*) and *Farewell My Concubine* (Chen Kaige, 1993), these filmmakers reached international audiences and established a model for worldly success at a time when most avant-garde artists were scratching out a bare existence in places like Yuanmingyuan and the East Village. Today market-savvy artists may emulate the lifestyle of movie directors, and Yang Fudong may draw heavily on the legacy of Shanghai cinema, but most video makers—because of the distinct nature and history of their medium—remain closer in spirit to underground filmmakers and documentarians.

Video, after all, allows for and even prompts a level of personalization normally unattainable on a major movie set. Its development outside China was tied to the post–World War II dissemination of television—which brought moving images on an intimate scale into the private recesses of the home—and to the growing availability, from the mid-1960s onward, of portable video cameras and ever-more sophisticated editing devices. The first major experimenter, Nam June Paik, began by distorting conventional TV broadcast images and, in 1965, obtained his own video-making equipment. His initial efforts were more or less documentary (capturing a pope's visit to New York for example), but by the time video technology entered the broader market in the 1970s, artists were already staking out the possibilities of the medium: recording real-life situations, typically shot close-up and personal; documenting performance-art events; appropriating existing film and video footage; emulating film or TV narrative, often with deliberate

subversions and disruptions of the form; fragmenting or proliferating scenes onto multiple screens; manipulating time perception to unconventional extremes; projecting images onto walls and objects. Almost immediately, video was seen as an image-flow that can be either a viewing experience in itself or a structural component in an encompassing installation.

Because of the Cultural Revolution, extensive information about video art did not reach China until the 1980s, nearly twenty years after its inception abroad, and the means to view and produce it effectively developed even later. Television became widespread in the People's Republic only in the late 1980s, the internet and small portable cameras only in the late 1990s. Consequently, the evolutionary history of video was drastically foreshortened. The full range of its technical potential and the formal innovations of such figures as Paik, Bruce Nauman, Gary Hill, Bill Viola, and Tony Oursler arrived almost simultaneously, as a range of options for Chinese artists to draw on—and, in many cases, to duplicate—without first working through the developmental stages experienced elsewhere and without concern for proprietary intellectual interests. Hollywood movies, experimental films, Chinese cinema of all periods, French New Wave, Italian Neorealist classics, Indian musicals, Hong Kong action flicks, Japanese horror movies and animation, Korean melodrama, music videos from Asia and the West, domestic and foreign TV shows and commercials, video games and the internet, as well as the experiments of serious video artists from around the world, fed an avant-garde imagination

Zhang Peili, *Water—Standard Version from the Ci Hai Dictionary*, 1992

Zhang Peili, *30 x 30*, 1988

newly freed from Socialist Realist restrictions. So rapidly and astutely were these influences absorbed that all the video artists covered here were showing internationally—many at no less a venue than the Venice Biennale—within a few years of making their first work.

China's First Wave

The dean of Chinese video is Zhang Peili (b. 1957), who conducted some of the earliest experiments with the technology and until recently presided as head of the sleek, well-equipped New Media Art Center at his alma mater, the China Academy of Fine Arts in Hangzhou. The two-decade span of his career to date encompasses the whole history of video in the People's Republic, from its private, technically crude beginnings to its current global, futuristic cachet. A graduate of the Zhejiang Art Academy (as it was known before 1993), Zhang had studied oil painting and gained his first notoriety as a member of the Pond Group, which included painter Geng Jianyi and a dozen others. In overnight guerrilla actions in 1986, the group twice tried to engage the general public with art by putting up oversize human silhouettes (once in papier-mâché on a wall, once in freestanding cardboard), the white figures striking tai-chi poses in outdoor areas used for that exercise every morning by the people of Hangzhou.

The artists then turned to more private endeavors. Geng produced the seminal *Second Situation* grisaille faces, and Zhang tacked up sheets of paper bearing intricate instructions for an action in which several people would observe through a peephole while two others engaged in a highly regulated dialogue (*Art Project 2*, 1987). He also painted many subdued oil-on-canvas studies of isolated objects—gloves, a saxophone—and, during a 1988 hepatitis outbreak, Zhang mailed rubber gloves to his acquaintances and displayed some, evidencing various states of damage, in grids under glass.

Hands working in gloves figured prominently in Zhang's initial video, *30 x 30* (1988; *page 167, below*), one of the earliest if not the very first art video made in China. Taking its inspiration from patience-trying

works by Warhol, Nauman, and others, it depicts—from a single, fixed point of view—gloved hands breaking a mirror, laboriously gluing the fragments back together, and then breaking the pane again. The title refers in deadpan, high modernist fashion to the size of the glass (thirty centimeters square), and the performance goes on for an intentionally mind-numbing three hours. (Zhang made the piece to test the bona fides of his colleagues at a conference on experimental art.) *Document on "Hygiene" No. 3* (1991), thought to be the first art video shown in a public venue in the People's Republic (it appeared in a 1991 exhibition in an underground garage in Shanghai), continues the concern with absurdly ritualized behavior, a constant theme in China from the imperial past to the Communist present. Shot at a time when the government was promoting public sanitation as a patriotic duty, the video work shows Zhang repeatedly washing a compliant hen.

Two years later, in a related vein, Zhang persuaded the well-known state TV news anchor Xing Zhibin, a woman of impeccable demeanor and diction, to read from a dictionary every word beginning with "water" (*Water—Standard Version from the Ci Hai Dictionary*, 1992, *page 167, above*). With disastrous floods much in the news, she delivers her methodical, nonsensical stream of words with the impassivity expected of a professional China Central Television broadcaster—replicating the neutral, reassuring tone she employed three years early when conveying the Party line on events in Tiananmen Square.

The fascination that some painters find in seriality Zhang seems to discover in repetition, occasionally reinforced by installations using numerous monitors. During the 1990s his focus was on common acts: toy penguins endlessly climbing stairs and sliding down a ramp (*Children's Playground*, 1996), human body scratching (*Uncertain Pleasure*, 1996), a man consuming a meal as recorded in multiple tight close-ups (*Eating*, 1997), and couples executing their ballroom maneuvers (*Endless Dancing*, 1999).

But of late Zhang's emphasis has been on appropriated footage, edited and combined to subvert its original meaning. *Actor's Lines* (2002) lifts a scene from Wang Pei's 1964 propaganda classic *Soldiers under Neon Lights*. An exchange in which a patriotic soldier

they'll find you and
force you to go away.

Wang Jianwei, *Living
Elsewhere*, 1997

tries to win the confidence of a troubled young man is repeated and repeated, while the characters' words are also multiply echoed until the propaganda vehicle becomes a Dadaist exercise. In the dual-screened *Last Words* (2003), death scenes from various Chinese movies are endlessly reiterated until neither death nor life seems to have any finality. *Charge* (2004), a montage of clips from Chinese and American war films, shows officers ordering their embattled troops to attack. The juxtaposition stresses a formal similarity in sign-systems and a humanist message affirming that we're all the same in certain situations. And in *Happiness* (2006), statements uttered by characters on one screen elicit wild applause—of the Cultural Revolution's programmed-response variety—from crowds on another screen, excerpted from a different movie. Nowhere in Zhang's oeuvre, so attuned to the transmogrifications his country is undergoing, does authenticity seem certain, or even feasible.

That issue has a lingering resonance for Beijing-based Wang Jianwei (b. 1958), who grew up as the son of military parents in Sichuan Province and underwent "re-education" in the countryside during the Cultural Revolution before graduating, at the age of thirty, from the Zhejiang Academy in Hangzhou. Trained as a painter, he opted, in the aftermath of Tiananmen, for more conceptual projects: fact-based texts and project notes composed in solitude; a grain-growing experiment entered into with a Sichuan farmer; petition of officials in the city of Chengdu to have a statue of Mao cleaned, while he videotaped the ambivalence-inducing process.

Wang's best-known video is *Living Elsewhere* (1997; *page 169*), the record of four displaced peasant families inhabiting the shells of luxury houses left unfinished for years on the outskirts of Chengdu. Symptomatic of the disruptions wrought by China's massive move toward industrialization and urbanization, their "floating population" status is offset somewhat by their patience and ingenuity—they farm the hard earth of the derelict suburban development—even though they know they will eventually have to move on.

Some of Wang's videos carry respect for being factual to the point of boredom, effectively duplicating the experience they study. Such is the case with *Production* (1996), with its endless teahouse conversations, or

Connection (1996; *opposite*), which on one screen presents family members, apparently watching TV or singing home karaoke, while various scenes from their favorite DVDs play on a facing screen. Other works, employing a technique akin to Zhang Peili's, memorialize and subvert old films by reediting their rhetorical structure. *Is Bukharin a Traitor?* (2002), for example, constantly reiterates a scene from the 1939 Russian film *Lenin in 1918* (once a big hit in China), until the images deteriorate and only the titular question—asked on the soundtrack about one of Lenin's fellow revolutionaries—lingers on repetitively in the air.

Like many of his fellow New Chinese artists, Wang also makes considerable use of blatantly artificial staging. His *Spider I* (2004) and *Spider II* (2005) employ white porcelain masks, color lighting, and enigmatic stylized body movements to explore the psychological intricacies of corporate life in a mysterious high-tech environment. *The Flying Bird Is Motionless* (2006; *page 172*) presents mythic, ritualized combat scenes enacted on a theatrically lit stage set where players costumed in headbands and flowing white tunics engage eachother with swords, bows, and spears.

Dodge (2006), a sculptural installation of sleek, oversize, plastic-looking humanoid figures tumbling down a rippled slope—matched with a red "tunnel" resembling the interior of a huge rectangular colon (or vagina)—takes its title and thematic cues from the accompanying video. The staged footage shows crowds of people in a limbo-like state of waiting, some singing karaoke to pass the time, suddenly intruded upon by doctors and nurses escorting a patient along the corridor, causing a waiting man to fall down a flight of stairs. Like Wang's earlier work *Square* (2003; *page 173*), which intercuts shots of people enjoying themselves in the present-day Tiananmen Square with flashbacks to the orchestrated rallies, troop revues, and marches of the recent past, the video implicitly questions whether benign neglect is not superior to mismanaged purposefulness.

Comic videos—especially animation works that use humor as a cover for acerbic social commentary—have become the trademark of Zhou Xiaohu (b. 1960), a native of Changzhou in Jiangsu Province and a grad-

Wang Jianwei, *Connection*,
1996

uate of the oil painting program at the Sichuan Academy of Fine Arts. Working originally as graphic designer, he began applying computer technology to his independent art projects in 1997. The video installation *No Malice Intended* (1999), one of his early forays into critique, features two men, on separate monitors, talking about a woman who goes about her private bed-and-bath routine in oblivious silence on a third monitor.

But Zhou came into his own—and has gained his greatest international notice—with stop-action works such as *The Gooey Gentleman* (*page 174*) and *Utopian Machine* (both 2002). The former, a broad satire of sexual preoccupations, centers on the nude torso of a man upon which a cartoon lady in a red bikini primps girlishly, pole dances, and accepts flowers from enamored fans. At times, the male torso morphs into a nude female torso hosting a naked male figure who climbs a ladder, clambers about the model's feminine contours and even sticks his head into her navel. *Utopian Machine*, in a shift from the elemental to the geopolitical, is a Claymation parody of the nightly TV news, replete with diplomatic exchanges, natural disasters,

crimes, a conference by the Long March Project, and scenes from the 9/11 attack.

Although Zhou still exhibits loosely painted figurative canvases (such as *Floater-Scenery* of 2006, showing a spread-armed man flying like a terrorist airliner toward the skyline of Shanghai), critical attention persistently gravitates to his videos. His torso-drawing technique turns up again in *Conspiracy* (2004), while *Crowd Around* (2005; *page 175*), an 11–minute compilation of Claymation shorts, zips through such subjects as Saddam Hussein, abortion, boxing, political assassination, and death by electric chair. In *Self Defense* (2006), a life-size female mannequin repeatedly trounces the men who accost her at every turn during an average day at the office. This "revenge of the sex object" theme is, in various guises, Zhou's mischievous response to all forms of exploitive authority.

Wang Jianwei, *Square*, 2003

Zhou Xiaohu, *The Gooey Gentleman*, 2002

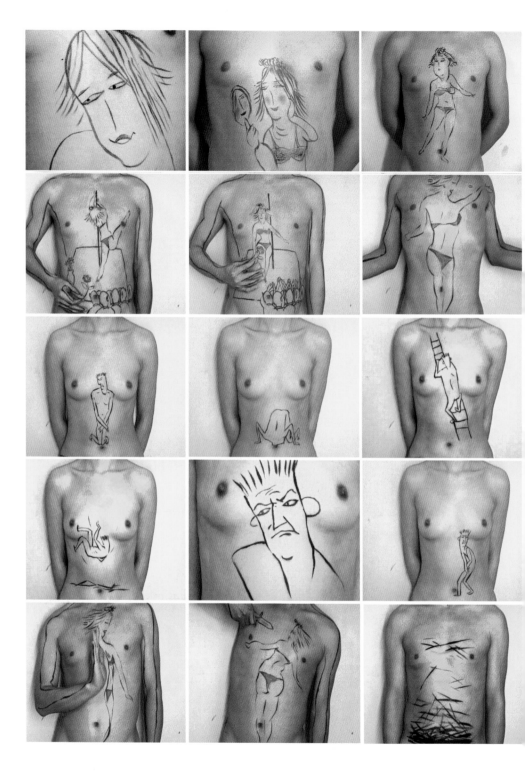

Zhou Xiaohu, *Crowd Around*, 2005. Mixed media, black & white animation video and color clay sculptures

Born in the Media Age

Feng Mengbo (b. 1966), who trained at the School of Arts and Crafts and the printmaking department of the Central Academy in his native Beijing, has undergone a remarkable aesthetic transformation, from familial sentiment to cyber-warrior swagger. Fascinated by new technology (his father was an engineer), he at first made oil paintings based on electronic screen images, such as his improbable pixelized double image of Mao Zedong hailing a cab (*Taxi! Taxi!*, 1994). But Feng's artistic identity was established internationally with the modest and heartfelt *My Private Album* (1996), a CD-ROM archive of extended-family photographs and documents.

By the following year, however, he had begun to apply computer-game technology to social issues, both historical and current. *Taking Mt. Doom by Strategy* (1997), created by hacking and reprogramming, melds the interactive video game *Doom* with clips from a film version of one of the Cultural Revolution's model operas, *Taking Tiger Mountain by Strategy*, in which a People's Liberation Army contingent pursues and ultimately destroys a band of Kuomintang fighters. *Q4U* (2002; *below*) ups the ante with multiple self-portrait avatars—video camera in one hand and blazing rifle in the other—whom human players must blast away at in a variation of the super-violent *Quake III Arena*. Such works are sometimes installed with multiple screens linked to trigger devices that force participants to respond with their entire bodies in a kind of high-tech dance of death. Feng also plays obsessively online, engaging a worldwide community of gamers.

Yang Zhenzhong (b. 1968)—a Zhejiang Institute of Silk Technology graduate who also studied at the China Academy of Fine Arts, both in his native Hangzhou—is a sometime photographer and curator in addition to being a video artist resident in Shanghai. His photo series Lucky Family (1995–99) uses chickens as stand-ins for variously sized human families, from contemporary one-child couples to

Feng Mengbo, *Q4U*, 2002. Video game still

Feng Mengbo,
Into the City, 2004.
Video stills

Yang Zhenzhong, *Let's Puff*,
2002

Yang Zhenzhong, *922 Rice
Corns*, 2000

Wang Wei, *1/30 of a Second Underwater*, 1999

traditional big broods. The video *922 Rice Corns* (2000; *page 179*) gently skewers gender competitiveness. A rooster and a hen peck rice grains in a courtyard, while the voices of a man and a woman call out the respective running tallies, which are also shown in electronic counter strips at the bottom of the screen. Equally engaging but much more sympathetic to the human condition is the incisive *(I Know) I Will Die* video series, begun in Shanghai in 2000 and repeated in numerous international cities thereafter. In each installment, person after person—caught in their everyday surroundings and attire—looks straight into the camera and says the words "I will die." The existentialist chestnut about the nobility of human consciousness (man being the only creature who knows he will die) is thus given a highly diverse, realistic, and nuanced reading, even as the strategies people employ to enunciate that terrible truth— bravado, humor, embarrassment, dread, resignation, defiance—reveal its ultimate unacceptability.

Almost as if drawing back from the abyss, Yang then turned to making such comedic fare as *Let's Puff* (2002; *page 178*), whose pretty, tank-topped girl blowing mightily on one screen seems to physically disturb the city scene projected on another screen. In *Light as Fuck* (2001), the artist appears to balance the entire upside-down Shanghai skyline on his fingertip, and the photo series Light and Easy (2002) repeats that digital feat with a number of massively heavy

Wang Wei, *Temporary Space*,
2003

Xu Zhen, *In Just the Blink of An Eye*, 2005. Installation

objects like an automobile, a traditional stone lion, and a Ronald McDonald sculpture.

The desire to make reality conform to one's wishes also may be the subtext of Yang's 2003 video *Spring Story*. Titled after a sentimental song by a popular People's Liberation Army singer, the compilation shows 1,500 cell-phone factory workers each saying one word or a short phrase from a famous speech made by Deng Xiaoping on his southern tour in spring 1992, when he articulated the state-capitalism policies that have since transformed China. The statement is thus reconstructed, assembly-line-fashion, by individuals who owe their way of life—mechanized but economically much improved—to its epochal content.

Wang Wei (b. 1972), a lifelong Beijing resident who graduated from the Central Academy, manifests an almost obsessive concern with confinement—physical, psychological, and social. Assigned a job as a photographer for the *Beijing Youth Daily*, he took a personal interest in the lives of the people—especially common people—he documented for the widely read publication. In *Post-Sense Sensibility* (1999), a seminal exhibition organized by artists Qiu Zhijie and Wei Meichen for an invited audience in a Beijing basement, Wang exhibited his first artwork, *1/30 of a Second Underwater*

(1998; *page 180*). The piece is a walkway of photo light boxes containing color close-ups of men's bubble-streaming heads underwater, their noses and fingers sometimes pressed against the transparent sheet upon which viewers tread, as the subjects enact struggles against drowning. (The show, which also included Zhu Yu's corpse-arm-and-rope *Pocket Theology* and Sun Yuan's *Honey*, with its dead face and fetus on ice, was in part a response to London's notorious 1997 *Sensation* exhibition.)

Wang's sculptural installation *70 Kilograms and 3.4 Square Meters* (2000) is a tall steel box, surrounded by bits of raw pig flesh, that evokes—via an internal soundtrack and video clips glimpsed through ragged punctures in the walls—a man struggling urgently to break out. *Hypocritical Room* (2002) is a movable tent-like chamber whose sides serve as screens for projections of the surrounding architecture—a shifting but always circumscribed chamber walled by the illusion of open space.

All of Wang's thematic and formal interests conjoin in *Temporary Space* (2003; *page 181*), which encompasses performance, installation, photography, and video. At the 25000 Transmission Center, a Long March Project venue in Beijing, the artist brought together ten brick scavengers (in this case, migrant workers displaced

Yang Fudong, *An Estranged
Paradise*, 2002

from the town of Zhangjiakou). These enterprising laborers retrieve and clean old bricks from demolished buildings and sell them at the city's countless new construction sites for a profit of about $5 a day. Over a period of three weeks, following Wang's directions, the workers amassed twenty thousand bricks and built, within the former industrial space of the art center, a roughly 1,100-square-foot, 13-foot-high structure without doors that confined visitors to the gallery's periphery—a fate reflecting the workers' own social marginalization. They then systematically dismantled the cryptlike edifice. It would be hard to conceive a more concise, concrete, and hauntingly visual meditation on the economic disparities, and constant physical and social disruptions, accompanying China's frantic urban growth.

More acidic in his provocations is Xu Zhen (b. 1977), a lifelong Shanghai resident who graduated from the city's School of Arts and Crafts in 1996 and made a name for himself on the art scene two years later with the art-action *Throwing a Cat*, in which he hurled a dead cat about a room for forty-five minutes, swinging it forcefully by tail or limb, until the carcass was shredded pulp—an event documented in his video *I'm Not Asking for Anything* (1998).

Shouting (1998) records the turn-and-look reactions (at once fearful, curious, and annoyed) of passing city crowds to a sudden, loud human cry. For *Art for Sale*, an exhibition he co-organized with Yang Zhenzhong and Fei Pingguo (also called Alexander Brandt), Xu made *From Inside the Body* (1999) which depicts a young couple trying to locate the source of a bad odor by sniffing their own bodies and each other, first clothed then unclothed, in a parody of heightening sexual arousal. In *Rainbow* (1998) a nude torso is struck repeatedly (though we do not see the actual blows), turning progressively redder until it approaches bruise-blue. Nothing fascinates Xu more than the elusive, it seems. A couple sitting in a boat in the black-and-white *We Are Right Back* (2001), unzip each other's pants but do no more than pull cosmetics, cigarettes and a lighter from their partner's crotches.

Over the years, Xu has created numerous installations that explore the issue of reality vs. representation, of contrasting truth as (or if) it exists versus the "truth" as it is reported by those with vested interests. *In just*

the Blink of an Eye (2005; *page 182*) is a recurring installation that features individuals posed as if in mid-fall, though actually supported by hidden braces. The video *18 Days* (2006) details the misadventures of Xu and friends as they attempt to "invade" neighboring countries, finally breaching Myanmar with an array of remote-control toys. His installation *It* (2007) features of a speck of dirt that, viewed through a microscope, discloses a replica of Neil Armstrong's first step on the moon—an event that conspiracy theorists allege was faked by the U.S. news media for Cold War advantage. Most ambitious of all, *8848 Minus 1.86* (2005) consists of "the summit of Mount Everest" in a huge refrigerated vitrine, accompanied by photos and a video showing Xu and his expedition team as they purportedly scale the world's tallest mountain and remove 1.86 meters of its peak, thus reducing its official 8848-meter height by the equivalent of Xu's body length (if one believes that Xu is over six feet tall).

Perhaps the key to Xu's shtick lies in the juxtaposition of three works: the video *Roadshow* (2000), in which he carries on like a maniacal pop singer; the photo series "Fought . . ." (2005–6), wherein he and his crew beat up iconic world figures (e.g., Bill Gates, Kofi Annan); and the video *An Animal* (2006), which shows a panda—the sentimental symbol of China—being jerked off by a handler in order to harvest semen for artificial breeding. That the totem animal of the world's most populous country is notoriously poor at procreation may be more than an easy joke here, recalling as it does China's relative impotence—until quite recently—in the geo-cultural arena. These three works, taken together, might well represent the dreams not just of Xu but of the contemporary Chinese avant-garde as a whole—personal celebrity, triumph over the West, and a pointed, though often superficially gleeful, critique of tradition and authority at home.

Video Vedettes

Working in video, a medium in tune with the times and unburdened by tradition, gives an air of freshness and freedom to certain artists, who have quickly become prominent on the international scene. Yang Fudong (b. 1971) is the Chinese video artist everyone

The First Intellectual

Yang Fudong,
The First Intellectual, 2000.
Photograph

Yang Fudong, *Honey*, 2003

Yang Fudong, *Seven Intellectuals in the Bamboo Forest*, 2003

Cao Fei, *Rabid Dogs,*
2002

"knows," even if they have heard of no other. He has had, for example, major appearances in Documenta (2002) and the Venice Biennale (2003, 2007). His work, like many of his actors, appeals by being good-looking and vaguely exotic, combining elements of Old China, Shanghai cinema of the 1930s, and MTV chic. Other frequently cited influences are the French New Wave and Jim Jarmusch. The exceptional depth and clarity of Yang's imagery is due in part to the fact that the majority of his pieces are shot on 35-mm film, then transferred to video for ease of display. Son of an army officer and raised in a military complex near Beijing, Yang studied at the preparatory school for the Central Academy but decided instead to attend the more liberal China Academy in Hangzhou. An oil painting major, he developed an interest in photography and film, and demonstrated experimental tendencies in his second year with the self-initiated project *Living in Another Space* (1992)—a silent, three-month performance during which he communicated only by writing on any available surface.

Returning to Beijing for three years, Yang in 1997 began production on his first film, *An Estranged Paradise*, shot mostly in Hangzhou and completed (with a score by a young Shanghai composer) in 2002 (*page 183*). The moody, black-and-white study concerns a young man, embroiled with his fiancée in that "heavenly" town during the rainy season, who feels himself afflicted by a vague, undiagnosable illness. The dialogue is sparse and oblique, the pacing glacial, and the atmosphere (the work's dominant element) one that blends social and physical changes with the protagonist's persistent ennui.

Yang moved to Shanghai in 1999 and worked for a time at a computer-game firm while he created numerous shorts of his own. *Backyard: Hey! Sun Is Rising* (2000) follows four contemporary young men who, for no apparent reason, carry swords and engage in quasi-rituals as they go about in an urban milieu. *City Light* (2000), in color, centers on a pair of robotically moving young businessmen engaged in activities

Cao Fei, *Cosplayers*, 2004

such as brandishing umbrellas, dancing with a young woman in a sun-drenched, hyper-new office, or acting like tough guys with guns on the streets at night.

Yang first gained wide recognition in China with a set of three color photographs, each labeled in English "The First Intellectual" (2000; *page 185*) and each showing a disheveled male yuppie, his face bloodied, clutching a brick to ward off his unseen attackers as he stands in the middle of an empty highway (clearly a fantasy) that leads to an office-towered cityscape. Like Wang Qingsong, whose *Night Revels of Lao Li* was produced the same year (*pages 160–61*), Yang is much concerned with the marginalization of contemporary Chinese intellectuals—a category that for him apparently includes artists and well-dressed young people from the new commercial elite. Is it a mere coincidence that Yang's subjects—like those of Wang, Zhen Guogu, and Yang Yong—seem emotionally marooned? Lacking any real ability to affect society, they simply mark time. Their freedom from physical drudgery yields only a stylish anomie: a disconnection from the past, the world around them, and each other. Another photo series advises, Don't Worry, It Will Be Better (2000) in red, Barbara Kruger-style text slugs, but the color images—languid, dressed-up youths staring out of windows or looking blank-eyed at the viewer—belie the brave, ironic title. At least these youths live in a world far removed from that of the back-street hookers whom the artist portrays in their mundane, nonworking moments in the staged photos of his Shenjia Alley series (2000).

At times, Yang's preoccupation with vacuous beauty verges on self-parody. The color video *Flutter, Flutter . . . Jasmine, Jasmine* (2002) is a veritable three-screen music video, replete with two hip, impossibly attractive young lovers mugging emotional rapture and distress on a city rooftop. *Honey* (2003; *page 186*) is a kind of obscure detective story focused on pretty young people wearing odd clothes (e.g., a chain-smoking girl with cropped, red-dyed hair, attired in a golden faux-fur skirt or swank faux-military garb) as they lounge around a brightly furnished apartment.

Yang's best-known work, the five-part, black-and-white *Seven Intellectuals in the Bamboo Forest* (2003; *page 187*), is billed as a modern-day take on the folk tales concerning the Seven Sages of the Bamboo Grove.

Yang's so-called intellectuals—more handsome, tight-lipped young things, posing in upscale clothes among the eerily scenic pine trees, rocks, streams, and hot springs of the Yellow Mountain preserve in Anhui Province—seem closer in spirit to an Abercrombie & Fitch cast than to the colorful third-century poets, scholars, generals, and philosophers who retreated from worldly affairs in the original tales. (Liu Ling, for instance, a hard-drinking poet given to receiving his guests in the nude, was trailed everywhere by a servant with a wine vessel and a shovel, ready to attend with equal promptness to his master's thirst or his death.) One looks in vain for such passion and wit among Yang's living mannequins. One of his recent works is a startling departure from glamour, affluence, and urban settings. *East of Que Village* (2007) observes, from a distance and in the bleak colors of the impoverished northern countryside in winter, the labor of peasants intermingled with—and visually echoed by—the scavenging of a pack of dogs. Are we witnessing the birth of a deeper social consciousness in the artist, spurred by the widening economic disparities and countless provincial displacements that attend China's new urban bonanza? Only time will tell.

With Cao Fei (b. 1978), a graduate of the Academy of Fine Arts in her native Guangzhou, such awareness is never far to seek. Indeed, she has assimilated the economic turmoil of the Pearl River Delta—south China's most rapidly industrializing, aggressively mercantile region—to such a degree that cultural disjuncture pervades her work, even following her recent move to Beijing and her turn toward fantasy-laced new-media projects.

A vein of subdued eroticism runs through Cao's early works. *Talk without Speaking* (2001) features performers using the sign language of the deaf to convey bold statements and questions ("Do you make love with your daughter?"). *Dancing* (2001) concentrates on the rhythms of a partially disrobing female figure. And in *Public Space—Give Me a Kiss* (2002), a man stands by the roadside doing something between dance movements and gymnastics, and asking passers-by for a kiss.

Exposed to countless experimental films from abroad through the cinema club established by her male

Cao Fei, *PRD Anti-Heroes*, 2005. Multi-media opera, Guangzhou Triennial

companion, the writer, editor, filmmaker, and avant-garde gadfly Ou Ning (b. 1969), Cao turned broadly satiric in *Rabid Dogs* (2002; *page 188*), which shows young office workers made up with canine faces and decked out in various Burberry-plaid garments, as they cavort like dogs let loose in a modern office. The ridicule of ravenous consumerism and how it can cause subhuman behaviors among well-trained workers is heavy-handed but memorable.

Burners (2003) flirts with soft-porn fantasies, but it was followed immediately by more oblique examinations of identity challenges (and games) in contemporary China. The black-and-white *San Yuan Li* (2003)—with its fast-paced editing and driving techno-beat soundtrack—explores the jarring physical and social changes in a former village, once a base of resistance in the Opium Wars, now swallowed up in the urban sprawl and modern-day drug problems) of Guangzhou.

Brightly colored and, at first blush, seemingly lighter at heart is *Cosplayers* (2004; *pages 164–65, 189*), which follows the fantasy enactments of young people who dress up like video-game characters and play out dreams of magical powers, mythic sexiness, and cathartic violence amid the mundanely surreal settings of real-life Guangzhou. The visual contrasts, especially with the players' own no-nonsense parents and their circumscribed, lower-middle-class lives, reveal the stifling discontent behind the costumed players' games. That bittersweet dynamic is echoed in *Milkman* (2005), which contrasts the daily reality of a deliveryman with his vivid aspiration to be a Beijing Opera performer.

Cao's work also extends to dance pieces and installations. For the second Guangzhou Triennial, she put together the experimental theater performance *PRD Anti-Heroes* (2006; *above*), in which bright sets, wacky

Above and opposite:

Cao Fei, *Whose Utopia?*
What Are You Doing Here?
2006

costumes, and exaggerated performances by a large cast were used to explore, agitprop fashion, the social and economic dislocations to which the Pearl River Delta populace is now subject. The humor was broad and the political sentiments daring by China's one-party standards. In 2006, at the Taipei Biennial, Cao spanned several generations and an ideological divide by inviting her father, well known for his heroic bronzes, to sculpt a clay bust while surrounded by some of his earlier portraits of Sun Yat-Sen (1866–1925), the first president of the Chinese republic and the universally acknowledged father of modern China. For the past several years she has taped Asian people of all ages in many different locales (including Guangzhou, Fukuoka, and New York) busting moves for her Hip Hop series, a paean to the liberating, culture-spanning power of physical joy.

When she won the Best Young Artist prize at the 2006 Chinese Contemporary Art Awards, Cao presented an installation of objects, photos, and video dealing with the daily reality and future-life fantasies of workers in a lightbulb factory in southern Guangdong Province. The piece, mounted at the Zendai Museum of Modern Art in Shanghai, pulled no punches in depicting the hard work and tough living conditions of the employees: a curtained bunk bed, for example, evoked dormitories in which the laborers live ten or twelve to a room, their personal possessions piled around them on mattresses and shelves. Yet Cao was equally objective in showing that the plant's working conditions are clean and the employees diligent and mutually cooperative—in part, perhaps, because the low but steady wage they make each month is an economic step up for these former country dwellers. In the dream-realization segments of the video *Whose Utopia? What Are You*

Doing Here? (2006; *above and opposite*), the workers form rock bands, dance in princess costumes, or discuss what an accompanying tabloid calls "a well-off life" for young couples: "rent an apartment, obtain the city's household registration, buy a house, and raise some children." (A slightly spicier version has a young woman returning to her home village one day with "sharp clothes and styled hair" to present her wealthy businessman beau to her family.)

Since early 2007, Cao has shifted much of her artistic activity online to the interactive realm of Second Life. There, operating under the name China Tracy, she has constructed the high-tech dystopia RMB City (which means roughly Money Town) and developed various soulful storylines with her foxy avatar. At the 2007 Venice Biennale, where she showed the cyber piece *Mirror*, she was one of four women artists repre-senting China in its newly authorized national pavilion. Clearly, her eyes, like those of the factory workers in *Whose Utopia?* are turned toward the future. In the sequence of shots with which that video culminates—one earnest laborer-dreamer after another staring steadfastly back at the lens—we return, in a sense, to the Big Faces that announced the emergence of China's post-Mao avant-garde. But much has changed. Cao's headshots are not iconic visages blown up to assert that personal autonomy has displaced patriotic regimentation and the cult of Mao. Rather, they are the living countenances—imperfect, nuanced, questioning, hopeful—of real people confronting what we might call, paraphrasing Geng Jianyi, a "third situation": that of the roiling New China of the twenty-first century.

I wonder Could I possibly
when do you think he'll be back
you really tied one on last night.

Yeah. ok.

this is my wife.

How was your High
please

大课营作业 怎排厘手

大课营作业

How about next week

Come

Can I take a day

第八课 让

Let

52785 GR8

Zhang Fang

朋友

Nice to meet you 佩服宝理 $A^2+B^3=C^2$

How do you make this

$\int_5^3 a^3+b^5+c^6$

Hey. who are yo

I'm just hanging o

doing a little

句子股4强5

speaking
process

!!

我上洗手间 (cock

I go to the bathroom

shave 刮胡子

I brush my teeth

I have had it up to here

Well. you can h

want any monkey

This is not a che

我同了

I rinse out my mouth

我漱口

It's for the birds

cry one's eyes out

(Cry one's eyes out)

非典 sars

I'll make some coffee

我来倒杯. 咖啡吧

vibra

Hello! 你好!

expert 行家. 行家

13910848410

speed 速度

bravery 勇敢

Bomb: 炸弹

WTO 世界贸易组织

Wang Qingsong

Ullens

interest in 是 使 参加

Can I interest you in a game of bridge

EXPO 世博会 Motorola 摩托罗拉 China 中国 the U.N. 联合国

DOCUMENTA

's getting a bit late Guanyin China Mansion 中国之家

champion = crown

观音菩萨

angel 天使

《老栗夜宴图》

out after.... dinner drink

What a wonderful view!

多么美好的风景啊!

go away Fad. Pop.

let me help you with your

让我来帮你拿引d

Its

ush/冲 hip-hop/
ttack/进攻 ballet/芭蕾
tmatch 比赛 waltz/华尔兹

environment/环境

key 关键

core 核心

significant 重要

humanitarian 人性

A级片

Venice Biennale

威尼斯双年展

$P^3=(1+P)^2$

THE SCENE NOW

CHAPTER 6

The Past Is Prelude

The immense changes that China and its art have undergone, at warp speed, are best appreciated in specific comparisons. During the Shanghai Biennale of 2004, an independent group show was mounted at the Liu Haisu Art Museum, a small institution named for an artist who, after studying in France, helped to introduce oil painting and the use of live models to China in the 1920s. The display commemorated the 1983 *Painting Experiment* exhibition at Shanghai's prestigious Fudan University. Held in a faculty lounge, the original show of abstract works by ten artists was open just four hours before being closed down by authorities. The participants' offenses included championing abstract composition at a time when representation was still de rigueur, asserting in a group statement that art needs to be as continually experimental as science, attracting a large unruly crowd, and gaining the implied support (signaled by his presence

at the opening) of Yan Wen Liang, a revered artist-teacher who had studied in Belgium and France.

No one was arrested in the 1983 incident, but professional reprisals did follow. The artist Jian-jun Zhang (b. 1955), refusing to submit a written self-criticism, was demoted from his position as a research assistant at the Shanghai Art Museum to that of doorman. Of the ten aesthetic culprits, only two have managed to sustain ongoing art careers. Li Shan, best known for his mid-1990s portraits of Mao with a flower in his teeth, has more recently produced calligraphy banners incorporating sketchy countryside scenes. Zhang, reinstated in his previous museum job after eight months, rose to head of the research department and then, in 1985, shocked the Chinese art world—and the general public—by selling his painting *Eternal Dialog* (1982; *below*) to U.S. collector Frederick Weisman for $10,000, a vast sum at a time when the average wage in China was $425 per year. At present, Zhang, a grad

Jian-jun Zhang, *Eternal Dialog*, 1982. Oil, sand, stone on linen, 67 x 92 cm

196

uate of the fine arts department of the Shanghai Drama Institute, divides his time between Shanghai and New York, teaches at New York University, and is widely known for conceptual works like his "scholar rocks" fashioned from pink silicone rubber or blocks of sumi ink (*right*).

Even in the fall of 2000, when Shanghai held its first truly international biennial, the economic prospects for most avant-garde Chinese artists still seemed meager. A few, with international recognition and foreign sales, had begun to take large studios in spiffy new artist enclaves. But many continued to gather in collegial bands, as they had in the destitute Beijing East Village days of the 1990s, to discuss their work, to encourage each other's efforts and to scheme—some hoping to fabricate another movement (such as the Stars group, '85 Art New Wave, Scar Art, Political Pop, Cynical Realism, etc.) that could catch Western attention, others aiming to become individually outrageous enough to gain wide notoriety. Apart from the occasional scandal, public notice was almost nil. Popular and officially condoned tradition-based artists, their skills honed in rigorous academies, could rely on showroom sales, commissions, and university teaching posts, but conceptually advanced practitioners were on their own—many showing more easily abroad than at home. China hosted only a handful of serious commercial galleries, notably ShanghART (founded in 1996) in Shanghai and Red Gate (1991) and Courtyard (1996) in Beijing, all run by foreigners. Sales—at dismally low prices by international standards—were almost exclusively to Western expatriates living in China, affluent emigrant Chinese in places like Singapore, and foreign buyers cultivated by a few galleries in the U.S. and Europe. Art museums were part of the official cultural bureaucracy, and alternative spaces operated with a watchful eye on governmental censors.

Today, just a decade later, the Chinese art scene is utterly transformed—like many other parts of Chinese society—into a gold rush environment. The *Art Asia Pacific Almanac 2010* reports that contemporary art is now exhibited in 37 museums, 23 nonprofit art spaces, and 197 commercial galleries. Why this explosion? It would be heartening to argue that a great intellectual and aesthetic renaissance has seized the PRC since its reopening to the larger world, but economic facts suggest a less elevated—and, in some ways, more

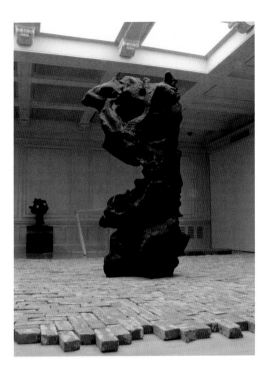

Jian-jun Zhang, *Sumi-Ink Garden of Recreation*, 2002. Sumi-ink, wood, old brickes, fish, plexiglass, water

compelling—impetus. In a February 2008 internet posting, the auction-tracking service Artprice reported that the overall price level for contemporary Chinese art has increased 780 percent since 2001, putting China into third place internationally behind the U.S. and Britain, displacing France. Of the 100 top price-getters worldwide that year, 36 were Chinese, and among the 35 living artists who had sold work for $1 million or more, 15 were Chinese. In 2007, one of Yue Minjun's smiling-faced works sold at auction for $5.3 million, while a suite of 14 drawings by Cai Guo-Qiang went for $8.5 million. In spring 2008, at the top of the market, Zeng Fanzhi's *Mask Series No. 6* (1996) set a record for a work of contemporary Chinese art at $9.7 million.

This price escalation has prompted a speculative fever among both domestic and foreign collectors, some of whom buy work sight unseen on the basis of artists' names and market trends, while others tramp through the mainland galleries and artists' workshops on buying raids led by dealers, Chinese critic-curators turned consultants, or foreign museum personnel conducting tours for their patron groups. Big-name artists find it nearly impossible to keep up with demand for their work, even when employing large

teams of assistants, and recent academy graduates do not hesitate to price their work at international levels, even when selling out of university exhibitions.

Many practitioners in China now seem to be taking their business cues from the first post-Tiananmen generation of voluntary exiles—figures like Cai Guo-Qiang, Xu Bing, Chen Zhen, Huang Yong Ping, Gu Wenda, and Zhang Huan, who built impressive international careers largely by managing their own affairs. Such artists occasionally work with one gallery or another but retain the prerogative to sell out of their studios whenever they like, to whomever they like, without the usual 50 percent bounty to dealers. And they are doing so, it must be said, with great commercial savvy.

To some extent, this trend reflects the well-honed mercantile skills for which China is renowned, a legacy only temporarily suppressed during the high Communist period. Yet it is also a not-so-subtle attempt to beat old-school Western dealers at their own entrepreneurial game. Observers wonder whether, as the situation matures, this artist-directed marketing will continue to flourish in the face of more disciplined global standards. Perhaps Chinese artists will ultimately conform to accepted protocols. Or, conversely, their methods may begin to influence how all contemporary art is marketed worldwide. Indeed, the "Chinese way" is already very close to the self-promotional practices of some of the West's most successful artists. The difference, as is so often the case in China, is primarily a matter of scale. With cheap space and labor at their command, artists like Wang Guangyi and Sui Jianguo are able to turn out signature works (Great Criticism paintings, empty Mao jacket sculptures) at a prolific rate. And what serious artist in the West could match the output of Zhang Huan's ninety-man crew working shifts in Shanghai?

Operations on a such a scale run the risk of overproduction—a charge that has been leveled against China many times—and of reinforcing a cultural stereotype. In other sectors of the world economy, one frequently hears reference to the "China price"—meaning the country's ability to turn out goods at a rate so low that it is cheaper to have products made in China and shipped to markets worldwide than it is to fabricate them at home. Some well-known Western artists are

now doing much the same by opening studios and workshops in the PRC, availing themselves of China's high technical skills and low material and labor costs. Just as in Chinese art-star operations, teams of assistants work from sketches to execute paintings, sculptures, and other art pieces that are then exhibited and sold by the supervising Western artist, with no "school of" or "workshop of" qualifier attached.

Outside the realm of traditional calligraphy and ink painting, the touch of the artist's hand lacks the ontological status in China that it retains in the West—despite Conceptualism, despite Warhol's design-and-sign methods, despite postmodern appropriation. Indeed, the very idea of uniqueness seems to have little bearing on the contemporary Chinese definition of art. In the PRC, a centuries-long tradition of copying as a form of pedagogy and tribute (along with an extensive history of outright forgery for profit), melded in the Maoist era with an official disregard for "capitalist" notions of copyright and private ownership of cultural products. Virtually all property, including intellectual property, became communal—just as it had once been in the traditional extended family.

Following the economic reforms of the late 1970s, the advent of freewheeling commerce led to legal abuses—massive DVD pirating of Hollywood movies, disregard for international publishing rights, huge open markets for fake luxury goods—that have been only somewhat rectified since China joined the World Trade Organization in 2001. These precedents, plus the fact that unofficial artists long had to rely solely on themselves, have generated business-as-usual practices among today's Chinese avant-gardists that exasperate many Western art professionals: blatant imitation of other artists' works, willingness to pay for art criticism and museum exposure, refusal to adhere to dealer-artist exclusivity, an elastic notion of "limited" editions, and mass replication of the artists' own most successful motifs.

Still, the potential profits are so great that many dealers are willing to hazard the race. Beijing currently has at least six active art districts and Shanghai has four. The number of galleries—from the funky confines of Shanghai's 50 Moganshan Lu to its swank emporiums on the Bund, from Beijing's once-industrial Factory 798 complex to the ever more specialized

Caochangdi—has increased over twenty fold since 2000.

A push toward greater commercial sophistication is evident in the Beijing Center for the Arts, situated in a walled compound of 1903 diplomatic buildings near Tiananmen Square, converted—under the direction of curator Weng Ling and financier Handel Lee, the power duo formerly behind Shanghai's posh 3-on-the-Bund makeover—into an luxury enclave whose gallery and theater are complemented by two designer stores, three swank restaurants, and a private club. Meanwhile, a number of major foreign galleries have set up shop in China and more are on the way.

Roughly one hundred auction companies operate in the PRC. Almost all deal primarily with antiquities but are prone, when they do sell contemporary art, to dealings that might well be illegal elsewhere. Observers on the scene routinely report bidding rings (often friends of the artist who reciprocally force up prices, knowing that they will not really have to pay if stuck with the highest bid) and prearranged purchase amounts or percentage discounts for preferred clients, who never pay the hammer price. The international firms Christie's and Sotheby's, holding twice-yearly contemporary Asian sales in Hong Kong and New York, adhere to more reputable standards and have enjoyed staggering increases in business.

Sotheby's New York, for example, mounted its first contemporary Asian (mostly Chinese) sale in spring 2006, taking in just over $13 million. Its fall 2007 offering went for nearly $38.5 million—a tripling in dollar-value activity in 18 months.

Before the market explosion, critics and independent curators such as Li Xianting, Fei Dawei, Feng Boyi, and Gu Zhenqing played vital roles in identifying or inventing significant art movements and highlighting the work of selected artists. These days, curating shows is tantamount to dispensing commercial anointments, and some critical freelancers have taken to advising collectors directly or peddling intellectual validation for hire. (Many richly illustrated monographs, for example, are financed by their artist-subjects—a practice by no means unique to China.) Periodicals are especially problematic. Government-backed journals give the official cultural picture, while

Li Songsong, *National Geographic,* 2006. Oil on canvas, 360 x 240 cm

the English-language *Artzine China* and *Leap* (both magazines and websites) deliver up-to-the-moment news about Chinese art. But no mainland art magazine—except perhaps the museum-based *Art Today*—has gained true critical esteem, and many publish articles commissioned by dealers or the artists themselves. Serious readers are forced to look abroad—to the bimonthly *Yishu,* edited in Vancouver and published in Taipei, to Hong Kong-based *Art Asia Pacific,* and to the major international art magazines, all of which carry occasional articles on Chinese art.

Biennials clearly have a major influence on individual artists' reputations and on trends in curating and collecting. There are fundamental differences between the relatively conservative Beijing Biennale, the more cosmopolitan Shanghai Biennale, the erratic Chengdu Biennial, and the critically up-to-date Guangzhou Triennial (now possibly defunct) and the modest Nanjing Triennial (status also in question). Because they are all tied to a greater or lesser extent to government agencies, these roundups are usually a mix of relatively safe and more avant-garde work. In some

Zhang Hongtu, *Shen Zhou—Van Gogh, #2*, 1998–9. Oil on canvas, 244 x 127 cm

instances, their greatest value lies in the independent satellite shows they generate and in the key art-world visitors they attract.

Art fairs have an even more direct impact on public perception of what's "hot," vigorously driving gallery and secondary-market sales. China presently has four contemporary fairs that matter: Beijing's spring China International Gallery Exposition (CIGE) and fall Art Beijing Contemporary Art Fair, the Guangzhou International Art Fair, and the ShContemporary in Shanghai, established in 2007 by Swiss dealer Pierre Hubert and former Art Basel director Lorenzo Rudolf.

This burgeoning of commercial venues and the adoption of a Warholian "good business is the best art"

mentality among Chinese artists, comes along with an equally radical change on the collecting front. Uli Sigg, a Swiss businessman and diplomat who holds one of the world's largest collections of contemporary Chinese art, once had the field virtually to himself. Arriving in China in the late 1970s, he built his holdings piece by piece. He speaks of having made a thousand studio visits over the years, even when no one in the PRC or anywhere else was bothering to look at—let alone buy—progressive Chinese work. (Indeed, his Chinese diplomatic friends used to offer Sigg traditional paintings as gifts so he would not have to disgrace his walls with avant-garde works.)

That's hardly the case today, with foreign collectors swooping in, newly rich Chinese business people

Zhang Hongtu,
Studs 9 x 9 x 2, 1992.
Wood, metal, paint,
243 x 219.7 x 15.2 cm

buying up contemporary art by the warehouse lot, and moguls opening full-blown museums at their own expense as part of their real-estate developments or individual status maneuvers. The property tycoon Guan Yi, for example, is said to have bought over five hundred works in five years, including the entire contents of Hou Hanru's group exhibition from the 2003 Venice Biennale. Increasingly, as in every part of the contemporary art world, foreign collectors buy on the basis of reputations and price trends, seeing only jpegs or catalogue illustrations before the artworks arrive on their doorstep.

Museums can be a helpful guide to the intricacies of contemporary art production in China, but only if one knows how to interpret their status and curatorial

mandate. In official circles, museums that specialize in antiquities are the most esteemed and best supported. "Fine arts" institutions (emphasizing historical work, with occasional forays into modern and contemporary shows) occupy the second rank, followed by contemporary art museums and exhibition centers, which are treated as the lowest cultural priority. Within state-sponsored institutions, many vital positions are held by career government functionaries with little or no appreciation for art, while other staff members—like directors Fan Di'an at the National Art Museum, Wang Huangsheng at the Central Academy of Fine Arts Museum, and Zhang Qing at the Shanghai Art Museum—are skilled specialists who struggle daily to maintain curatorial independence. Indicative of the government's unwav-

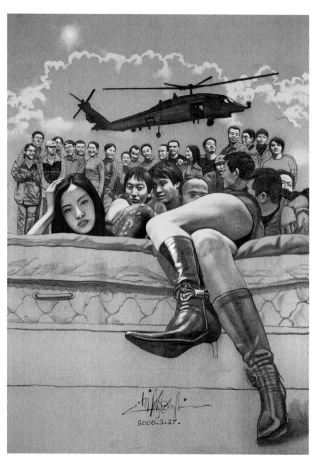

Zhong Biao, *Midday Sun*, 2006. Charcoal and acrylic on canvas, 198.4 x 150 cm

Park (site of the existing Shanghai Art Museum, the historical Shanghai Museum, and the city's new Opera House) for his individually financed showcase. Relying in part on revenues from the deluxe restaurant on its top floor, the museum opened in September 2005 under the direction of veteran curator Victoria Lu. Also inaugurated in 2005, the Zendai Museum of Modern Art (Zendai MOMA) is currently located in a hotel-retail-residential plaza in Shanghai's futuristic Pudong district. Dai Zhikang, founder of the Zendai Group securities and real-estate firm, now plans for a much larger museum as part of the Zendai Himalayas Center slated to open in 2011. The development, to be located next to the Shanghai New International Expo Center, will encompass shopping and restaurant space, a five-star art hotel, a performance hall and a studio complex for artists and other creators, as well as a 111,000-square-foot museum devoted to art, film, design, fashion, and architecture. In 2010, Shanghai also saw the opening of the Minsheng Art Museum, supported by the Minsheng banking company, with artist Zhou Tiehai as the exhibition space's president and programming head, as well as the Rockbund Art Museum, part of an ongoing public-private redevelopment project near the Bund. For the time being at least, both institutions function on the kunsthalle model—as does the city's sleek Z-Art Center, located in the outlying Zhanjiang technology park.

Alternative spaces are the least biased by official sanctimony or commercial self-interest, though they do, of course, reflect the personal tastes (and social networks) of their principal organizers. Over the years, Eastlink Gallery in Shanghai, under the direction of Li Liang, and China Art Archives and Warehouse, overseen by artist Ai Weiwei in Beijing, have been models of astute, provocative programming. Projects like Zhuang Hui's *Factory Floor* installation (2003, *page 125*)—a full-scale polystyrene simulation of a work area in the East Is Red Tractor Factory, where the artist was once employed—might never have been realized without the encouragement of the now defunct X-Ray Art Center in Beijing. And so it goes to this day, in places like Shanghai's BizArt, started with foreign sponsorship in 1998; Guangzhou's adventurous Vitamin Creative Space, co-founded by directors Zhang Wei and Hu Fang in 2002; and Beijing's 160-square-foot Arrow Factory storefront, launched in 2008.

ering nationalism is the fact that China still has no museum devoted to Western art of any kind.

Private museums—an offshoot of emergent private wealth in China—run the entire gamut from vanity exercises to real-estate boondoggles to genuine curatorial endeavors. Most are a mix of all three. Among the more legitimate endeavors is the Today Art Museum in Beijing. Founded in 2002 by entrepreneur Zhang Baoguan and opened in 2006 as part of a residential, office, and retail business complex, it maintains a professionally run, critically respectable exhibition program and art publishing business under director Zhang Kikang. In Shanghai, the Hong Kong jewelry mogul Samuel Kung somehow (there is a whole book to be written on the "how" of such maneuvers in today's China) managed to secure the title Museum of Contemporary Art (MoCA) and a location in People's

Wei Dong, *A Hunting Trip # 1*,
2004. Acrylic on canvas,
142.2 x 188 cm

Qiu Shihua, *Landscape*,
1991. Oil on fibre paper,
110 x 166 cm

Yun-Fei Ji, *The Scholar Flees
in Horror* (detail), 2002–5.
Mineral pigments and
ink on mulberry paper,
96.5 x 116.8 cm

In addition, many of the most important shows of the past thirty years have been mounted in borrowed or rented spaces—nonart government buildings, high-rise lobbies or basements, disused office suites, parking garages. Government regulations, somewhat less rigorously enforced since the gold rush began, require official permission for all public art displays. Because galleries are private enterprises that appeal to a relatively small number of people, they are allowed to operate on their own recognizance, so long as they do not blatantly offend public morality or the political sensitivities of officials. Government-sponsored art institutions whose staffs are larded with party drones, have license to exhibit as they see fit—a privilege that they can subcontract to independent curators by lending space for a show or having a senior administrator sign off on a detailed exhibition proposal. In some cases, freelancers simply install a permitless guerrilla show at some out-of-the-way site, gambling that the worst likely outcome these days is an early closing order and an admonition not to repeat the offense.

One practice that troubles Western observers but passes for normal procedure in China is that of major museums renting gallery space to any reputable artist who is willing and able to pay for a "museum show." Private art centers, many of them created to entice high-end tenants to a real-estate development and then virtually abandoned once the sales are complete, welcome paying events, be they corporate cocktail parties or self-promotional art shows. Meanwhile, government institutions, burdened by bureaucracy and chronically underfunded, have little alternative but to lease out their gallery spaces and their cultural imprimatur. In 2007 the going rate for a full-dress exhibition in a public venue, including Beijing's prestigious National Art Museum, was $40,000 for a two-week run.

So many anomalies abound in the Chinese system that we are eventually driven to reconsider our own norms—or the truth that lies beneath what we tell ourselves are Western professional rules. When Shanghai MoCA held its alternative biennial in 2006, one of the three designated curators was art collector Uli Sigg, who at the same time had a show at Zendai MOMA honoring the winners of his annual Contemporary Chinese Art Awards—thus, in both

instances, conferring critical prestige on the very artists he collects. In theory, this is unthinkable in the West. And yet one does not have to delve very deeply into the doings of mega-collectors who sit on the boards of art museums in the U.S. before such distinctions begin to evaporate. Once again the "Chinese way" has been to look not at what we say we do but what we actually do, and to turn that reality to advantage wherever possible. This immense, newly capitalistic country on the far side of the globe has an unsettling way of reflecting our cultural-financial reality like a magnifying mirror: it is probably not the distortions but the accuracies of the image that make us wince.

Consider the example of the late Chen Yifei, who made his stake selling (through Marlborough Gallery and others) large-scale paintings of exotic Shanghai beauties of the 1930s. Meeting Shanghai Biennale visitors in 2002, he sat at a café table in front of the upscale home-décor and fashion boutique that he owned in Xintiandi (roughly New Heaven and Earth), the jazzy shopping and entertainment enclave in a renovated section of the old French Concession. The painter's conversation ran to art and artists, but it was continually interrupted by calls on his cell phone regarding his three new lifestyle magazines, his modeling agency, and his film production company.

Perhaps Chen's approach had something to do with Chinese artists having undergone, virtually overnight, the shift from a period of enforced people's art to today's postmodern eclecticism, without ever passing through an era of high-minded modernism. It is as if they said to themselves, since we're purging anticapitalism from every other aspect of life, why not drive it out of art—which, after all, prides itself on being at the social forefront?

China may be presenting the world with a new economic paradigm for culture—one that is totally unembarrassed by a frank interplay between art and money. When artists in the U.S. get rich, they tend to buy a house in the Hamptons and a luxury car. When artists in China score big—selling at international prices while enjoying a low Chinese cost of living—they often buy not just a house and a car but a trendy restaurant-bar and a few side businesses as well, pulling friends and relatives up the economic ladder behind them. Like so many of their countrymen,

He Sen, *Stuffed Animal*, 2007. Oil on canvas

artists in China have found an entirely new application for the old Maoist slogan *Xiang Qian Kan* (Look to the Future)—especially given that, as mystery novelist Qiu Xiaolong has pointed out, *qian* is a homophone for "money."

The negative effect of the 2008 world financial system crisis on the Western market for contemporary Chinese art—at first denied—proved to be significant, though far from fatal. Famous names—Ai Weiwei, Cai Guo-Qiang, Zhang Huan, Huang Yong Ping—continued to thrive. But foreign dealers, collectors, and nonprofit institutions became cautious about investing in lesser-known and emerging Chinese artists. Western art, coming from a much more familiar socio-historic and intellectual context, seemed a safer bet in hazardous times. Fortunately for China's artists, the domestic market burgeoned to a degree that more than offset the international retraction. Plainly put, the PRC continues to create millionaires eager to validate (and flaunt) their new wealth by purchasing Western luxury goods, Chinese antiquities, and contemporary art produced on their own shores.

Rising Talents

In the New China, as in the West these days, the very idea of formal groups and movements seems an anachronism, a throwback to a simpler time before widespread internet communication and the lightning responses of a global market, trading predominantly in individual names. With the world's growing focus on China—bolstered by media events like the 2008 Beijing Olympics and the 2010 Shanghai World Expo—the work of certain artists has entered with exceptional ease into the international discourse. These rising artists tend to be relatively young, of course, but some mature practitioners, too, are catching fire because the rise of China itself is so momentous and the search for as yet unexploited work so intense.

Zou Cao (b. 1975), who has done university studies in both oil painting and philosophy, continues the avant-gardist Big Face tradition with a simple but effective motif: world-famous visages (Warhol [*above*], Kissinger, Madonna, Mao, Michael Jackson) superimposed on a large rendering of his own fingerprint, a device that

207

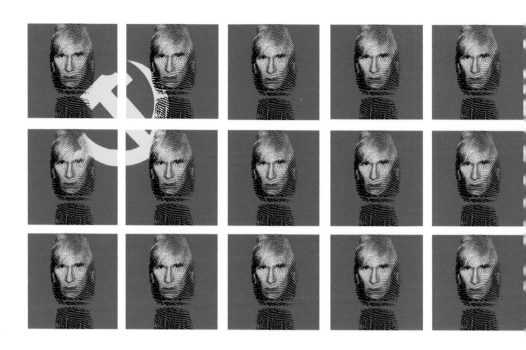

Zou Cao, *Internationale—Andy Warhol*, 2010. Oil on canvas; 15 panels, each 90 x 90 cm

democratizes celebrity by asserting his—and our—symbolic ownership of these icons, and the equal-to-any worth of the artist's own identity.

Observers who have started to weary of the flat, uninflected surfaces of so much Chinese avant-garde painting often cite Li Songsong (b. 1973), a graduate of the oil painting department of the Central Academy in his native Beijing, as a practitioner who knows how to activate a surface through lush brushwork (whether he is working in rich colors or a more or less black-and-white palette) and blocky segmentation of his images, which are often based on news photographs *(page 199)*. Veteran painter Zhang Hongtu (b. 1943) moved to New York in 1982, after the Cultural Revolution derailed an art career that began with training at the Central Academy high school and the Academy of Arts and Crafts. Zhang has produced a large body of work devoted to Chinese themes: in addition to Mao images in every conceivable material and format, including a cutout ping-pong table, he has also made the satiric installation *Studs 9 x 9 x 2* (1992; *page 201)*, which consists of dual red panels reminiscent of a Forbidden City gate, "studded" with extruded metal bolts that look remarkably like an array of limp penises. In the past few years he has gained attention in China and the West with pictures that combine

scenes from classic Chinese ink painting with the oil-paint brushstrokes and colors of Monet, van Gogh *(page 200)*, and Cézanne, painters considered too radical to have been taught in the curriculum of Zhang's student years.

Zhong Biao (b. 1968), who studied at the Zhejiang Academy in Hangzhou and now teaches at the Sichuan Academy in his native Chongqing, combines images from his personal digital databank into mildly surrealistic paintings with flat backgrounds and subdued palettes. His highly representational figures and objects combine East-West and old-new, teasing logic in the deadpan Magritte fashion. The painting *1913 A.D.* (2006), for instance, shows three Chinese gentlemen in garb from that era seated in front of a picture of a modern-day young man taking a photograph of the very portrait group they form. The work's mise-en-abyme is an apt corollary for the postmodern mediation of history through unanchored images. Other works are replete with traffic jams, McDonald's references and mini-skirted women *(page 202)*. In keeping with the current Chinese art-scene ethos, Zhong has produced—in addition to his independent work—a series of four commissioned paintings, The Beauty of Flying (2004), for Dragonair airlines. More recently, in works such as *To the Future* (2010), tempo-

arily installed at the Z-Art Center in Shanghai, he has created immersive environments that combine huge floating-figure murals, mirrored walls, video projections, and recorded sound.

Raised in Inner Mongolia, Wei Dong (b. 1968), a Beijing Normal Institute graduate, currently resides in the New York area and paints intricately composed, exquisitely rendered figurative compositions of enigmatic import, usually involving voluptuous young women provocatively half-dressed in either traditional or Revolutionary attire (*page 203*). Also raunchy at times, though more caricatural, are the tightly packed ink-and-pigment scenes by Yun-Fei Ji (b. 1963), who trained at the Central Academy in Beijing and now bases his globe-hopping career in New York. His pale, visually dense works—resembling landscapes or quiet interiors seen from a distance—are cluttered with ghosts, symbolic animals and plants, common folk, political figures, and other elements evocative of China's long history (*page 205*).

Qiu Shihua (b. 1940) stands apart from not only these figurative painters but the whole maximalist surge in contemporary Chinese art. A product of the Xi'an Academy and a former sign painter, he was able to spend time in Europe and the U.S. in the late 1980s but owes his distinctive style to traditional Chinese painting precepts and his strong Taoist beliefs. Since the early 1990s he has specialized in off-white oil paintings (*page 204*) that he says actually depict—through subtle gradations of tone—natural vistas derived from Chinese masters and the Impressionists. While Western viewers might relate his works to minimalism or conceptual art, Qiu intends his implicit landscapes to be neither purely retinal nor purely strategic. They are designed, rather, as topographies of the mind's perceptions of the outer world, offering intimations of a spiritual dimension beyond the material.

Such homages to the past characterize the work of many artists garnering responses in the more nationalistic art environment of today's China. These include Lu Shengzhong (b. 1952), a professor in the folk art department of the Central Academy of Fine Arts (CAFA), who updates vernacular paper-cutting techniques to produce books, wall pieces, and large installations from myriad red-paper cutouts (*below*). Both Yao Lu (b. 1967), a CAFA teacher in the photography

department, and Wang Tiande (b. 1967), a high-ranking academic at Shanghai's Fudan University, use piles of construction debris and green netting (Yao) or piles of ash (Wang) to create images that appear to be traditional Chinese landscapes (*pages 210–11*). Wang is also noted for semi-calligraphic works made with cigarette burns on layers of paper or clothing. Ye Yongqing (b. 1958), on the Sichuan Academy staff, is best known for sketchily painted birds, rendered in nervous black lines on tan canvas, which contrast tellingly with the

Lu Shengzhong, *The Book of Humanity—The Empty Book*, 2005. Paper-cut, glass, metal screws, Chinese traditional bound books, dimensions variable. Installation view, University Art Museum, University at Albany, State University of New York, 2005

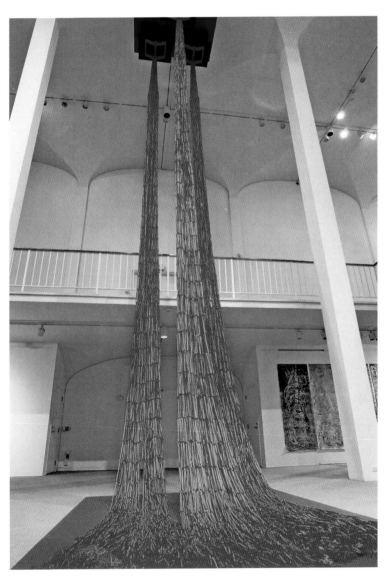

Wang Tiande, *Gu Shan I(c)*,
2007. Photograph, 32 x 163
cm. Set of 3, edition of 9

Ye Yongqing, *Fly*, 2006. Acrylic on canvas, 200 x 200 cm

his human figures evolved from relatively normal forms to large-eyed, plastic-skinned mutants. Today his large canvases are usually devoid of people altogether, devoted instead to shiny, close-up, stylized views of dice, billiard balls, CDs, liquor glasses, matchsticks, golf courses, and other items associated with the "good life" of leisure and gaming.

Oversize sculptural parody is the specialty of Wang Du (b. 1956), who studied at the Guangzhou Academy of Fine Arts and has resided in Paris since 1990, where he fled, aided by his wife, a French journalist, after a nine-month prison stint for openly criticizing local corruption. A former steelworker and founder of the Southern Artists Salon, Wang today targets media culture with painted polyester-resin figures (common social types, politicians, and entertainers, as well as futuristic nudes over-endowed through plastic surgery and genetic engineering). His installation *Space-Time Tunnel* (2004) invites viewers to slide through a jointed hundred-foot-long tube lined with international press clippings and sixty-six monitors playing news broadcasts from around the world.

More enigmatic are the works of Wu Ershan (b. 1972), who moved to Beijing from Inner Mongolia and studied oil painting at the Central Academy before coming into his own as an installation artist. In the seminal 1999 *Post-Sense Sensibility* exhibition, he showed *Red Man Green Woman* (its title a catch phrase for dissolute, acquisitive people), wherein rabbits, ducks, and pigeons went about their business amid an orgy of androgynous "human" figures made from fruits and vegetables. Other pieces commingling the Old and New China include the physically commanding *The New Land* (2004; *opposite, below*), with a tattered Chinese junk sail looming over huge metal vats of wax in the stylized shapes of the seven continents (evoking perhaps a world yet to be conquered by the old, frayed dream of empire). *Interior Scene* (2005; *opposite, above*) is a three-layer structure—an unfurnished bottom chamber with a ceiling fan, a radically horizontal red crawl space, and an uppermost low-ceilinged bedroom—that was enlivened at the second Guangzhou Triennial by, respectively, a long-bearded scholar-monk, a scuba diver, and a bevy of girls in red bathing suits. Together, its compartments could well represent the interior of the New Chinese mind, awash with unresolved cultural conflicts.

elegant, anxiety-free birds of conventional Chinese painting (*above*).

Nothing could be farther from the sexy, here-and-now orientation of He Sen (b. 1968). A Sichuan Academy graduate who has also studied at the Kunsthochschule Kassel in Germany, the artist is known for his photorealist paintings of alluring young women posed with drinks, cigarettes, and girlish toys (*page 207*). Working from projected photographs, He (who has taught in the photography and digital media department of the Central Academy in Beijing) strives to create a physical and moral limbo for his smoldering subjects. Placed against a blank background and rendered in muted ranges of gray or purple (except for an occasional flash of full-color alcohol or lingerie), the young women come across as decadent, childish, erotic, and dangerous to themselves and others. In some paintings, these vixen have no eyes; in others, they meet the viewer's gaze with the frankness of hookers in training. In both cases, He maintains, they represent a newly affluent generation, already corrupted by money, that sees no meaningful role for itself, now or in the future.

If He could be suspected of secretly enjoying the sights he allegedly deplores, his Beijing-based peer Chen Wenbo (b. 1969), another Sichuan Academy alumnus, seems to relish unapologetically the accoutrements of the New Chinese lifestyle. In past years,

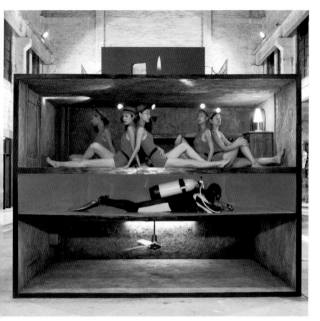 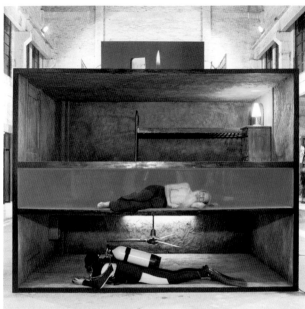

Wu Ershan, *Interior Scene,*
2005

Wu Ershan, *The New Land,*
2004

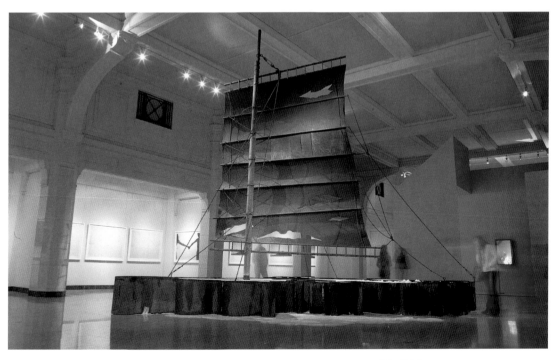

Zhang Enli, *Cigarette Butt*, 2008. Oil on canvas, 34 x 45 cm

Though he first became known for caricaturist portrait heads, painter Zhang Enli (b. 1965) has, in recent years, shown great sensitivity in his depictions of everyday objects. Focusing on a single item in series including Bucket (2007) and Bed (2008), these works continue the venerable approach of representing not the appearance but the essence of a subject, as in the deadpan *Cigarette Butt* (2008; *above*). Often derived from casual aide-mémoire photos taken by the artist, the images, somewhat reminiscent of Luc Tuymans's pictures, are simultaneously plain and ethereal. Their diffuse forms and open, uncontextualized spaces recall traditional Chinese brush painting, which Zhang studied before pursuing an interest in Western art history and techniques. Having graduated from the Arts and Design Institute of Wuxi Technical University in 1989, he now lives in Shanghai and teaches at the city's Donghua University.

There is a surprising diversity to the paintings of Jia Aili (b. 1979), who grew up in modest circumstances in Dandong, Liaoning Province, on the banks of the Yalu River separating China from North Korea. Although he took degrees (2004, 2006) from the Luxun Academy of Fine Art, a well-respected school with lingering ties to Russia and the Social Realist mode, Jia's own work clearly departs from that hortatory esthetic, edging sometimes toward sci-fi fantasy, sometimes toward modernist-style pure painting. Now based in Beijing, the artist in 2007 produced moody, deftly painted works that are vaguely apocalyptic in tenor. *Nameless Day 1* shows a nude figure in a desolate landscape with a rocket mounting skyward in the background; the Wasteland and Serbonian Bog series both feature a male nude in a gas mask who clambers though domestic ruins or wanders in a phantasmagorical swamp (*opposite*). An untitled work from the same year has the same figure bowing his head before a jet engine on a sledge.

Jia Aili, *The Wasteland No. 1*, 2007. Oil on canvas, 267 x 200 cm

Yu Hong, *Female Writer*, 2004, She series. Acrylic on canvas and photo on aluminum; 150 x 300 cm (painting), 170 x 116 cm (photo)

Yu Hong (b. 1966), though she has previously been rather overshadowed by her husband, Liu Xiaodong, is today widely respected in her own right, especially for her treatment of feminist themes. Holder of a Central Academy MFA in oil painting, she employs an expressive-realist style to depict figures either against an undefined background, where each individual's physiognomy and attire stand out, or, as in the series She, immersed in domestic environments that suggest both the subject's social standing and inner life (*above*).

Photography remains arguably the richest art form in the PRC today, with notable new practitioners still tending predominantly toward staged scenes. The work of Bird Head, the Shanghai duo created in 2004 by Song Tao (b. 1979) and Ji Weiyu (b. 1980), both natives of the city and graduates of its College of Arts and Crafts, may be described as documentary. But they also seem to go out of their way to be technically uncouth, producing views of new urban dreariness that are often blurry, washed-out, or ill-composed (*left*). In doing so, they come across as both socially and photographically disabused, rejecting fine artistry for an equally deliberate post-punk aesthetic.

Bird Head (Song Tao and Ji Weiyu), *Bird Head World 2004–5*, 2005. Photograph

Currently residing in New York, Zhang O, originally from Guangzhou, with degrees from Beijing's Central Academy and both St. Martin's School and the Royal College of Art in London, seems at first blush to be practicing straight portraiture. Yet her photographs of village girls, ages four to six, from the remote reaches of Hubei Province in the series "Horizon" (2004) are rebukes to both Cultural Revolutionary and new consumerist models of mindlessly happy childhood. Often posed at a high horizon line with blue sky behind, always captured in highly saturated colors, they might have been quasiheroic, rosy-cheeked darlings. Instead, they squat before us, meeting the viewer's gaze with the wariness of the spiritually impoverished and marginalized.

Zhang O, *Daddy and I*
no. 18, 2006.
Digital C-type print

Chen Qiulin, *Ellisis Series
No. 2*, 2002. Photograph

Chen Jiagang, *Diseased City-Chengdu—The Cop and the Thief*, 2006. Photograph

Daddy and I is the name of Zhang's ongoing (since 2005) series of Western men with their adopted Chinese daughters (*page 217*). On the surface the images present a testament to filial devotion that transcends cultures. But their lush gardenlike settings, keyed-up lighting, eerie absence of mother figures, ambiguous embraces, and stark contrasts of size, age, and physiognomy present us with a potentially disturbing subtext, even for viewers who do not already know Zhang's sexually charged videos and her wall work *Water Moon* (2001–2), with its pinhole views of historical erotic drawings projected and photographed on a nude woman's body.

On yet other levels, Zhang's Daddy and I photographs explore an intricate and ever-shifting power dynamic. Are these "exotic" little girls totally dominated by their looming protectors, or do they in fact exert a sly emotional mastery over them? The question holds whether one views the subjects as participants in an archetypal family romance, as signifiers of the constructedness of all paternal relationships, or as symbols of China's postcolonial present and future.

With some of the newer photographers, staging and image manipulation are so pronounced that they become an integral part of the viewer's conscious experience. Chen Qiulin (b. 1975), trained in the printmaking department of the Sichuan Academy, saw her tiny hometown near the Yangtze River in Hubei Province wiped out by the rising waters of the Three Gorges Dam. Her photographic work to date has been a kind of sustained, ambivalent lament over the price of modernization: expansive color scenes in which characters in traditionalist costumes, some from the opera stage, cavort alone or in the presence of stone-faced contemporaries amid the rubble of demolition, occasionally with highrises soaring about them like unnatural cliffs (*opposite*). Her sculptural installations, echoing this displacement theme, have included one hundred common Chinese family names carved in tofu and arrayed by a roadside, as well as abandoned village buildings reassembled, brick by brick, inside the Long March space in Beijing.

Chen Jiagang (b. 1962) does his reconstitutions digitally. Trained in the architecture department of Chongqing University and the China Southwest Architectural and Design Institute, he was recognized

219

as an outstanding young architect by the UN in 1998. His success in the design business has allowed him to branch out culturally—in 1996, he founded the Sichuan Upriver Museum—and to pursue his own photographic work, for which he began winning national awards in 2002. His procedure is to take multiple individual shots of complicated scenes—industrial landscapes, old city neighborhoods, crowded social gatherings—and to meld them seamlessly into single large-format prints whose subdued color lends a somber, wistful tenor to these contemplations of China in transition (*pages 218–19*).

Much more insouciant, Chi Peng (b. 1981) exemplifies the new orientation—and swift new career pace—of artists in the People's Republic today. Originally from the east-coast province of Shandong, he studied in the digital media department of Beijing's Central

Academy and began exhibiting his work internationally a full year before his graduation in 2005. His early black-and-white images, shot and printed with sharp-focus precision, involve a hermaphroditic nude character in white body paint who seems to be confronting his own image in a mirror (*below*). In several works the figure on one side of the glass has, for example, a breast that is missing from the figure on the other side.

Chi's later color works are peopled by hordes of naked young men running through city streets or office hallways, chased by model airplanes in bright China red. In other instances, the nudes themselves have become human dragonflies swarming over cityscapes (*right*) or the open sea. In his most provocative series to date, *I Fuck Me* (2005; *page 222*), the artist duplicates his own image, creating scenes in which his twin selves have gay sex in public places—a phone

Chi Peng, *Consubstantiality I, II, III*, 2003. Altered photographs

booth, a restroom, an office cubicle. In the New China, apparently, neither the spirit nor the libido consents to confinement.

The photographic work of Shanghai-based Lu Chunsheng (b. 1968), who trained as a sculptor at the China Academy in Hangzhou, is extremely diverse and mysterious, though consistently wry in its mildly surrealistic humor. His black-and-white photo suite *Water* (2000) depicts a man in a white nightshirt standing on barren concrete at the center of a stain-like, progressively widening pool of water. I Want to be a Gentleman (2000), a black-and-white series, shows men poised stiffly on frighteningly high and narrow plinths (get it?). The series One of the Most Stupid Attacks Against Science Fiction Is That It Is Unable to Predict the Future (2005; *page 223*) contains both black-and-white images (e.g., a man with a bare torso and his pants pulled down reading aloud from a towering soapbox in a factory courtyard under the superimposed legend "Science Fiction Is Not Erotic") and lusciously colored shots (e.g., men gathering ominously before one isolate fellow on massive seaside rocks, in numbered works called *The First White Man to be Pushed Down*).

Cui Xiuwen (b. 1970), originally from Harbin, Heilongjiang Province, and a graduate of both Northeast Normal University and the oil painting department of Beijing's Central Academy, came to international attention with *Ladies' Room* (2000; *page 224*), a clandestinely shot video (with spun-off photos) showing "night service" girls adjusting their hair, makeup, clothes, and underwear before the women's restroom mirror of a high-end Beijing club—their routinized gestures evoking the realm of sexual commerce that waits just beyond the bathroom walls and the camera's ken. *Underground* (2002) implies painful anxieties in an unwitting female subway passenger, recorded licking, prodding, and tearing away chapped skin from her lips for twenty minutes.

We don't know if the rider's troubles are sexual, but we know that Cui's thematic interests are almost obsessively so. In 2001 she produced the photographic series Chengcheng and Beibei, consisting of color studies of two naked young children—the boy goofing around impishly for the lens, the girl striking calcu-lated, frighteningly lubricious poses. Since Cui claims

Chi Peng, *Perception*, 2006.
Digital photograph

221

Chi Peng, *I Fuck Me Series I*,
2005. Photographs

that these approximately five-year-old kids were not
coached, their respective comportments suggest a star-
tlingly early assimilation of extreme gender roles—or,
conversely, the eruption of an innate Mars/Venus
boyishness and girlishness. Such erotic imperatives
are only slightly more sublimated in Cui's recent
paintings, photographs and videos in which a young
model, chosen for her resemblance to the artist, is
presented (sometimes singly, sometimes with myriad
clones) as a uniformed schoolgirl, a short-skirted
maiden in white, and eventually an expectant mother.
In every case, the female figure—standing, lying, or
curling sensually upon herself—dominates her envi-
rons, whether mundane setting or the precincts of the
Forbidden City (*page 225*).

Although new to the exhibiting scene, Qiu Anxiong
(b. 1972)—a Shanghai artist who graduated from the
Sichuan Academy and the Kunsthochschule in
Kassel—arrived in a big way. In fall 2006, his
animated videos were on view simultaneously at four
major venues in Shanghai: the official biennial at

the Shanghai Art Museum; MoCA Shanghai's
competing *Entry Gate* roundup; *A Yellow Box in
Qingpu*, mounted on the far western edge of the city by
the intellectually revered Chang Tsong-Zung (Johnson
Chang), head of the Hanart TZ Gallery in Hong Kong,
along with China Academy of Art professor Gao
Shiming and artist-architect Hu Xiangcheng; and
Swiss collector Uli Sigg's Chinese Contemporary Art
Awards show at Zendai MOMA. The following year,
UniversalStudios–Beijing (now Boers-Li Gallery),
headed by the influential Pi Li, presented a solo for
which an entire disused passenger train car was
installed in the gallery, with a mix of old films and
new travel footage playing at each of the car's windows
and Qiu's videos running on multiple screens in the
space alongside.

Qiu, who teaches at Shanghai Normal University,
seems to have the gift of strategic friendship. He
once ran the Bistro, a music bar in Chengdu, that
became a hangout for Zhou Chunya, Zhang Xiaogang,
and other key art-world denizens, and his first video

Lu Chunsheng, *One of the
Most Stupid Attacks Against
Science Fiction Is That It Is
Unable to Predict the Future:
The First White Man to Be
Pushed Down,* 2005.
Photographs

Cui Xiuwen, *Ladies Room*, 2000. Video

was shot with a camera borrowed from Yang Fudong. His animations adopt the ink-and-wash look of traditional Chinese painting, with wry imagery filtered through the postmodern sensibility of William Kentridge. The most ambitious of them, the *New Book of Mountains and Seas* (2006; *page 226*), updates the ancient illustrated text *Classic of Seas and Mountains*, composed by various authors more than two millennia ago. Bereft of an overarching plot, the original is a systematic compilation of hundreds of semifanciful descriptions of places and creatures, interlarded with brief mythological anecdotes. Qiu new version, created from six thousand sketches drawn by the artist over a six-month period, has a slow, dramatic sweep that seems part course of empire, part *2001: A Space Odyssey* prologue. The primordial void separates into earth and sky, creatures and humans appear, primitive villages give way to walled cities,

ominous blackbirds deliver a mysterious box, and modernization suddenly arrives, along with the birth of hybrid beings (often part-animal, part-machine), eventuating in rampant urban growth that ends in a 9/11-style cataclysm, from which a sole man survives.

The video artist Sun Xun (b. 1980), originally from the remote coal city of Fuxin in Liaoning Province, was by age 28 showing solo at both a major New York gallery and the city's revered Drawing Center. He pursues commercial activity as well, having founded the animation studio Pi in 2006. Due perhaps to the startling changes in his own background, he has taken skepticism toward personal and collective history as his principal theme.

Like Qiu Anxiong, Sun favors a graphic approach to video. His *Lie of the Magician* (2005; *page 227*),

Cui Xiuwen, *One day in 2004, no. 6*, 2005. Chromogenic print

Qiu Anxiong, *New Book of
Mountains and Seas*, 2006.
Video animation

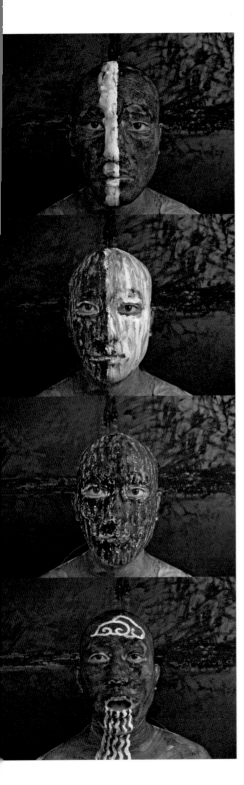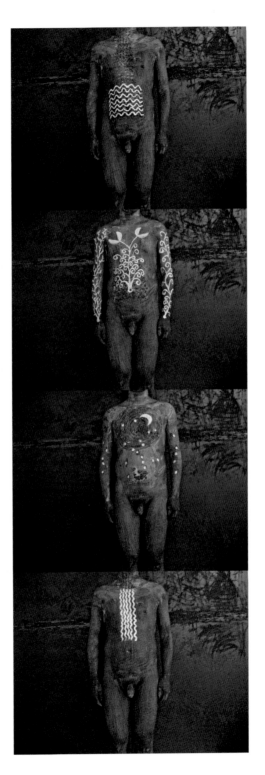

Sun Xun, *Lie of the Magician*, 2005. Animation video, 4:14 min.

completed the year of his graduation from the China Academy in Hangzhou, presents the artist's face and naked torso as the field for a rapidly changing series of drawn patterns and images: cloud, rain, plants, fish, birds, animals, sun, moon, and stars. The artist, in effect, becomes his art. Clothed in black-and-white stage attire at the beginning and end of the piece, he is himself the godlike Magician, whose entire act is one deception after another.

Shock of Time (2006) grounds such thinking in more historical material. Here the opening and closing sequences feature images of construction equipment, tractors, and straining workers—standard fare in the

Zhang Ding, *Great Era*, 2007. Video, 14 min.

pages of the Cultural Revolution publications that serve as the ever-changing surface for Sun's drawings. A throbbing field of black-and-white dots gives way to a cement mixer, then to the words "history is a lie of time." Following, in rapid succession, are a faceless, top-hatted man with cane and cape (the Magician again), a clock, turning gears, and a pendulum. A headless man comes to break through a wall with a sledgehammer, creating a black shape that turns white and then begins to morph, occasionally resembling the map of China. Loudspeakers spill ink, and the video reaches its crescendo with the phrase "mythos expels truth."

The message, visual and textual, is at once clear and disheartening. Schooled in the mercurial, repeatedly "corrected" chronicle of China, and immersed in the nation's current social transformations (to say nothing of its volatile art world), Sun seems to have taken flux, indeterminacy, and the equivalency of "history" and "lie" not as products of particular cultural conditions but as fundamental principles of reality.

Another emerging star video-maker of exactly the same age, Shanghai-based Zhang Ding (b. 1980) produces, in addition, related photo series and installations. The artist hails from Gansu Province in the northwest, home to the famed Buddhist art grottoes near Dunhuang. He studied oil painting at Northwest Minorities University, Langzhou, and new media at the China Academy of Art, Hangzhou.

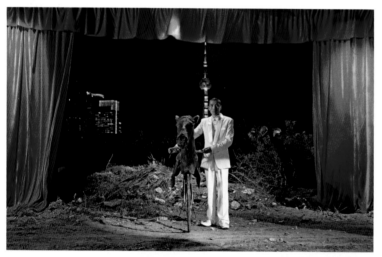

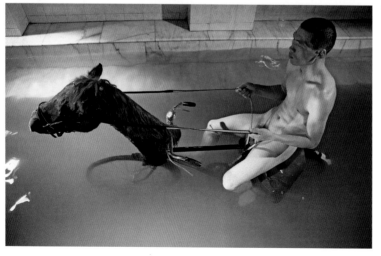

Zhang focuses on the struggle to maintain a quirky sense of identity in harsh circumstances. He keeps an archive of photos of missing-person notices. His ongoing video interview series Pry (begun 2005) examines the lives of unconventional individuals such as an aging transvestite. The artist's two Boxing videos (2007) show him using suspended cacti as punching bags, tearing his bloody fists as he attempts to prove his mettle against these supremely tenacious life forms. In *Great Era* (2007; *left*), he rides a bicycle equipped with a saddle and a horse's head—a metaphor perhaps for his own "pony," his art—in two very different contexts: through the streets of Shanghai (replete with outdoor ballroom dancers), while attired in a white suit; and, nude, inside a small swimming pool. The installation *Dream of Yabulai* (2008), with multiple monitors mounted on an openwork wooden

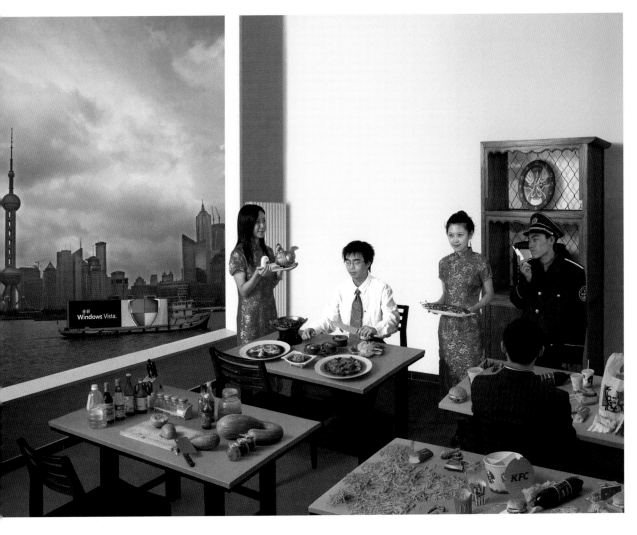

THEY (Ta Men),
Repast, 2007.
Photograph

structure, features scenes of desolation and Sisyphus-like striving—barren vistas, earthmoving equipment in action, a monkey on a chain, a man crawling on a sand dune, another man pulling a roller-suitcase along a river's edge.

As always in China today, a number of artists elude classification by medium because their practice, more conceptually than materially based, floats freely from one art form to another. The young team THEY, composed of three 2001 Central Academy graduates (Chen Li, b. 1973; Lai Shengyu, b. 1978; and Yang Xiaogang, b. 1979), all originally from Hunan Province, specializes in wacky contemporary scenes

realized with equal dexterity as either paintings or large color photographs. Typically, something odd is going on in an austere interior while a totally unrelated scene looms outside beyond the curtainless oversize window (*above*). In the painting *World Trade Center* (2007), a man sits impassively, his back to the viewer, at one table while girls bound like hostages kneel on the surface of another table before a view of what looks like Manhattan's tower-studded lower West Side Highway at sunset. The photograph *Membrane* (2007) features a similar interior in which one man watches TV while two others (one suited, one nude) sit wrapped in plastic, with the four tables strewn with bricks and toy earthmovers; outside in Beijing the bird's nest Olympic

229

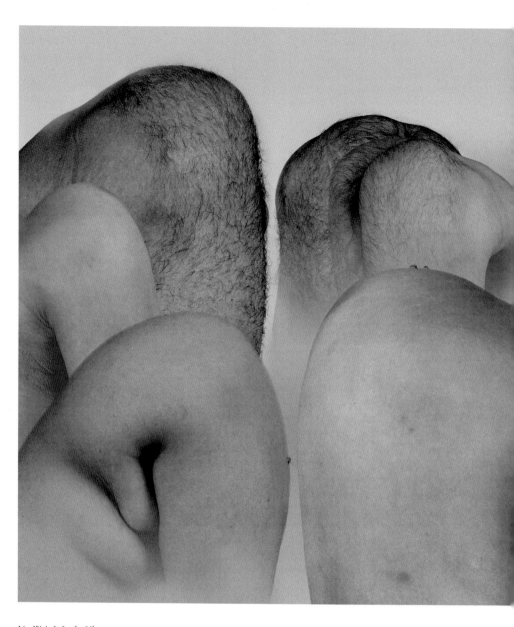

Liu Wei, *It Looks Like a Landscape*, 2004. C-print

Stadium is under construction. The artists have an uncanny feel for both the humor and anguish of runaway change beyond the common citizen's control.

Liu Wei the younger (b. 1972), whose name is identical in English (though not in its second Chinese character) to that of the well-known painter, is another case in point. A graduate of the China Academy in Hangzhou, he now lives and works in his native Beijing, creating projects that range widely in format and theme—usually combining incongruent elements in unlikely conceptual melds. The multichannel, sped-up video *Hard to Restrain* (1999) views spot-lit naked humans from above as they scramble and swarm like so many hyperactive bugs. *Gospel—Hearsay* (2002), a performance installation, combines a Chinese sedan chair with a row of cross-bearing confessionals; one person sitting in the chair reads a Bible passage, then passes it to down the line of confessional occupants. *Event of Art* (2003) proffered microphones on a table in front of an English wall sign reading "everyone has the right to speak," yet anyone who tried to use one of the mikes was drowned out by overpowering feedback. In two videos, shot in 2005 and 2009, Liu goes to Tiananmen Square on the anniversary of the 1989 student massacre and asks people what day it is, or shows them a photograph of a protester facing off with a line of tanks. In both cases, the citizens respond blankly or with an obvious unwillingness to reveal what they remember, or what they think and feel.

Liu is most widely known for several monumentally scaled photographs from 2004, in which a traditional gray-toned landscape of jutting hills turns out, upon close inspection, to be composed of cropped nude human figures, bent over to reveal only a sea of backsides (*pages 230–31*). The wavering building models of the installation *Super Structure* (2005–7) are made from the leathery material used for dog's toys. Many of Liu's paintings, looking like abstracted cityscapes, are derived from computer-generated images. *Indigestion* (2005), the artist's most caustic comment to date on the state of the world, comprises several gigantic asphalt turd-forms studded with plastic figurines, toys, tanks, building parts, airplanes, and weapons.

Li Zhanyang (b. 1969)—previously known for sculptures depicting scenes from folklore, literature, or everyday life (a pig's leg from the butcher shop, a car accident, mahjong players)—caused a stir in Beijing during the Olympic summer of 2008 with "Rent"—Rent Collection Courtyard (2007), a suite of thirty-four life-size painted fiberglass figures parodying the Chinese art world. The piece alters the peasant exploitation theme of the original Mao-era *Rent Collection Courtyard* (1965–66, *page 45*), focusing instead on the ruthlessly complex—but also mutually beneficial—social dynamic among present-day artists, dealers, critics, and collectors. Li, who was born in the far northeastern province of Jilin and did not attend art school, portrays himself in the work as an onlooker, enraptured by the numerous serio-comic scenes that play out before and around him: former Art Basel director Samuel Keller and Chinese artist Cai Guo-Qiang carrying the Christ-like body of the late international curator Harald Szeemann; megacollector Uli Sigg, with bare torso, earnestly pushing a wheelbarrow filled with bits and pieces of his art holdings; curator Gao Minglu in a barred cell, holding a lamp aloft like Diogenes searching for one honest man; art star Ai Weiwei sprawled like a decadent emperor, his feet being washed and massaged by maidens (one of whom sucks his finger) while his long-suffering wife serves tea and fans his face (*opposite*). Perhaps the most piquant tableau in "Rent" centers on a seated Mao, next to whom visionary German artist Joseph Beuys half crouches with one arm extended, presumably whispering to the Great Helmsman of the fantastic world of "social sculpture" to come (*see cover*).

Look to the Future

Before 2008, everyone involved with the New Chinese art scene asked the same question: will the bubble burst? That all-or-nothing paradigm, as the current worldwide readjustment shows, ignores art's wider context. As advanced countries have experienced greater and greater economic disparity over recent decades, with wealth—and so a proclivity for luxury items like artworks—gravitating to the top players of a global, increasingly winner-take-all game, the art market has soared. In the early 2000s, prices for art of all sorts escalated in astronomical fashion, reaching what might seem obscene, unsustainable levels, and

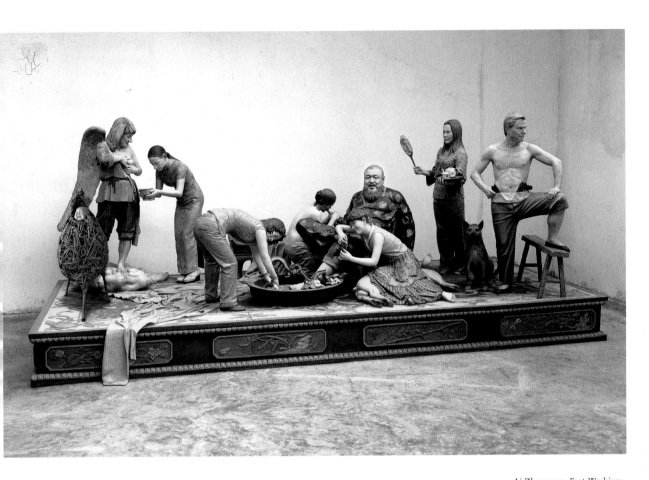

then climbing again. Now that a slow post-2008 recovery is in process, that pattern has begun to reemerge, especially at the very highest levels of the price structure.

It should be remembered, too, that the contemporary art bonanza is only a minute component in the general upsurge of Chinese prosperity. That rate of growth, currently about 10 percent annually, is not evenly distributed, of course. One of Deng Xiaoping's galvanizing precepts was that some people should be allowed to grow rich before others—a virtual prescription for the creation of art collectors. According to Simon Castets, citing *Forbes* and Merrill Lynch in the December 2007 issue of *Yishu*, China in 2005 could claim 300,000 millionaires and five million people making over $30,000. In 2010, CNN reported the nation had 64 billionaires. The cost of living, meanwhile, is about one-fourth of that in the U.S. (although the difference is much less dramatic in major cities, where collectors are likely to live). If and when all this changes, Chinese art will probably be affected neither more nor less than other segments of the economy. Seldom do the rich suffer most in an economic downturn.

To be sure, the art-world spotlight inevitably moves. The ethos of modernism is novelty and change— "make it new," in Ezra Pound's prescient, merciless words. Curators, critics, and dealers look for fresh aesthetic material the way global capitalists look for untapped natural resources, tax havens, and cheap labor pools. What's next—India? The 'Stans of Central Asia? South Africa? In the broader perspective, how many Chinese names and artistic identities can be held at any one time in the world's collective critical mind? Surely nowhere near the 150 or so discussed in this book. As thousands of art students graduate each

Li Zhanyang, *Foot Washing: Christiane Leister, Nataline Colonnello, Tang Xin, Livia Gnos, Lin Suling, Ai Weiwei, Lu Qing, Urs Meile, Bird's Nest with Baby Head*, from the series "Rent"—Rent Collection Yard, 2007. Resin, 224 x 541 x 282 cm, edition of 2

Shen Chen, *Untitled No. 20233-09*, 2009. Acrylic on canvas, 162.6 x 101.6 cm

Lin Yan, *Monument*, 2007.
Xuan paper, 139.7 x 127 cm.
Private collection, New York

235

Cui Fei, *Tracing the Origin I*, 2006. Phototransfer on paper, 76.2 x 55.9 cm. Princeton University Art Museum, Princeton, N.J.

market equity. On the one hand, some Chinese artists' works are selling for twenty-five times what they cost a few years ago. On the other hand, even the field's top-selling works—like Zhang Xiaogang's painting *Tiananmen Square* (1993; *page 239*), which went for $2.3 million at Christie's Hong Kong in November 2006—are only beginning to reach parity in an environment where, say, *Mont Saint-Victoire* (1987) by mid-range American artist Mark Tansey can bring $3 million, as it did at Christie's New York the very same month. For most other Chinese artists, even the major stars, prices still lag far behind those commanded by their Western peers—though the gap is closing fast.

How well the country's art and artists do in the future, however, will depend greatly on how well China does in the next few years erecting a proper art-world infrastructure. Museums must be brought up to international standards—in physical plants and in operating procedures—so that loans and exchanges can be freely made. Art academies and universities should maintain their current rigor while expanding curricula to include more postwar history and methodology. (The 2008 appointment of Xu Bing as a vice president of the Central Academy is a positive sign.) Galleries need to become reliable representatives of select stables of artists, not just occasional showcases for an artist's convenience and fast sales. Mainland auction houses must be reformed. An independent critical press will have to be both demanded and sustained. Cultural policy decisions ought to be taken out of the hands of bureaucrats and turned over to the impressive graduates now coming out of arts administration and art history programs at home and abroad. Tax codes should be altered to reward cultural gifting. Nonprofits need to be upgraded from rag-tag alternative spaces to sophisticated institutions, a shift requiring them to learn membership development and corporate solicitation. Finally, companies and rich individuals must be introduced to the counter-intuitive concept of patronage . . . Or so it seems to a friendly outsider.

year, a great winnowing would seem to be at hand—with a relatively small number of Chinese artists destined to remain at the forefront of consciousness.

The increasing nationalism of the post-2008 Chinese art scene—with its insistence on the mystical quality called authentic "Chineseness" and its insidious suspicion that maybe China doesn't need the rest of the art world—exacerbates a longstanding problem for Chinese artists living abroad. Though such artists sometimes show in mainland China, they reside in a professional (and sometime spiritual) limbo between cultures, fully accepted by neither. In New York alone, this affects scores of deserving artists (some known by their Westernized name order) such as abstract painter Shen Chen (*page 234*); molded-paper constructionist Lin Yan (*page 235*); Cui Fei who makes exquisite pseudo-calligraphy out of thorns and twigs (*above*); cut-paper artist Xin Song (*opposite*); and Ruijun Shen, whose works range from delicate painting to animations to scruffy installations, reflecting both tradition-based and experimental techniques (*page 238*).

Stability and consciousness of national identity are not all bad, of course, since they can facilitate an overdue

The persistence of these problems is well illustrated by the saga of the Ullens Center for Contemporary Art. Occupying nearly 70,000 square feet, the UCCA opened November 5, 2007, in Beijing's Dashanzi art district, known familiarly as Factory 798, a refurbished industrial area currently home to scores of art galleries, artist's studios, bookshops, and restaurants.

The center, housed in the twin vaulted naves of a beautifully repurposed former munitions factory, hosts shows that focus on contemporary Chinese art, including selections from the 1,500-piece Guy and Myrium Ullens collection, as well as international exhibitions.

Launched with a stellar staff that included the noted scholar and curator Fei Dawei, the institution early on espoused the highest professional standards—above all, a determination to keep programming free of commercial influences. Many of its exhibitions have been admirable, from the inaugural survey of '85 New Wave material in 2007 to a one-person show of works by Liu Xiaodong in 2010. Yet Fei Dawei departed virtually before the doors opened, senior positions—almost always held by Westerners—have rotated at an alarming rate, and by 2008 the center was hosting "Christian Dior and Chinese Artists," in which works

commissioned from big-name artists were displayed side-by-side with products from the French fashion house. Then, in spring 2011, most of the Ullens contemporary Chinese art holdings were auctioned off at Sotheby's Hong Kong for nearly $55 million, about three times the high estimate.

As this example shows, it will take not just money and good intentions but something more—a fundamental readjustment in Chinese thinking—before the country attains the artistic infrastructure it deserves. The problem is pervasive. Seen from a distance, the Shanghai skyline is dazzling; examine it closely, you find that most of its glitzy towers are now Class C buildings. The residential apartment blocs that rise in ever greater numbers throughout urban China, while physical if not social or spiritual improvements for inhabitants of the old hutongs, are plagued by tacky designs, inferior materials, poor workmanship, and a

Xin Song, *Lust/Caution* (detail), 2007. Papercut from magazines, 85.1 x 142.2 cm. Private collection

Ruijun Shen, *Murder*, 2006.
Ink and tempera on silk,
114.3 x 177.8 cm

substandard level of maintenance. Most buildings show significant wear within months of opening, and anyone looking at them critically must ask if the PRC's entire construction extravaganza will have to be redone in twenty years. The new push for profits, coupled with a long-standing disdain for the trials of common folk (a quirk shared by emperors and commissars alike), feeds a Chinese preoccupation with form over substance, the look of modernity without the democratic essence.

For in the midst of all this talk of market frenzy, we need to remember that there is a pink—or perhaps a red—elephant in the room. Everything considered here depends ultimately on the policy decisions of the Communist Party. For the moment, its leaders have decided that art—even controversial art, so long as it does not portray raw sex or insult living politicians—can enhance China's national image, particularly abroad. Thus they have given support to traveling exhibitions and allowed visual-art districts like Shanghai's Suzhou Creek and Beijing's Dashanzi to prosper.

That could change. The Chinese government faces stupendous challenges in the years ahead. Environmental havoc, increasingly dangerous economic disparities, human rights issues, millions of displaced and jobless citizens, simmering discontent

in Tibet and among ethnic minorities, a populace in danger of growing old before it grows rich—to say nothing of the problem trying to govern 1.3 billion people (who become daily more accustomed to choice in every other aspect of their lives) with a single political party. For the moment, while there is money to be made in the private sphere, artists—like many other educated, upwardly mobile citizens—seem content to let party loyalists exercise their power. Indeed, one often hears that the government is not disliked. So long as corruption is kept within reasonable bounds, the lack of politicking (and thus of personal civic responsibility) is something of a relief. Until, of course, one has a grievance—like the hapless millions whose lives have been uprooted by the construction of the Three Gorges Dam.

In the realm of art, directives concerning permissible content and modes of presentation come down from the national ministries in very general language, to be interpreted and enforced—often in an arbitrary and inconsistent manner—by provincial, municipal, and district officials whose disposition may have more to do with that morning's interaction with a colleague or spouse than with their mundane understanding of art and law. Many people in the art world, as in every other sector of the society, have learned to get around officialdom the way Western teenagers get around

their parents. Finesse works much better than confrontation. So far, no contemporary Chinese artist has stepped forward to be a sacrificial hero in the mold of jailed activist Liu Xiaobo, who received the 2010 Nobel Peace Prize in absentia. Given the fate of the Tiananmen Square protesters, the Falun Gong adherents, and the silenced literary troublemakers, who can blame artists for their caution? In 2009, Ai Weiwei, whose works were earlier considered more more irreverent than threatening (*page 12*), was beaten by police for supporting investigations of the 2008 Sichuan earthquake; in 2011, his Shanghai branch studio was demolished by government order; then, in early April of the same year, he was "detained" incommunicado by the police in Beijing, on suspicion of "economic crimes—which carry potentially serious consequences in China. As this edition goes to press, his fate is unknown.

Throughout the Chinese art world, understandably, a self-censorship prevails that is by now so insidious it barely impinges on consciousness. When artists are not playing a deliberate cat-and-mouse game, testing to see where the limit is today, they avoid blatantly unacceptable material almost instinctively. It remains to be seen whether the government's combination of diversion and intimidation will continue to work, especially when domestic problems intensify and the rate of increase in private wealth subsides.

Come what may, though, China—with its size, its wealth, its energetic populace—is not about to disappear. As we have seen in the preceding chapters, the country's artistic fate, both by design and momentum, seems set for the foreseeable future. Whatever global economic currents may dictate, whatever policy changes the Communist Party enacts, whatever social and political complications ensue, the rich reality of the New China, as it evolves in the century ahead, will be reflected in a deftly intelligent art of quick, voracious responsiveness.

Zhang Xiaogang,
Tiananmen Square, 1993.
Oil on canvas,
150 x 188.5 cm

APPENDIX

HISTORY LESSONS

Out of the infinite complexity of China's past, certain salient features remain ever-present in the popular imagination, mental landmarks for even the most radical new artists. Foremost, perhaps, is the legacy of centralized authority. Following nearly three millennia of dynastic kingships and the turmoil of the Warring States period (475–221 B.C.), during which warlords of seven states wrangled bloodily for dominance, Qin Shi Huang (259–210 B.C.), initiator of the Great Wall, established himself as the first emperor of all China. Though invaders or internal schemers periodically overturned dynasties, the Imperial paradigm—predicated on the Mandate of Heaven, a cosmic blessing (manifest in natural and political order) that flowed to just rulers—lasted more than two thousand years, until the founding of the Republic of China in 1911. Just thirty-eight years later, an imperium was, in effect, reinstated with the 1949 triumph of the Communist Party, still the sole political authority in China. (To this day, aspirants must be voted into the party, which now numbers seventy-eight million members—less than 8 percent of the adult population.)

The physical persistence of the Great Wall (in legend a four-thousand-mile bulwark against marauding barbarians), along with its easy day-trip proximity to Beijing, has served as a persistent reminder of another great constant in Chinese history—the ceaseless oscillation between enclosure and openness. The traditional name for China (*Zhongguo*), "the Middle Kingdom," may have originally referred to the physical position of the Zhou domain (1122–256 B.C.) among its vassal states but was soon associated with the notion of an imperial center (the Throne of Heaven), metaphorically situated halfway between heaven and earth, surrounded by concentric rings of places and peoples whose importance diminished in proportion to their distance from the center.

From its very beginnings a land not only of agricultural peasantry but also of shopkeepers and adventurous, highly sophisticated traders, China has alternatively welcomed commerce from abroad and sent its own commercial agents far and wide—but then, fearing internal disorder and a corruption of traditional proprieties, shut itself off from threatening foreign peoples and goods. For millennia, the Silk Route, extending as much as five thousand miles by land and sea, brought indirect contact—through objects traded at various intermediary points—with peoples throughout Asia and parts of Europe.

Yet, in the thirteenth century A.D., Marco Polo found what seemed to him almost an alternative universe operating under the Mongolian emperor Kublai Khan and returned to the West with tales of wonders— including paper money—whose fascination has scarcely diminished to this day. Though commerce was actively sought, and individual travelers and official emissaries usually welcomed, in small numbers,

or their expertise or entertainment value, foreign groups were customarily viewed as inferior and potentially menacing. The subjugation by the Mongols from 1271 to 1368 and the displacement of the ruling Han majority by the invading northern Manchus, marked by the shift from the Ming to the Qing dynasty in 1644, are just two memorable examples of the cost to empire that might result from military or moral laxity.

More relevant to today's policies are the threats that came from across the seas. In the early fifteenth century, Ming authorities—wishing to establish Chinese dominance over sea trade—sent the eunuch admiral Zheng He on repeated voyages to South Asia, the Indian Ocean, and perhaps as far as the coast of Africa. Zheng succeeded brilliantly, but the cost of the expeditions was so great that future large-scale ships and flotillas were banned, leaving China vulnerable to sea-borne encroachments in the sixteenth century, especially from the Portuguese.

In the eighteenth century, Britain, suffering a severe trade imbalance due to the wild popularity of tea, porcelain, and silk at home in contrast to the limited demand for British products in China, set about redressing its losses by smuggling opium (produced in British-controlled India) into China, where importation of the physically and socially debilitating drug was legal. The contraband was trafficked in monopolistic fashion for decades by the British East India Company, with the unstinting support of British government. China resisted, futilely, fighting two Opium Wars (1839–42 and 1856–60) that resulted in major humiliations: the opening of six ports to Western merchants; the ceding of Hong Kong to Britain; the establishment of self-governing areas or "concessions" in Shanghai and elsewhere; the accreditation of foreign diplomats and the acceptance of missionaries, travelers, and businessmen in the Chinese interior; permission for British ships to carry indentured Chinese citizens abroad; payment of cash reparations to Britain and France; and legalization of the opium trade. France, Britain's ally in the Second Opium War, as well as supporters Russia (which thereby obtained a large portion of Manchuria) and the United States shared in these benefits.

The ineffectuality of the Qing dynasty (1644–1911) gave rise to numerous revolts, two of which stand out

Zhang Dali, *Demolition: Forbidden City*, Beijing, 1998. Site-specific work

to this day. Following famines in the 1840s, Hong Xiuquan, a farmer's son who had repeatedly failed the civil service exams, came to believe that he was the younger brother of Jesus Christ, ordained to drive out the devil worship of the Manchus. From 1850 to 1864, in a move that presaged the latter stages of Maoism, he led the fanatical Taiping Rebellion, aimed at establishing a Heavenly Kingdom on earth. Under Hong himself as absolute ruler, wealth was to be equally distributed throughout a classless, non-sexist society, free of private property, opium, tobacco, gambling, alcohol, polygamy, foot binding, prostitution, and slavery. After seizing Nanjing and making it his capital, Hong (when not distracted by wine, women and such theological matters as redefining the Holy Trinity) continuously battled the imperial armies—at a cost of 20 to 30 million lives (out of a population of 400 million)—until his forces were utterly crushed and his own body was found, wrapped in a yellow robe, awash in a city sewer.

In the Boxer Rebellion (1899–1901), members of the secret Society of Right and Harmonious Fists, so named for their skill in weaponless hand-to-hand fighting, at first targeted the Qing power structure. But they were persuaded by the dowager empress Cixi (a culturally conservative former concubine) to turn

243

instead against foreigners residing in China—prompting the deaths of 230 Western missionaries and many thousands of Chinese Christians. In June 1900 the Boxers assaulted the foreign legations near the Forbidden City, but the Western garrison held out for fifty-five days, until liberated by an eight-nation expeditionary force. (The military outcome was affected in part by the Boxers' belief that they would be impervious to bullets, capable of superhuman feats of physical strength, and aided by a spirit army incensed at the presence of "white devils" on Chinese soil.) Altogether, some 54,000 foreign troops and 50 warships participated in the eradication of the Boxers in Beijing, the port city of Tianjin, and provincial outposts. Thereafter, the Western powers imposed Boxer Protocols that effectively emasculated the Qing government, forcing it to pay large reparations and accept the stationing of foreign troops in the capital.

China had been sending students and officials abroad throughout the latter half of the nineteenth century, with the hope of learning how to modernize the homeland without sacrificing its sovereignty and traditional character. Starting in 1849, the California Gold Rush (America transliterates from Mandarin as "Beautiful Country," while San Francisco is "Old Gold Mountain") and construction of the transcontinental railroad brought so many Chinese laborers into the United States—where Oriental phobia ran high—that in 1882 Congress passed the Chinese Exclusion Act. Even after the bill was repealed in 1943, only 105 Chinese per year were allowed to immigrate to the States—a quota that remained in place until 1965.

Meanwhile, the incursion of foreign-owned railroads and factories into China brought both admiration and resentment of Westerners and a domestic pressure for new goods: newspapers, banks, street lights, photographs, cinema, bicycles, automobiles. The intellectual reforms that followed the Boxer Rebellion—admission of women to universities, the displacement of Confucian studies by Western empiricism, elimination of the classics-based civil service exam—helped prepare the way for republicanism, social unrest, modern art practices, and, eventually, socialist theory.

The empress Cixi died in 1908, leaving the two-year-old Pu Yi to reign briefly as the last legitimate emperor. In 1911, while troops were dispatched south to Sichuan Province to quell rioters protesting foreign ownership of railroads, revolutionaries in Wuhan, in the central province of Hubei, began an armed insurrection at the urging of their exiled leader Sun Yat-sen. A Christian medical doctor trained in Hawaii and Hong Kong, Sun had fled after his first republican revolt failed in 1895. Advocating the Three Principles of nationalism, democracy, and public welfare, he was named first president of the Provisional Republic of China, founded in Nanjing in December 1911. However, Sun soon had to cede the presidency to general Yuan Shikai, who forced the abdication of the emperor and eventually assumed the exalted title himself, prompting open rebellion in several provinces in 1916, just before Yuan's death.

In 1919 popular outrage over the Versailles Treaty, in which the Western powers granted stretches of Chinese territory to Japan despite China's support of the Allies in World War I, led to a massive demonstration in Beijing and initiation of the commemorative May 4th Movement, which blamed China's weakness not only on imperialists and warlords but also on an antiquated and backward-looking Chinese culture. The advocates of radical modernization included a Marxist faction that laid the groundwork for the formation of the Chinese Communist Party in 1921.

Sun Yat-sen, who died in 1925, had helped found another powerful entity, the Kuomintang (Nationalist Party), in 1912. For nearly thirty years (1921–49), the Kuomintang contended politically and militarily with the Communists for control of China, with Chiang Kai-shek and Mao Zedong eventually emerging as supreme leaders of the opposing forces. In 1934 Mao's battered army undertook the legendary Long March, a year-long 5,000-mile retreat to the stronghold city of Yan'an in Shaanxi Province, which remained the Communist home base until 1947. Seventy-eight percent of the original 90,000 marchers are believed to have perished, but the Communist cause was saved and the leadership of the party (notably Mao, Zhou Enlai, Lin Biao, and Deng Xiaoping) was solidified for decades to come.

While hostility toward the Western powers built for nearly a century as Europe and Russia pushed to segment China into distinct, mutually exclusive "spheres of influence" (while the U.S., not wishing to

be left out, promoted an "open door" policy), it was nearby Japan that most profoundly devastated the country. The Japanese deprived China of Taiwan and Korea in the First Sino-Japanese War (1894–95), then occupied Manchuria in 1931, and finally ravaged huge portions of the mainland in the Second Sino-Japanese War (1937–45)—known in China, fairly enough, as the War of Resistance Against Japanese Aggression. Among the most crushing onslaughts was the Rape of Nanjing (1937), a six-week rampage of looting, sexual assaults, and mass executions that left 200,000 city residents dead. In all, 15 million Chinese died in the second war with Japan.

At times during that massive conflict, Kuomintang and Communist forces united to confront the invaders, but in 1946, following the Allied defeat of Japan, civil war broke out again. Triumph finally came for the Communists on October 1, 1949, when Mao declared the birth of the People's Republic of China. Two months later, Chiang Kai-shek fled to Taiwan, which had already received two million Nationalist refugees, along with mainland China's gold reserves, and the majority of its greatest artistic treasures from the imperial collections.

Even in the best of times, modern China had been a place where the splendors of the emperor's court in Beijing were offset by factors like the decadence of the port city Shanghai. (Called both the Paris of the East and the Whore of the Orient, Shanghai was famed not only for international banks and trading houses on the Bund but also for nightclubs, opium dens, prostitutes, and smugglers in the darker quarters.) The entire country had endured child labor, local tyranny by landowners and warlords, abuse of domestic servants, brutal suppression of striking workers, famines, and outright starvation. Now, struggling to right these old wrongs, the fledgling Communist government also faced the damage wrought upon the national infrastructure by three decades of civil conflict and foreign invasion.

Mao's response, initially salutary, would eventually involve nationalization of industries, collectivization of farms, organization of the populace into closely monitored communes and work units (danwei), substitution of ration tickets for currency, and an "iron rice bowl" policy guaranteeing lifelong employment and care (education, medical treatment, retirement) in exchange for unwavering devotion to the common good, as determined by the cadres of the Communist Party.

The new PRC's military and diplomatic maneuvers often irked the West. The United States especially objected to China's support of Communist North Korea during the Korean War (1950–53); its harassment of Taiwan (through the shelling of Kinmen Island and repeated threats to invade the errant "province" of Taiwan itself); an on-again, off-again alliance with the Communist superpower, the USSR; and material support of North Vietnam during its struggles against France and the U.S. (1941–75), followed by China's own aborted incursion into Vietnam in 1979. But it is, of course, within the borders of the PRC proper that the greatest consequences of the Communist victory played out.

Early on, remarkable improvements were made. The first Five Year Plan (1953–57) built up national infrastructure, tamed inflation, and greatly boosted industrial production. Foot binding was outlawed, and greater rights were granted to women. Before long, however, the hidden costs of a command society became evident. Internal passports were instituted in 1956, restricting domestic travel. In 1957, Mao's propaganda ministry declared a policy of intellectual freedom, including freedom to openly criticize government decisions: "let a hundred flowers bloom, let a hundred schools of thought contend." People who came forward with complaints and suggestions—as they did in great numbers and with great élan—were soon entrapped. An "anti-rightist" campaign deprived some 400,000 of jobs and homes, dispatching most to labor camps or forced "re-education" in the remote countryside.

The next year, Mao launched the Great Leap Forward (1958–60), which forced farmers into agricultural communes, drafted huge numbers of workers into often ill-conceived dam, canal, and irrigation projects, and directed country folk to set up backyard furnaces for the production of steel. As a result, agricultural output fell, metal production faltered, and famine set in. To maintain the illusion that quotas were being met and exceeded, grain was shipped in disproportionate quantities to the cities. Nearly 40 million people died.

In 1959, the year that the disaster of the Great Leap became undeniable and that China definitively reasserted its dominion over Tibet, causing the Dalai Lama to flee to India, Mao resigned his chairmanship of the state but retained that of the Communist Party. After allowing others to deal with economic recovery for seven years, he reclaimed authority in 1966—symbolically with a famous swim in the Yangtze River, showing himself to be an exceptionally vigorous seventy-two-year-old; and practically by throwing his support to the radical student Red Guards in the Great Proletarian Cultural Revolution (1966–76). This titanic social upheaval, which cost several hundred thousand lives, was directed not only against "rightist" (i.e., moderate) elements within the party and the government but against all remnants of the feudal past, including classic works of art and literature; religious objects, buildings, and practices; rich peasants; and intellectuals of every stripe. Professors were beaten, some fatally, by their own students; universities were closed; artworks were shattered and books burned; members of the intelligentsia (including 16.5 million "educated youths") were exiled to the countryside, to learn from farmers and workers; self-criticism sessions became de rigueur and offenders were often humiliated before large crowds. The Little Red Book, a compilation of excerpts from Mao's speeches and writings, became the only fully sanctioned volume in print—to be carried at all times and cited religiously.

Within three years, Mao began to distrust the mass hysteria he had unleashed, but the fervor was sustained—even after his death on Sept. 9, 1976—by his wife, Jiang Qing, and three colleagues known collectively as the Gang of Four, until the group's arrest in October 1976.

Power then passed to Deng Xiaoping, although his various titles (e.g., vice premier, vice chairman of the Communist Party) never reflected the full extent of his dominance—a common circumstance in modern Chinese politics. China had already become a nuclear force (atomic in 1964, thermonuclear in 1967) and had launched its first satellite in 1970. In addition, relations with the West had thawed in the early 1970s. Practicing "Ping Pong diplomacy" in the spring of 1971, the U.S. table-tennis team became the first ordinary Americans to enter China in over two decades. That fall, despite resistance from the U.S. (which advo-

cated a dual recognition), the People's Republic of China was seated at the UN in place of Nationalist Taiwan. In 1972, Richard Nixon became the first U.S. president to visit Communist China.

With the PRC's international status rising, Deng sought to make the country a global economic player as well. In the late 1970s he undertook the Four Modernizations (defense, farming, technology, and manufacture), eventually declaring that "poverty is not socialism; to grow rich is glorious." The goal was—and for the party still is—"socialism with Chinese characteristics," which has translated into (currently diminishing) state ownership of major industries. The One Child Policy was instituted in 1979 to stem China's population boom (the populace, despite multiple disasters, had tripled in less than a century). Riddled with exceptions and more loosely applied—via social pressure and financial penalties—in the countryside than in the cities, the One Child Policy has nevertheless worked, making the current national head-count some 350 million lower than it would have been otherwise. It has also fostered the abortion or abandonment of many girls, spawned the "little prince" syndrome of spoiled little boys, and created a surplus of over 20 million unmarried males.

Seeing the capitalistic, ethnically Chinese bastions of Taiwan and Hong Kong (a British crown colony since 1842) prospering glaringly at the PRC's borders, Deng moved, from 1978 onward, to establish a growing number of Special Economic Zones, spurring both local enterprises and international joint ventures. In 1980 China was granted "most favored nation" trading status with the U.S.

Such socio-economic revamping animated not only a long-suppressed entrepreneurial spirit but also—especially once information, investments, visitors, and pop culture began to pour in from the West in the 1980s—a burgeoning desire for democratic reform. Fervor peaked in spring 1989, when for seven weeks students, activists, and workers gathered in Beijing's Tiananmen Square in numbers that at times topped one million, issuing demands, protesting corruption, and thrilling to open dissent. Their icon in the final days of action was the thirty-three-foot-high Goddess of Democracy, a white figure bearing a striking resemblance to the Statue of Liberty.

For Western observers the Tiananmen demonstrations, which included a hunger strike, had elements of the Hungarian Revolt (1956), the Prague Spring, and the Days of May in Paris (both 1968). Sadly, they ended in the same fashion—with troops and tanks. Deng Xiaoping, who had headed the anti-rightist purge of 1957, overruled high-ranking moderates and sympathizers, and ordered Tiananmen Square cleared by military force on June 3 and 4. Many hundreds were killed, wounded, or arrested, though to this day the massacre is shrouded in a veil of official denial.

Deng resigned his official offices after Tiananmen Square but continued to wield behind-the-scenes influence virtually until his death in 1997. His successors—Jiang Zemin (in power 1989–2002) and Hu Jintao (2002–present)—have continued Deng's policy of "capitalism, yes; democracy, no." China's ongoing economic miracle has thus astonished the world, as the PRC peaceably gained control of Hong Kong (1997), preserving its more individualistic brand of capitalism on the principle of "one country, two systems," joined the World Trade Organization (2001), and sent an astronaut into space (2003). China recently hosted the international Olympic Games in Beijing (2008) and the World Expo in Shanghai (2010).

Chinese leaders can make a plausible case for needing autocratic party rule in a country so vast. Behind them lies a long history of squabbling warlords, foreign invasion, and civil war; before them daily is the spectacle of the USSR's dissolution into a gangster state, exploited by self-serving oligarchs. In the official view, a unified China is infinitely preferable to a China riven into antagonistic political (and potentially military) factions. At present, the new middle class, enchanted by its own economic luck, seems more than willing to play along.

So, for now, the People's Republic—cohesive and prospering—remains a nation without free elections, where Mao is officially said to have been "70 percent correct, 30 percent wrong" (his major error being the now denounced Cultural Revolution), where the Tiananmen massacre has virtually no place in history books or the consciousness of those under thirty-five, where many new fortunes are made through illicit dealings with government agencies, where banks are overextended on bad development loans, where civil

rights activists are routinely censored or jailed, where tens of thousands of (largely unreported) rural protests take place each year, where the environment is aggressively polluted, where Tibet is subjugated by force, where economic advantage is pursued abroad (especially in Darfur and other African locales) without regard to human rights, and where economic disparities run rampant. It is also a land of energy and hope, geared to practical solutions, and home to a dazzlingly rich culture, sustained—as any visitor will attest—by some of the shrewdest, hardest working, and most hospitable people on earth.

Wang Keping, *Idol*, 1979. Wood, National Art Museum of China, Beijing

SELECTED BIBLIOGRAPHY

Entries are limited to a small number of critical surveys and group-show catalogues likely to be of interest to scholars and non-specialists alike. Those wishing to pursue more focused study will find abundant monographs and articles listed in Britta Erickson's internet compilation at www.stanford.edu/dept/art/china and in the online CVs of the artists discussed in *New China, New Art*. Several of the books cited below also contain substantial bibliographies.

Andrews, Julia F. *Painters and Politics in the People's Republic of China, 1949–1979*. Berkeley: University of California Press, 1994.

Andrews, Julia F., and Gao Minglu. *Fragmented Memory: The Chinese Avant-Garde in Exile*. Columbus: Ohio State University, Wexner Center for the Arts, 1993.

Andrews, Julia F., and Shen Kuiyi, eds. *A Century in Crisis: Modernity and Tradition in the Art of Twentieth Century China*. New York: Guggenheim Museum, 1998.

Barmé, Geremie. *Shades of Mao: The Posthumous Cult of the Great Leader*. London: M.E. Sharpe, 1996.

—. *In the Red: On Contemporary Chinese Culture*. New York: Columbia University Press, 1999.

Berghuis, Thomas J. *Performance Art in China*. Hong Kong: Timezone 8, 2006.

Boers, Waling, Pi Li, and Brigette Oetker, eds. *Touching Stones: China Art Now*. Cologne: Walther König, 2007.

Chen Long, ed. *Shanghai Spirit: Shanghai Biennale 2000*. Shanghai: Shanghai Art Museum, 2000.

Chiu, Melissa. *Breakout: Chinese Art Outside China*. Milan: Edizioni Charta, 2006.

Clark, John, ed. *Chinese Art at the End of the Millennium*. Hong Kong: New Art Media, 2000.

Cohen, Joan Lebold. *The New Chinese Painting, 1949–1986*. New York: Harry N. Abrams, 1987.

Doran, Valerie C., ed. *China's New Art, Post-1989*. Hong Kong: Hanart TZ Gallery, 1993.

Driessen, Chris, and Heidi van Mierlo, eds. *Another Long March: Chinese Conceptual and Installation Art in the Nineties*. Breda: Fundament Foundation, 1997.

Erickson, Britta. *On the Edge: Contemporary Chinese Artists Encounter the West*. Hong Kong: Timezone 8, 2005.

Erickson, Britta, et al. *China Onward: The Estella Collection: Chinese Contemporary Art, 1966–2006*.

Humlebaek, Denmark: Louisiana Museum of Modern Art, 2007.

Fang Zengxian and Xu Jiang, eds. *Techniques of the Visible: Shanghai Biennale 2004.* Shanghai: Shanghai Art Museum and Shanghai Fine Art Publishers, 2004.

—, eds. *Hyperdesign: Shanghai Biennale 2006.* Shanghai: Shanghai Art Museum and Shanghai Fine Art Publishers, 2006.

Fei Dawei, ed. *'85 New Wave: The Birth of Chinese Contemporary Art.* Beijing: Ullens Center for Contemporary Art, 2007.

—, et al. *In Between Limits.* Kyongju and Seoul, Korea: Sonje Museum of Contemporary Art, 1997.

Feng Bin, et al. *Reboot: The Third Chengdu Biennale.* Chengdu: Chengdu Contemporary Art Museum, 2007.

Fibicher, Bernhard, and Matthias Frehner, eds. *Mahjong: Contemporary Chinese Art from the Sigg Collection.* Ostfildern, Germany: Hatje Cantz Verlag, 2005.

Fong, Wen C., James C.Y. Watt, et al. *Possessing the Past: Treasures from the National Palace Museum, Taipei.* New York: Metropolitan Museum of Art; Taipei: National Palace Museum, 1996.

Gao Minglu. *Chinese Maximalism.* Chongqing: Chongqing Publishing House, 2003.

—, ed. *Inside Out: New Chinese Art.* San Francisco, San Francisco Museum or Modern Art; New York: Asia Society; Berkeley and Los Angeles: University of California Press, 1998.

—. *The No Name: A History of a Self-Exiled Avant-Garde.* Guilin: Guangxi shi fan da xue chu ban she, 2007.

—. *Total Modernity and the Avant-Garde in Twentieth-Century Chinese Art.* Cambridge, Mass.: MIT Press, 2011.

—. *The Wall: Reshaping Contemporary Chinese Art.* Buffalo: Buffalo Fine Arts Academy; Beijing: Millennium Art Museum, 2005.

Galikowski, Maria. *Art and Politics in China, 1949–84.* Hong Kong: Chinese University Press, 1998.

Grosenick, Uta, and Caspar H. Schübbe, eds. *China Art Book.* Cologne: DuMont Buchverlag, 2007.

Guo Xiaoli, Li Peigi, Xu Tengfei, eds. *Thirty Years of Contemporary Chinese Art 1979–2009,* Shanghai: Minsheng Art Museum, 2010.

Hearn, Maxwell K., and Judith G. Smith, eds. *Chinese Art: Modern Expressions.* New York: Metropolitan Museum of Art; New Haven: Yale University Press, 2001.

Holm, David. *Art and Ideology in Communist China.* Oxford: Clarendon Press, 1988.

Holm, Michael Juul, and Anders Kold, eds. *Made in China.* Humlebaek, Denmark: Louisiana Museum of Modern Art, 2007.

Hou Hanru, texts selected and edited by Yu Hsiao-Hwei. *On the Mid-Ground.* Hong Kong: Timezone 8, 2002.

Hua Tianxue, Ai Weiwei, and Feng Boyi, eds. *Fuck Off.* Shanghai: Eastlink Gallery, 2000.

Huang Rui, ed., *Beijing 798: Reflections on Art, Architecture, and Society in China.* Hong Kong: Timezone 8 and Thinking Hands, 2004.

Huot, Claire. *China's New Cultural Scene: A Handbook of Changes.* Durham and London: Duke University Press, 2000.

Iturrioz, Susana. *Zhù Yì: Chinese Contemporary Photography.* Vitoria-Gasteiz, Spain: Basque Museum-Centre of Contemporary Art, 2007.

Jiang Jiehong, et al. *The Revolution Continues: New Art from China: The Saatchi Collection.* New York: Rizzoli, 2008.

Jin Shangyi, Liu Dawei, and Feng Yuan, eds. *The Album of the First Beijing International Art Biennale, China.* Beijing: Peope's Fine Arts Publishing House, 2003.

Jordan, Francesca, and Primo Marella. *China Art Now: Out of the Red*. Milan: Marella Arte Contemporanea, 2003.

Jose, N., ed., *Mao Goes Pop: China Post 1989*. Sydney: Museum of Contemporary Art, 1993.

Kelly, Jeff, et al. *Half-Life of a Dream: Contemporary Chinese Art from the Logan Collection*. San Francisco: San Francisco Museum of Modern Art; Berkeley and London: University of California Press, 2008.

Kim, Yu Yeon, et al. *Translated Acts: Performance and Body Art from East Asia 1990–2001*. Berlin: Haus der Kulturen der Welt; New York: Queens Museum of Art, 2001.

Köppel-Yang, Martina. *Semiotic Warfare: A Semiotic Analysis of the Chinese Avant-Garde, 1979–1989*. Hong Kong: Timezone 8 Limited, 2003.

Kóvskaya, Maya, ed. *China Under Construction: Contemporary Art from the People's Republic*. Futurista Arts, 2008.

Kung, Samuel, ed. *Entry Gate: Chinese Aesthetics of Heterogeneity*. Shanghai: Museum of Contemporary Art, 2006.

Laing, Ellen Johnson. *The Winking Owl: Art in the People's Republic of China*. Berkeley: University of California Press, 1988.

Li Zhensheng. *Red-Color News Soldier: A Chinese Photographer's Odyssey Through the Cultural Revolution*. New York: Phaidon Press, 2003.

de Lima Greene, Alison, et al. *Red Hot: Asian Art Today from the Chaney Family Collection*. Houston: Museum of Fine Arts, 2007.

Lü Peng. *A History of Art in 20th Century China*. Milan and New York: Charta, 2010

Millichap, John, ed. *3030: New Photography in China*. Hong Kong: 3030 Press, 2006.

Mowry, Robert D., ed. *A Tradition Redefined: Modern and Contemporary Ink Paintings from the Chu-tsing Li Collection, 1950–2000*. Cambridge, Mass.: Harvard University Art Museums; New Haven and London: Yale University Press, 2007.

Nuridsany, Michel. *China: Art Now*. Paris: Éditions Flammarion, 2004.

Pakesch, Peter, ed. *China Welcomes You: Desires, Struggles, New Identities*. Graz: Kunsthaus Graz; Cologne: Walther König, 2007.

Pollock, Barbara. *The Wild, Wild East: An American Critic's Adventures in China*. Hong Kong: Timezone 8, 2010.

Rogers, Howard, ed. *China: 5,000 Years; Innovation and Transformation in the Arts*. New York: Solomon R. Guggenheim Foundation; Beijing: Art Exhibitions, Beijing, 1998.

Sans, Jérôme. *China Talks: Interviews with 32 Contemporary Artists*. Hong Kong: Timezone 8, 2009.

Smith, Karen. *Nine Lives: The Birth of Avant-Garde Art in New China*. Zurich: Scalo Verlag AG, 2006.

—, et al. *The Real Thing: Contemporary Art from China*. London: Tate Publishing, 2007.

Sullivan, Michael. *The Arts of China*. Berkeley, Los Angeles, London: University of California Press, 1967; multiple revised editions.

—. *Art and Artists of Twentieth-Century China*. Berkeley, Los Angeles, London: University of California Press, 1996.

Tinari, Philip, ed. *Airplanes and Parachutes: A Jonathan Napack Anthology*. Beijing: Art Basel, 2007.

—. *Artists in China*. London: Verba Volant, 2007.

—, ed. *U-Turn: 30 Years of Contemporary Art in China*, Vol. I. New York: AW ASIA, 2007.

Wang Huangsheng, Hou Hanru, and Hans Ulrich Obrist, eds. *Beyond: An Extraordinary Space of Experimentation for Modernization: The Second Guangzhou Triennial*. Guangzhou: Guangdong Museum of Art, 2005.

Watiss, Wendy, et al. *Photography from China, 1934–2008*. Houston: FotoFest, 2008.

Watt, James C.Y., et al. *China: Dawn of a Golden Age, 200–750 AD*. New York: Metropolitan Museum of Art; New Haven and London: Yale University Press, 2004.

Wu Hung, ed. *Contemporary Chinese Art: Primary Documents*. New York: Museum of Modern Art, 2010.

—. *Exhibiting Experimental Art in China*. Chicago: University of Chicago, David and Alfred Smart Museum of Art, 2000.

—. *Making History: Wu Hung on Contemporary Art*. Hong Kong: Timezone 8, 2008.

—. *Shu: Reinventing Books in Contemporary Chinese Art*. New York: China Institute, 2006.

—. *Transience: Chinese Experimental Art at the End of the Twentieth Century*. Chicago: University of Chicago, David and Alfred Smart Museum of Art, 1999.

—. *Wu Hung on Contemporary Chinese Artists*. Hong Kong: Timezone 8, 2009.

Wu Hung and Christopher Phillips. *Between Past and Future: New Photography and Video from China*. Chicago: University of Chicago, David and Alfred Smart Museum of Art; New York: International Center of Photography; Göttingen, Germany: Steidl Publishers, 2004.

Wu Hung, Wang Huangsheng, and Feng Boyi, eds. *Reinterpretation: A Decade of Experimental Chinese Art (1990–2000); The First Guangzhou Triennial*. Guangzhou: Guangdong Museum of Art, 2002.

Xu Jiang and Li Xiangyang, eds. *Urban Creation: Shanghai Biennale 2002*. Shanghai: Shanghai Art Museum, 2002.

Yang, Alice. *Why Asia? Contemporary Asian and Asian American Art*. New York: New York University Press, 1998.

Yang Xin, et al. *Three Thousand Years of Chinese Painting*. New Haven and London: Yale University Press; Beijing: Foreign Languages Press, 1997.

Yao, Pauline J. *In Production Mode: Contemporary Art in China*. Beijing, Hong Kong: Chinese Contemporary Art Awards and Timezone 8, 2008.

Zhang Li, ed. *Towards a New Image: Twenty Years of Contemporary Chinese Painting, 1981–2001*. Beijing: Beijing Contemporary Visual Art Development Company, 2001.

INDEX OF NAMES

Photography Credits

Ai Weiwei, courtesy Galerie Urs Meile, Lucerne-Beijing: 12, 112, 113, 114, 115; 116 photograph © Tate, London 2011; 117, photograph by Watanabe Osamu, courtesy Mori Art Museum
Bai Yiluo, courtesy Galerie Urs Meile, Lucerne-Beijing: 153 (bottom)
Bird Head (Ji Weiyu and Song Tao), courtesy the artist: 216
Cang Xin, courtesy China Square Gallery, New York: 144, 145
Cai Guo-Qiang: 8, photograph by Iro Ihara, courtesy Cai Studio; 42–43, photo graph courtesy National Gallery of Canada; 65 © Solomon R. Guggenheim Foundation, New York, photograph by David Heald; 66 photograph by Tatsumi Masatoshi, courtesy Cai Studio
Cao Fei, courtesy the artist and Lombard-Fried Projects: 164–166, 188, 189, 190, 191, 192, 193
Chen Jiagang, courtesy China Square Gallery, New York: 218–19 (top)
Chen Lingyang, courtesy Galerie Urs Meile, Lucerne-Beijing: 146, 147
Chen Qiulin, courtesy the artist and Max Protetch Gallery, New York: 218 (bottom)
Chen Shaoxiong, © Chen Shaoxiong, courtesy Barbara Gross Galerie, Munich, and Universal Studios, Beijing: 152, 153 (top)
Chen Yifei: 18
Chen Zhen, courtesy Galleria Continua, San Gimignano–Beijing: 54, photo graph by Daniel Moulinet; 55, photograph by Attilio Maranzano
Chi Peng, courtesy Chambers Fine Art, New York: 220, 221, 222
Cui Fei, photograph by Bruce White, courtesy Cheryl McGinnis Gallery: 236
Cui Xiuwen, courtesy Marella Gallery Beijing: 224, 225
Ding Yi, © Ding Yi, courtesy the artist and ShangART Gallery, Shanghai, and Galerie Karsten Greve, Paris : 41
Fang Lijun, courtesy Arario Gallery, Beijing: 29 (top)
Feng Mengbo, © Feng Mengbo: 176, 177
Feng Zhengjie, courtesy Willem Kerseboom Gallery, Netherlands: 27
Geng Jianyi: 16–17
Gu Dexin, courtesy the artist and Galleria Continua, Beijing: 67 (top); 67 (bottom), photograph by Ela Bialkowska
Gu, Wenda © Wenda Gu: 60, 61
Hai Bo, courtesy the artist and Max Protetch Gallery, New York: 136, 137
He Sen, courtesy AW asia, New York: 207
He Yunchang, courtesy Chambers Fine Art, New York: 85, 86, 87
Hong Hao: 157
Hong Lei, courtesy Chambers Fine Art, New York: 128
Huang Yan, © Huang Yan, courtesy the artist and Chinese Contemporary Gallery, Beijing: 148, 149
Huang Yong Ping, courtesy the artist and the Walker Art Center: 56, 57 (top), 59; 57 (bottom), photograph by Thomas Svab, Vancouver Art Gallery
Yun-Fei Ji, © Yun-Fei Ji, courtesy James Cohan Gallery, New York and Shanghai: 203
Jia Aili, courtesy the artist: 215
Jian Feng: 19
Jian-Jun Zhang, © Jian-Jun Zhang: 196, 197
Li Shan, courtesy the artist and ShangART Gallery, Shanghai: 23,
Li Songsong, courtesy Galerie Urs Meile, Beijing-Lucerne: 199
Li Wei, courtesy Marella Gallery, Beijing: 13, 151
Li Zhanyang, photographs by Oak Taylor-Smith, courtesy Galerie Urs Meile, Beijing-Lucerne: front cover, 233
Li Zhensheng, courtesy Contact Press Images: 121
Lin Tianmiao, courtesy Pekin Fine Arts, Beijing: 68
Lin Yan, courtesy Cheryl McGinnis Gallery, New York: 235
Lin Yilin, © Lin Yilin: 100, 101
Liu Jianhua: 50
Liu Jin, © Liu Jin: 104 (right)
Liu Wei (b. 1965), courtesy Galerie Urs Meile: 39 (right)
Liu Wei (b. 1972), courtesy Galerie Urs Meile: 230–31
Liu Xiaodong, © Liu Xiaodong, courtesy Mary Boone Gallery, New York: 36–37
Liu Zheng, courtesy Pekin Fine Arts, Beijing: 140, 141, 142–43
Lu Chunsheng, courtesy the artist and ShangART Gallery, Shanghai: 223
Lu Shengzhong, courtesy the artist and Chambers Fine Art: 209
Luo Brothers, courtesy the artists: 32
Luo Zhongli: 21
Ma Liuming, courtesy Pekin Fine Arts, Beijing and AW asia, New York: 79 (top), 80 (top)
Miao Xiaochun, © Miao Xiaochun, courtesy Walsh Gallery and Pekin Fine Arts, Beijing: 156
Mo Yi, © Mo Yi, courtesy Walsh Gallery: 139
Qi Zhilong: 26
Qin Feng, courtesy of Ethan Cohen Fine Arts and the artist: 39 (left)
Qin Ga, © Qin Ga, courtesy Long March Space, Beijing: 92
Qiu Anxiong: 226
Qiu Shihua: 204
Qiu Zhijie: © 93, 94, 95
Ren Xiong: 20

Rent Collection Courtyard, courtesy Wang Song: 45
Rong Rong, © Rong Rong / © Rong Rong & Inri: 132, 133
Shao Yinong and Mu Chen: 6-7; 134, 135 courtesy Goedhuis Contemporary, New York
Shen Chen, courtesy Cynthia Reeves Gallery, New York: 234
Ruijun Shen, courtesy the artist: 238
Shen Shaomin, courtesy Galerie Urs Meile: 52,
Sheng Qi, courtesy the artist: 148
Shi Guorui: frontispiece, 154–55
Shi Jinsong, courtesy Chambers Fine Art, New York: 51
Shi Yong, courtesy the artist and ShangART Gallery, Shanghai: 72, 73
Song Dong, courtesy Chambers Fine Art, New York: 90, 91
Song Yongping, courtesy China Square Gallery, New York: 123
Xin Song, courtesy Cheryl McGinnis Gallery: 237
Sui Jianguo, courtesy Arario Gallery, Beijing: 46, 47, 48–49
Sun Xun, courtesy the artist and ShangART Gallery: 227
Sun Yuan and Peng Yu: 104 (left), 105
THEY (Ta Men), courtesy the artists and Beyond Art Space, Beijing: 229
Wang Guangyi, courtesy the artist and ShangART Gallery, Shanghai, and Arario Gallery, Beijing: 22, 30, 31
Wang Jianwei: 169, 171, 172, 173
Wang Jin, courtesy Pekin Fine Arts, Beijing: 97, 98, 99
Wang Keping, courtesy AW asia, New York: 247
Wang Ningde, courtesy Marella Gallery, Beijing: 126, 127
Wang Peng, © wangpeng: 76, 77, 89
Wang Qingsong, © Wang Qingsong, courtesy the artist and Pekin Fine Arts, Beijing, and China Square Gallery, New York: 160–161, 162, 163, 194–195
Wang Wei, © Wang Wei, courtesy Michael Petronko Gallery, New York: 180, 181
Wang Tiande, courtesy the artist and Chambers Fine Art: 210–11
Wei Dong, © Wei Dong: 203
Weng Fen (Weng Peijun), courtesy Pekin Fine Arts, Beijing: 118–19, 159
Wu Ershan, © One Production: 213
Wu Shanzhuan: 71
Zhan Wang, courtesy Haines Gallery: 47
Xiamen Dada, courtesy Walker Art Center: 78
Xiao Lu, courtesy China Square Gallery, New York and Ethan Cohen Fine Arts, New York: 79 (bottom)
Xiao Yu, courtesy Pace Beijing: 52
Xing Danwen, © Xing Danwen, courtesy Galerie Sollertis, Toulouse; Moti Hasson Gallery, New York; and Kiang Gallery, Atlanta: 129, 130–31
Xu Bing, © Xu Bing Studio: 62, 63, 64
Xu Zhen, courtesy of the artist and Long March Space, Beijing: 182
Yan Pei-Ming, courtesy David Zwirner, New York, and Galleria Massimo De Carlo, Milan: 35
Yang Fudong, courtesy ShanghART Gallery, Shanghai: 183, 185, 186, 187, 240–241
Yang Maoyuan: 53
Yang Shaobin, courtesy Arario Gallery, Beijing: 38
Yang Yong, courtesy Pekin Fine Arts, Beijing: 138
Yang Zhenzhong, courtesy the artist and ShangART Gallery, Shanghai: 178, 179
Yang Zhichao, © Yang Zhichao, courtesy Eastlink Gallery, Shanghai: 88
Ye Yushan: 45
Ye Yongqing, courtesy Chinasquare Gallery: 212
Yin Xiuzhen, courtesy Chambers Fine Art, New York: 69, 70
Yu Hong, courtesy Long March Space: 216
Yu Youhan, courtesy the artist and ShangART Gallery, Shanghai: 24
Yuan Dongping, © Yuan Dongping: 122
Yue Minjun, courtesy the artist, Max Protetch Gallery, New York, and Alexander Ochs Galleries, Berlin/Beijing: front cover, 10, 25
Yun Fei-Ji, © Yun Fei-Ji, courtesy James Cohan Gallery: 203
Zeng Fanzhi, courtesy the artist and ShangART Gallery: 29 (bottom)
Zeng Hao, courtesy Arario Gallery, Beijing: 34
Zhang Dali, courtesy Kiang Gallery, Atlanta: 96, 120, 243
Zhang Ding, courtesy the artist and ShangART Gallery: 228
Zhang Enli, courtesy the artist, ShangART Gallery, and Hauser & Wirth: 214
Zhang Hongtu: 198, 199
Zhang Huan, © Zhang Huan: 82, 83, 84, 108, 109, 110, 111
Zhang O, © O Zhang: 217
Zhang Peili, courtesy Jack Tilton Gallery, New York: 167
Zhang Yimou, Credit: The Kobal Collection/Era International: 166
Zhang Xiaogang: 28, 239
Zhao Bandi, courtesy the artist and ShangART Gallery, Shanghai: 103
Zheng Guogu; courtesy the artist and Barbara Gross Galerie, Munich, and Universal Studios, Beijing: 102
Zhong Biao, courtesy the artist and Frey Norris Gallery, New York: 202
Zhou Chunya, courtesy the artist and ShangART Gallery, Shanghai: 40
Zhou Tiehai, courtesy the artist and ShangART Gallery, Shanghai: 33
Zhou Xiaohu: 174, 175
Zou Cao, courtesy Von Lintel Gallery, LLC: 208
Zhu Ming, courtesy the artist and Chinese Contemporary Gallery, Beijing: 74–75, 80 (bottom), 81
Zhu Yu: 107
Zhuang Hui, courtesy the artist: 124–25

Front cover:

Li Zhanyang, *History Observed: Joseph Beuys, Mao Zedong*, from the series "Rent"—Rent Collection Yard, 2007. Resin, 195 x 217 x 160 cm, edition of 2. Photo by Oak Taylor-Smith, courtesy Galerie Urs Meile, Beijing-Lucerne

Frontispiece:

Shi Guorui, *Shanghai, China, October 21–22, 2004.* Camera obscura, gelatin silver print, 129 x 360 cm

This book includes a number of passages drawn from the author's many reports on China in *Art in America* magazine, published between 1998 and 2010. These excerpts, which have been variously modified and recontextualized, are used with the permission of Brant Publications. The discussion of Xu Bing is drawn from the author's copyrighted essay "Dust to Dust: Xu Bing Then and Now" in Tessa Jackson, ed., *Artes Mundi: Wales International Visual Art Prize*, Bridgend, Wales: Artes Mundi and Seren, 2004. The passage on Sun Xun is adopted from his essay in *Sun Xun: Shock of Time*, New York: Drawing Center, 2009.

See page 255 for photography credits.

Prestel, a member of Verlagsgruppe Random House GmbH

Prestel Verlag
Neumarkter Strasse 28
81673 Munich
Tel. +49 (0)89 41 36-0
Fax +49 (0)89 41 36-2335

Prestel Publishing Ltd.
4 Bloomsbury Place
London WC1A 2QA
Tel. +44 (0)20 7323-5004
Fax +44 (0)20 7636-8004

Prestel Publishing
900 Broadway, Suite 603
New York, N.Y. 10003
Tel. +1 (212) 995-2720
Fax +1 (212) 995-2733

www.prestel.com

Prestel books are available worldwide. Please contact your nearest bookseller or one of the addresses on the left for information concerning your local distributor.

Library of Congress Control Number: 2011928488
British Library Cataloguing-in-Publication Data: a catalogue record for this book is available from the British Library. The Deutsche Bibliothek holds a record of this publication in the Deutsche Nationalbibliografie; detailed bibliographical data can be found under: http://dnb.ddb.de

Editorial direction by Christopher Lyon
Copyediting by Mary Christian, New York
Picture research by Ling-Yun Tang and Shoshana Olidort
Cover and layout concept by Ilja Sallacz, Agentur Liquid, Augsburg
Design and layout by Bernd Walser Buchproduktion, Munich
Origination by Reproline Mediateam, Munich

Printed and bound by Uhl, Radolfzell

Verlagsgruppe Random House FSC®-DEU-0100
The FSC® certified paper Hello Fat matt has been supplied by Deutsche Papier

Printed in Germany

ISBN 978-3-7913-4550-5 (second edition)

Richard Vine is senior editor for Asia at *Art in America* magazine. He holds a Ph.D. in literature from the University of Chicago and has served as editor-in-chief of the *Chicago Review* and of *Dialogue: An Art Journal*. He has taught at the School of the Art Institute of Chicago, the American Conservatory of Music, the University of Riyadh in Saudi Arabia, the New School for Social Research, and New York University. His articles have appeared in various journals, including *Salmagundi*, the *Georgia Review*, *Tema Celeste*, *Modern Poetry Studies*, and the *New Criterion*, and in numerous art catalogues and critical compendiums. His book-length study *Odd Nerdrum: Paintings, Sketches, and Drawings* was published by Gyldendal/D.A.P. in 2001.

PRESTEL

MUNICH · LONDON · NEW YORK

"*New China* is the finest introduction to Chinese avant-garde art since the 1970s, a textbook and guidebook for students and collectors, as well as Mao's working people.... A superb, controlled survey of a vast, writhing subject."

—Don J. Cohn, *Art Asia Pacific*

"For years a sharp-eyed and sometimes critical observer of China's art scene, Richard Vine brings an insider's discernment to this fascinating account of the rise of Chinese contemporary art."

—Christopher Phillips, Curator,
International Center of Photography, New York City

"An insightful account of contemporary Chinese art by a seasoned observer. Vine's book is particularly valuable in introducing major visual modes of this art and explaining what is unique and exciting about them."

—Wu Hung, Director, the Center for the Art of East Asia, University of Chicago

ISBN 978-3-7913-4550-5

9 783791 345505

WWW.PRESTEL.COM